THE TELEVISION SERIES

Tony Garnett

Manchester University Press

THE TELEVISION SERIES

series editors

SARAH CARDWELL
JONATHAN BIGNELL

STEPHEN LACEY

Tony Garnett

Manchester University Press
MANCHESTER AND NEW YORK

distributed exclusively in the USA by Palgrave

Published by Manchester University Press
Oxford Road, Manchester M13 9NR, UK
and Room 400, 175 Fifth Avenue, New York, NY 10010, USA
www.manchesteruniversitypress.co.uk

Distributed in the United States exclusively by
Palgrave Macmillan, 175 Fifth Avenue,
New York, NY 10010, USA

Distributed in Canada exclusively by
UBC Press, University of British Columbia, 2029 West Mall,
Vancouver, BC, Canada V6T 1Z2

British Library Cataloguing-in-Publication Data is available

Library of Congress Cataloging-in-Publication Data is available

ISBN 978 0 7190 6629 0 paperback

First published by Manchester University Press in hardback 2007

This paperback edition first published 2012

The publisher has no responsibility for the persistence or accuracy of URLs for any external or third-party internet websites referred to in this book, and does not guarantee that any content on such websites is, or will remain, accurate or appropriate.

Printed by Lightning Source

To Catherine, Mark, Lauren and Owain

Contents

General editors' preface

Television is part of our everyday experience, and is one of the most significant aspects of our cultural lives today. Yet its practitioners and its artistic and cultural achievements remain relatively unacknowledged. The books in this series aim to remedy this by addressing the work of major television writers and creators. Each volume provides an authoritative and accessible guide to a particular practitioner's body of work, and assesses his or her contribution to television over the years. Many of the volumes draw on original sources, such as specially conducted interviews and archive material, and all of them list relevant bibliographic sources and further reading and viewing. The author of each book makes a case for the importance of the work considered therein, and the series includes books on neglected or overlooked practitioners alongside well-known ones.

In comparison with some related disciplines, Television Studies scholarship is still relatively young, and the series aims to contribute to establishing the subject as a vigorous and evolving field. This series provides resources for critical thinking about television. While maintaining a clear focus on the writers, on the creators and on the programmes themselves, the books in this series also take account of key critical concepts and theories in Television Studies. Each book is written from a particular critical or theoretical perspective, with reference to pertinent issues, and the approaches included in the series are varied and sometimes dissenting. Each author explicitly outlines the reasons for his or her particular focus, methodology or perspective. Readers are invited to think critically about the subject matter and approach covered in each book.

Although the series is addressed primarily to students and scholars of television, the books will also appeal to the many people who are interested in how television programmes have been commissioned, made and enjoyed. Since television has been so much a part of personal

and public life in the twentieth and twenty-first centuries, we hope that the series will engage with, and sometimes challenge, a broad and diverse readership.

Sarah Cardwell
Jonathan Bignell

Acknowledgements

This book is one of the outcomes of the research project 'Cultures of British Television Drama, 1960–82', funded by the Arts and Humanities Research Council. Research was undertaken in 2002–05 by Lez Cooke and Helen Wheatley, and the project was managed by Jonathan Bignell, John Ellis and myself, at the University of Reading, Royal Holloway University of London, and Manchester Metropolitan University.

Although this book bears my name alone, it would not have been possible without the help, support and advice of a great many people. First, I would like to thank Jonathan Bignell and Sarah Cardwell, the editors of the series in which this monograph appears, for suggesting that I write it in the first place. Thanks are due, too, to the editorial team at MUP who have answered my queries with patience and clarity (often when I have shown neither). I also owe a debt to generations of students who have responded to, and often challenged, my thinking about realism, television drama and Tony Garnett's work, especially the TV Drama Critical Option groups (1998–2001) in the Department of Film, Theatre and Television at the University of Reading (you know who you are). Special thanks are due to Karen Shepherdson, who generously allowed me to read and refer to her unpublished PhD thesis on Garnett's work, and who provided me with some vital primary source material; also Lez Cooke, not only for his wide-ranging work on British television drama, but also for allowing me access to unpublished interview material. I am particularly grateful to Helen Saunders, Tony Garnett's PA at World Productions, who answered all my requests for information and material promptly and with good humour.

Most of all, I am extremely grateful to Tony Garnett for his generosity and time in granting me several interviews, and giving me access to hard-to-come-by programmes. He has been unfailingly courteous, helpful and articulate (although I, of course, take responsibility for the use I have made of the material). I hope I have done the work justice.

And last of all my family, to whom this book is dedicated, for their support, patience and love.

Stephen Lacey

Introduction: telling the truth

> There's only one serious obligation that we have to the audience: that is to tell the truth. All the other obligations depend upon skill, ability and so on, but what the audience has the right to expect from us is that we should tell the truth. Of course, only God, should He or She exist, knows *the* truth, but we have an obligation to tell *our* truth ... If you present *your* truth, but make people aware there are other potential 'truths', you're giving them the opportunity, the encouragement and the confidence to examine *their* truths. (Garnett 1998: unpaginated)

Tony Garnett has been telling his truths for over forty year, as an actor, story editor and then producer, within the context of British television, film and Hollywood cinema. It is as a television producer that he is best known, of course, but his earlier experience as an actor was important to the particular working practices that he later developed when, as he put it, he became the one making the phone calls (2000a: 13). Garnett has been responsible for a considerable variety of work, including some of the most influential plays/films of British television history. His first play as producer was *Cathy Come Home* (BBC 1966), which was the first television drama that was also a social and political event (possibly one of the most auspicious debuts in television history). It is still regarded as part of the essential iconography of the decade. In the 1970s, he was part of the team that produced *Days of Hope* (BBC 1975), a four-part series on the 1926 British General Strike, which, despite its historical theme, created a strong contemporary political resonance. In the 1990s, he was executive producer for *This Life* (BBC 1996–97), which extended the possibilities for contemporary drama series, using digital technology to create a distinctive visual style. Around these key points, Garnett has also produced films for the cinema as a British independent, such as *Kes* (1969), *Prostitute* (1980) and *Beautiful Thing* (1996). He spent a decade in Hollywood (1980–90), during which he produced four films, including *Handgun* (1983) and *Shadow Makers*

(1990). As managing director of World Productions since 1990 (Island World Productions until 1993), he has overseen, and/or been executive producer for, a range of one-off films, series and mini-series (see Chapter 4). Although not a natural 'joiner', at his own admission, he served on the executive of his union (Association of Cinematographic and Television Technicians: ACTT) in the late 1960s and was one of the Governors of the British Film Institute and Chair of the Production Board in the early 1990s.

Garnett is one of a small group of television producers who have helped to define what being a television producer is, and has been, since the 1950s (and how Garnett has developed this role in particular contexts is a theme of this book). In this sense, his career runs parallel to those of Kenith Trodd, Verity Lambert and Irene Shubik, who also have long-established presences in television drama in its many forms. He is insistent, as television producers usually are, on the collaborative nature of television drama production. Indeed, one of his talents as a producer is to find collaborators (often new to television drama) with whom he can work effectively, and to build teams that secure continuity of approach – political and aesthetic – across time. 'What we try to do is to keep the cohesion of a working group of people to benefit everybody's creative development' Garnett commented in interview: 'You help each other. You lever each other up and everybody gets better' (Bream 1970: 38). His best known collaborator is the director Ken Loach, with whom he worked consistently, though not exclusively, between 1965 (*Up the Junction*) and 1978 (*Black Jack*). The tag 'Loach and Garnett' has come to define a particular style of class-based realism, politically of the left and shot in an observational film style that connotes documentary (Chapter 1). This is particularly true of their work with writer Jim Allen. There are, and have been, many more regular collaborators, at all levels of production, several of whom were given their first opportunities in television – or, in some cases, their first attempt at television drama – by Garnett: in addition to Allen, Garnett has worked with writers Barry Hines in the 1960s and 1970s, and Amy Jenkins, Jimmy Gardner and Richard Zajdlic since 1990; directors Rolland Joffe, Les Blair, Jack Gold and Roy Battersby (these last two recruited from documentary and features); cameraman Tony Imi (also recruited from documentary). Garnett also gave Mike Leigh his first chance to make improvised drama for television.

Garnett is particularly hostile to 'auteurism', insisting that drama production is a collective practice, artistically and socially. Auteurism in its crudest form explains the creation of 'significant' drama (as distinct from formulaic or generic drama) as the product of a single, authorial

consciousness. However, this position is impossible to sustain in relation to both film and television production. It is a last stand in favour of nineteenth-century notions of the artist as romantic outsider, railing against the alienation of industrialisation. As Tim Adler has commented acerbically of the cinema, 'the only film-makers worthy of canonisation as author-artists were those whose personal style emerged in spite of the profit-hungry Moloch that was the studio system' (Adler 2004: 5). However, dismissing auteurism does not dispel the question of authorship of television drama, which remains a particularly knotty problem, historically and structurally. For much of its history, television drama adopted the practice of literature and stage drama and accorded the writer the status of prime creator; indeed, most of the books in this series are devoted to writers. Even in the more ratings-driven, commissioner-controlled environment that is contemporary broadcasting, writers remain crucial, and are often defended against interference (not least by Garnett). The first book-length study to take television drama seriously, Brandt's *British Television Drama* (1981), is organised around writers – an effective political expedient, since it was only the writer who could guarantee cultural 'worth' in a medium that has been seen as inherently trivial. At other times, the creative influence of directors and – less often – producers has been admitted (especially in the 1970s, when a new generation of high-profile drama directors emerged – see Cooke 2003). It is interesting to note that both Garnett and Loach celebrated their seventieth birthdays in 2006; Loach, fresh from the triumph of a Palme D'Or for *The Wind that Shakes the Barley*, has been celebrated with a retrospective of his films and a documentary, whilst Garnett's birthday has past largely unnoticed.

Whilst it is now rare to see a strictly auteurist account of drama production (and even Dennis Potter's collaborators are recognised), an 'author' – who may not now be a writer – is still important to the process, often functioning as a 'brand', locating a 'product' for reviewers and audiences in a competitive market. Despite his disclaimers, Garnett is often discussed as the 'author' of the dramas he produces and this pre-dates the Thatcherite commercialisation of broadcasting (see Chapter 4). From an early point in his career, Sydney Newman referred to 'Garnett-type productions' in memos to his (Newman's) superiors (Chapter 2). As the forms and structures of drama production developed at the BBC, Garnett frequently became the main interpreter and defender of the drama he produced, often facing down considerable hostility. He later referred to this as an era of 'producer power', in which the producer 'was in the driving seat' (Garnett 2000a: 13). Producer power meant

having the authority to create and nurture projects in a way that was indeed 'authorial', though not to the exclusion of everyone else. Authorship of television drama is, therefore, rarely attached to a single individual, and may be thought of as an institutional space, to be filled by a variety of practitioners – writers, script editors, directors, executives as well as producers – and frequently argued over. Since the 1950s, arguments over the autonomy of programme makers within an increasingly industrialised production system have been essentially about the relative power relationships between practitioners struggling to stamp their authority over the text. Authorship is also a process that begins before commissioning and carries on after the programme has been aired, especially when a series/serial, which may adapt to the way it is received, is being considered.

Garnett has worked in a variety of production contexts across the decades, and his role as producer has altered in the process. In the 1960s and early 1970s, the division between various production roles in the BBC was more fluid than it has become subsequently, and Garnett was able move from actor to story editor to producer (and subsume the story editor's role into that of producer). In the 1970s, he formed Kestrel Productions with Ken Trodd and others, and moved into feature film production, at which point he was confronted with the necessity to raise money as well as drive a project along. In the 1980s, as an independent producer in Hollywood, he was confronted with the economic realities of a fully-formed capitalist production system. Since 1990, as the head of an independent production company in the newly-competitive British broadcasting structures, Garnett has operated in a way that might be compared with the writer/producer 'hyphenates' of contemporary US television, such as Steve Bochco (*Hill St Blues*, NBC 1981–87; *NYPD Blue*, ABC 1993) and Joss Whedon (*Buffy the Vampire Slayer*, WB 1997–2003). Roberta Pearson (2005) has argued that the growth of cable television and a consequent focus on the demographic profile of audiences, as opposed to simple calculations of audience share, has favoured the hyphenate, producing distinctive programming for particular – and desirable in advertising terms – viewers. That US hyphenates are literal authors is not as important as the fact that they control every stage of the process, placing an authorial signature on programmes even when they have not written them. Whedon has described his role as executive producer as 'being responsible for everything in every frame of every show. That's my job, whether or not I'm directing the episode' (quoted in Pearson 2005: 18). Allowing for the differences between the two productions contexts, this is not dissimilar to Garnett's conception of his role. Garnett has always been a

hands-on producer, involved in each stage of the production process and often contributing directly to the script. The 'writing' of a contemporary drama script, then, is the result of a complex and often collective process, in which Garnett, like Whedon, is the key figure, even when he does not actually contribute a single word.

Garnett's authorial signature is intimately connected to a realist politics and aesthetics, which is still the best way of describing the spine that runs though his work. Realism, with its various qualifiers – social, magical, hyper – and its near-synonyms (notably naturalism), is a much-debated term in cultural criticism. Contested, rejected and renewed, it has remained remarkably resilient, adapting to each new twist of cultural fashion and political circumstance. For Garnett, realism is both method and intention, a set of priorities for encountering the social world and a means of representing it. As he put it in the 1990s:

> [A]lthough I've had one or two adventures and experiments with other forms, most of my life I've been trying to work in, struggle with, and makes sense of the broad tradition of this country of social realism. It's unfashionable now, but it still interests me. Social realism is a stance: it's all about a way of representing the world and of thinking about society. Social realism is not a formula. (Garnett 1998: unpaginated)

As this reveals, Garnett has been constantly pulled back towards social realism, although this has been an engagement with a tradition, rather than the adoption of a pre-existing form (and it does not describe *all* the work he has been responsible for). Garnett has been consistently self-aware of this struggle, placing it in a political, aesthetic and moral context; he is both a practitioner and an intellectual – indeed, a practising intellectual in that his thinking is most evident in his practice. He has also pursued the realist project across the developing forms of television drama, from the single play to the mini-series to the renewable, multi-episode series/serial hybrid. 'Social realism' comes laden with expectation, and popularly connotes a drama that reveals the situation of the working-class at the level of its culture and everyday practices. A discussion of social realism, and of 'analytical realism', which is the preferred term in this book for that strand of Garnett's work that offers an explanation as well as a description of class and power, will occur across the chapters that follow.

More than any other drama producer, perhaps, Garnett has been associated with the introduction of new technologies into drama production. In the 1960s, as a new producer who was engaged in thinking through the possibilities of a drama for a new mass medium,

he (with Loach and cameraman Tony Imi) explored the use of lightweight 16 mm cameras. Developed as a technology for use in current affairs and documentary, 16 mm cameras were deemed inappropriate for drama in the period. However, *Up the Junction* (1965) and *Cathy Come Home* both revealed a way of moving into and engaging directly with the social world, rather than representing it metonymically through the studio set (although both included studio footage – see Chapter 2). Film as a technology and a political aesthetic for television drama became as much a part of the 'Loach/Garnett' signature as the 'gritty' subject matter of their plays (which we should now call films). Garnett also showed early interest in television/cinema tie-ins, and attempted to secure limited cinema release for both *Cathy Come Home* and *The Lump* (BBC 1967). This was rejected by the BBC at the time, but seems prescient in an era of cross-media production. In the 1990s, Garnett introduced new digital video cameras into drama production with the hospital-based drama series *Cardiac Arrest* (BBC 1994–96). Cheaper and more flexible, digital video allowed Garnett and his collaborators to develop a fluid, actor-centred shooting style that permitted a higher ratio of filming per day. Developed in subsequent series (*This Life* and *The Cops* (1998–2001) in particular), this approach was visually distinctive and cheap to produce, buying Garnett kudos with broadcasters in the process (Chapter 4). Garnett has also become interested in the relationship between television, as it has been traditionally conceived, and newer forms of publication such as the internet. *Attachments* (BBC 2000–3) was set in the office of an Internet start-up company seeking to capitalise on the success of its owners' website. World Productions established that website in reality, updating it to reflect developments in the series and inviting responses from the viewer (Chapter 4). Although not a notable success, *Attachments* demonstrated a different way of thinking about television drama, and Garnett remains keenly interested in the potential for new media to challenge and renew current thinking about dramatic form and modes of delivery.

Garnett has repeatedly asserted his interest in reaching a mass, popular audience, and this is one of the main reasons why, despite forays into cinema, he has returned to television. The 'popular' in popular television is a contested and ambiguous term, as it is when applied to culture as a whole. Popular television is still sometimes subject to the condescension and hostility that greeted the expansion of television in the 1950s, and which embraced 'mass' culture as a whole; that it was meretricious, evidence of a creeping Americanisation, destructive of 'authentic' and popular (pre-consumerist) working-class

culture and the product of an industrialised system (Schiach 1989). Yet the arguments have not remained static. Television is seen as a popular medium, defined in terms of its reach and connection to a national audience; measured against the potential audiences for television drama, theatre and even cinema will always be minority pursuits. However, debates about the popular are also conducted within television, between different kinds of programming aimed at an increasingly fragmented audience. Standing inevitably behind 'the popular' is the shadow of serious, or 'quality', drama, echoing the categories used elsewhere in culture (see Bignell and Orlebar 2005: 120–2) and linked to class-based value systems (Bourdieu 1992). It is not a question of different formats – 'quality' one-off films versus 'popular' soaps – and arguments about the popular and populism increasingly play across different programme categories and genres. Since 1990 Garnett has worked consistently within the popular renewable drama series, but his name is seen as a guarantee of 'quality' and innovation across the broadcasting spectrum.

Garnett's desire to address the popular audience is, at one level, a political need to speak to the largest number of people possible. In the 1960s, the survival of the single play depended on its attracting large audiences (Chapter 2), and The Wednesday Play regularly attracted high viewing figures – a significant reason why dramas such as *Cathy Come Home* had such an impact. It is also a question of speaking to a particular *kind* of audience, a working-class one – again proceeding from a complex political need to value the working-class and its culture and produce change. As Garnett wrote later, 'I like the challenge of having to ask, "What can I get my cousin Norah to watch?"' (2001: 82). Since the 1990s, however, the audience is rarely as large and unified as it was when twelve million people sat down at the same time to watch *Cathy*. Very little contemporary drama beyond the soaps/continuous serials finds the really big audiences available in a pre-digital and satellite age. However, as indicated above, it is the 'quality' of audiences for advertising purposes, rather than quantity, that is important. This has implications for the way that the working-class is represented, as Garnett has observed:

> Gross numbers are not so important now, it's the demographics that are important. If you want to sell fancy cars, or upmarket consumer durables or luxury drinks, you ... want a programme wrapping around your ad that will attract the well-off ... This does not mean that the working class will not be represented at all on these programmes, but it does affect the filter through which they are portrayed, the point of view, the stance taken. (Garnett 2001: 80–1)

This is as true of the BBC, seeking to secure loyalty from influential groups, as it is of commercial broadcasters (see Chapter 4). This has produced a paradox: since 1990, Garnett's work has increasingly been made for 'minority' channels, especially the series/serials that have a relationship to social realism, which do not, by and large, appeal to 'cousin Norah' and the wider popular audience. *This Life*, one of the most influential and 'popular' of 1990s series, did not attract a large audience, although it did attract a young and affluent one, for which BBC2 were very grateful (see Chapter 4). In fact, Garnett has been far more pragmatic in his approach to the popular audience than his public pronouncements might suggest, and far more attuned to other, non-class oriented, elements in contemporary culture. World Productions may create work for BBC2 and 3 or Channel 4, but often attempts to reach out beyond the usual audience by working within popular genres ('cops'n'docs'), refashioning them in the process (Chapter Four). Indeed, Garnett has produced series that have tried to address the situation of the contemporary working-class – or a section of it – through generic drama (see, for example, *The Cops*, (BBC 1998–2001)). He regularly talks of his work as 'Trojan horse drama', offering some of the immediate pleasures of genre to both broadcasters and audiences, but containing a more realist, less easily consumable content as well.

The main concerns in this book are, as the above outline suggests, with Garnett's role as a television producer, working within a social realist tradition. I have adopted a broadly chronological approach, partly because Garnett's work has developed in response to wider social, political and cultural developments – sometimes in very direct ways. The historical narrative of the creation, disturbance and then dismantling of the post-war consensus, and the consequences of this for the way that culture has operated (and especially television), runs through this book. I have also tried to give a sense, inevitably schematic, of these historical pressures and to draw on them when discussing particular programmes. Chapter 1 looks briefly at Garnett's biography, but not to 'explain' the work in terms of the life, and biographical interpretations are not relevant. Garnett is, however, part of a particular post-war generation of working-class intellectuals, freed from their class origins by education and the transformations of the economy, and rising to a position of political and cultural power. Chapter 1 also examines the conditions, ideologies and practices of drama broadcasting in the mid-1960s, and charts Garnett's career from actor to producer. Additionally, this chapter examines what is meant by 'realism' and considers how it has been transformed, drawing on the theoretical work of Raymond Williams, for whom Loach and Garnett's

work was a test case. Chapter 2 discusses the creation of The Wednesday Pay anthology series, and considers Garnett's work for it, in its formal and cultural contexts. Inevitably, *Up the Junction* and *Cathy Come Home* loom large in this analysis, along with debates about realism and documentary drama. However, the chapter argues that Garnett's work is broader and more experimental than is often allowed, open to a range of influences from the theatre and cinema, and space is given to this often marginalised work. Chapter 3 begins in about 1968 and discusses the establishment of Kestrel Productions and some of Garnett's cinema work. By 1971, Garnett was back at the BBC, producing some of his most contentious work (with Loach and Allen), and much of the chapter analyses this. It also explores Garnett's decision to leave for the USA and Hollywood at the end of the 1970s, and considers some of the work he produced whilst there. Chapter 4, the final chapter, charts Garnett's return to British television and the establishment of Island World Productions (later World Productions) in 1990. This meant a changed role for Garnett, moving from producer to executive producer for many of the programmes he produced. It also meant taking on the disciplines of the long-running renewable series/serial, and of developing a style of drama production that could exploit new digital technology and explore the realist potential of popular, generic drama. This journey is discussed through analysis of key series/serials from the last fifteen years' work, placed in the context of ideologies and practices of production, and debates about genre and dramatic form.

As this book is appearing in a series on British television, I am mostly concerned with Garnett's work for the small screen. His time in Hollywood does not, for example, receive the attention that his period at the BBC and at the head of World Productions does. Where I have focused on films for the cinema, it has been mainly because they were important to his creative and political development (such as *Kes*), or where he has operated as producer, director and writer (*Prostitute* and *Handgun*). Garnett is primarily a producer, and his contribution to each project has often been at the development, commissioning, post-production and post-screening stages. Consequently, I have tended to place the analysis of particular programmes in their production contexts and consider their public reception (to which Garnett frequently contributed). Whilst the producer's role is an authorial one, as indicated above, and close textual analysis is important to this kind of analysis, there is probably less of it than there would be if Garnett were a director or writer. I have also, out of necessity, had to be selective in what I could discuss in any depth. My choices have been shaped by

several factors. Some programmes receive attention because they are widely seen to be influential or are part of existing cultural and academic discourse – for example, *Up the Junction, Cathy Come Home, Days of Hope, This Life* – and I hope to contribute something to the discussion. Others are present because they exemplify a particular aspect of Garnett's realist practice (*The Spongers* and *Law and Order* for example) or a particular stage in his development as a producer. Space is also given to experiment in the work to which he has contributed, especially in the 1960s, all of which indicates the expansive nature of realism. This is a book about Tony Garnett, and not World Productions, and this has meant omitting, reluctantly, certain popular series from the prodigious output of World Productions from detailed consideration, such as *Ballykissangel* and *No Angels* for which Garnett has had limited responsibility. In certain cases, I have included series that I argue are worthy of consideration, even though they have not excited public interest or academic attention (*Buried*, for example). Like the other authors in this series, I imagine, I chose my subject because of a fascination and engagement with the work that is both political and aesthetic. I have attempted to describe, explicate and analyse Garnett's work, and in doing so have realised how much I, and British television, am indebted to it.

From actor to producer: into the driving seat

On 15 June 1966, Sidney Newman, the Head of the Drama Group at the BBC, wrote a memo to Kenneth Adam, the Commissioner of Programmes, entitled 'The Wednesday Play'. The memo, which Newman thought 'short on fact and long on thought' (Newman 1966b: 2), was an articulate defence of the anthology series (1964–70), with which he (and later Tony Garnett) had become closely identified. The memo is mainly about the need to attract – and keep – good writers committed to working in television, and stands as a clear statement of the unique conditions of drama production in the mid-1960s when demand exceeded supply. It is also an early attempt to define what a television producer is and does. Newman introduced the role of the producer when he first took over the Drama Group in 1963, separating it from that of director. Noting that plays such as *Up the Junction* (1965) were 'tricky', Newman argued that to produce them required exceptional abilities:

> Individuals who are experienced enough to be wise, to win and not offend (too much) audiences: clever enough to inspire writers along the right lines and strong enough to control directors who may be, and often are, headstrong and dangerously original. The fact that they have to be good organisation men and good business managers as well ...! Frankly we have not got one producer who possesses all these qualities. (Newman 1966b: 4)

The fact that the role of the producer is described as a list of personal attributes and not organisational functions is both an indication of the way that Newman operated as Head of Drama, playing hunches about individuals rather than promoting according to established procedures, and of the ill-defined character of the role itself. At one level, the producer was clearly expected to exercise a supervisory function (and the memo was a counter to the charge that The Wednesday Plays in general,

and *Up the Junction* in particular, were needlessly controversial). Yet, as Newman acknowledged, 'the immediate supervisory control system has, in the sense of its complexity, barely gotten off the ground' and few producers knew what was required of them. Beyond this, the producer was not a role that Newman felt many creative or ambitious people would want:

> It is true to say that very few of our people, or worthwhile people in England generally, want this kind of job. The pay is not so great and is regarded as not having so much 'fun' nor worth the anguish, pain frustration and above all, responsibility. Remember, they are the ones who have to satisfy BBC policy, their immediate superiors, the critics, the audiences, win actors, directors, save money and so on. (Newman 1966b: 4)

Newman is defending his team against the charge of dereliction of duty, and may therefore be arguing disingenuously, but his comments represent a common view of the burdens a producer might be expected to shoulder. Who, indeed, would want such an ill-defined and thankless role, and what would they do with it? As Newman was writing this memo, Tony Garnett, in his first project as a producer, was working with a writer new to television, Jeremy Sandford, and one of a new generation of directors, Ken Loach, on a location-based drama about homelessness called *The Abyss* – later to become *Cathy Come Home*. This was one emphatic answer to Newman's question.

Tony Garnett was born in Birmingham on 3 April 1936, the son of a toolmaker, and was educated in a local grammar school. His chief interest was always acting, and he spent much of his time as a teenager at Stratford, the home of the Royal Shakespeare Company. After leaving school, he acted in local repertory theatres before taking up a place the University of London where he studied psychology. He spent, he says, little time at the university, and developed a parallel career as an actor whilst studying (his choice of London as a place to study being dictated by his desire to be close to the television studios) (Garnett 2001: 70). By the late 1950s and early 1960s, he was a relatively successful actor, rarely out of work, and with a profile of creditable performances on television and, occasionally, film – although 'usually failing to get the really interesting parts'. As he later wrote: 'If Albert Finney turned down a part, they'd ask Tom Courtenay or Alan Bates, and if they weren't free they would ask me' (*ibid.*: 72). The fact that he was in line for parts intended for other working-class actors from the provinces indicates that his biography shared much with those of his

contemporaries. Like many bright, young working-class men and women, Garnett was a beneficiary of the 1944 Education Act that guaranteed secondary education for all, and which provided the main channel for upward social mobility in the two decades that followed. Like many others, Garnett's journey was from the provinces to London, from the working- to middle-class, from a skilled factory job (like that of his father) to a profession. Garnett was part of the social revolution that followed World War II, the reverberations from which would be felt through the decades that followed.

The figure of the young working-class man from the provinces (they are less often women) is everywhere in contemporary culture by the late 1950s, and can be traced across the novel, theatre, cinema as well as television. It is bound up with the history of post-war realism and is indicated by the acting roles that Garnett played, which changed as one decade turned into the next. As well as appearing in a Shakespeare adaptation, *The Age of Kings* (1961), Garnett played in a variety of roles in popular drama series, such as a teenage 'delinquent' in *Dixon of Dock Green* (BBC 1955–76). He also acted in some of the more interesting and distinctive plays of the period, including David Mercer's trilogy, *Generations* (BBC 1961–63), in which he played a left-wing activist who dies on the Berlin Wall, and in Troy Kennedy Martin's first television play, *Incident at Echo Six* (BBC 1958). He appeared in early episodes of the ground-breaking, realist police series, *Z Cars* (BBC 1962–78). He also acted in feature films, including *The Boys* (1962) about the trial of a group of working-class youths accused of murder (he played one of the boys).

At the beginning of his career 'the representation of the working-class was from the outside.' Garnett observed: 'As an actor, I felt like one of Shakespeare's rude mechanicals. The posh did the important things in iambic pentameters, and I spoke the prose. The working-class were patronised as criminals and comic relief' (2001: 71). No matter how much trouble the 'disturbed' teenager caused on the way, 'I was always caught by Sergeant Dixon or contained by my probation officer' (2001: 70). The reference point for actors like Garnett was the new generation of American film stars, Marlon Brando and James Dean, who brought both a class-based realism to their roles and a distinctively generational perspective. This was echoed in both *The Generations* and *The Boys*. The latter adopted the point of view of the boys on trial, not that of the prosecuting lawyer (played by Richard Todd, the epitome of upper-middle-class suaveness – the clash between two generations of actors, and two competing acting styles, being the subtext of the film).

The changes in culture, of which Garnett's acting career is an

example, had their roots in wider transformations in post-war British society. The end of World War II saw a Labour government, led by Clement Atlee, elected with an overwhelming majority, committed to a new, egalitarian agenda, and informed by a determination to ensure that the endemic poverty of the 1920s and 1930s would never return. The 'post-war settlement', as it is often called, saw the 1944 Education Act put into effect and the National Health Service (NHS) and a system of comprehensive social insurance established (in 1948). The settlement was accepted by the Conservatives, who returned to power in 1951. This was just one aspect of a wider consensus about the contours of post-war policy in the economic, social and foreign policy fields that dominated government thinking – and much political discourse and policy discussion beyond government – in the 1950s. The principle elements of the consensus were a commitment to full employment and the 'mixed economy', in which the state would have a guaranteed, but not dominating, role; an acceptance of, and support for, the NHS, social insurance and universal education – in short, the machinery of the welfare state; and a commitment to, and membership of, the newly-established Western military alliance, NATO. Many of the terms of this consensus plays across the history of the decades that followed, celebrated, contested and re-defined under pressure from changing historical circumstances.

The consensus was underpinned by economic prosperity, or, in the favoured term, affluence. Between 1951 and 1964, unemployment averaged 1.7 per cent, whilst earnings increased by 110 per cent and the standard of living rose by 30 per cent in real terms. This new prosperity was manifested in the phenomenal increase in consumer expenditure, which doubled in the same period. Affluence was undoubtedly more selective than the rhetoric suggested, and these statistics conceal marked regional and social variations: it was also much more easily registered in the ownership of consumer durables, such as television sets and fridges, than it was in, say, housing – a point *Cathy Come Home* made forcefully. Not for the last time, television was central to debates about the nature and meaning of social change; it is no accident that a politically-oriented, working-class young man building a career in acting should be attracted to working in the new medium. The phenomenal growth in the ownership of television sets through the 1950s and 1960s was both a symbol of affluence – and celebrated as such by the popular press and television itself – and a carrier of messages about that affluence. In 1951 there were just 760,000 licensed television sets in the UK, but by 1955 this had risen to 4.5 million and this rate of growth continued throughout the decade and

into the next; by 1964, there were 13 million licensed sets, which represented 82 per cent of the UK population (Laing 1986 and Lacey 1995). The expansion of television ownership was paralleled by an increase in the number of broadcast hours and the geographical reach of the network. In 1954, the BBC broadcast for just 6 hours a day, but by the mid-1960s the aggregated BBC and ITV output was 16 hours (this was before the era of daytime, let alone 24-hour, transmission). The event that did most to establish television as a 'national' mass medium was undoubtedly the Coronation of Queen Elizabeth II in 1953.

That the 1950s should be interpreted through the symbolism of the Coronation is an indication that traditional and conservative accounts of post-war change were dominant. However, the conservative hegemony was severely shaken three years later as a result of a series of apparently unrelated events from across the political and cultural spectrum. The key event was the Suez debacle, when an ill-fated Anglo-French invasion of the Suez Canal zone in October 1956, following the Egyptian nationalisation of the canal, led to international condemnation, a run on sterling and an ignominious withdrawal. The USA engineered a condemnation of the invasion at the United Nations, revealing the real structures of the post-war world. Britain could no longer see itself as the moral, if not the political, leader of the free world. Also on the international stage, troops of the Soviet Union invaded Hungary, suppressing an uprising by the growing independence movement and executing its leadership. And in April 1956, the new Soviet party chairman, Nikita Khrushchev, denounced Stalin to a secret meeting of the USSR Communist Party Congress, admitting the 'mistakes' of Stalinist oppression. These latter two events both confirmed Western assumptions about Soviet expansionism and precipitated a crisis in the British left, especially in the Communist Party of Great Britain, which led to an important re-alignment and renewal especially amongst intellectuals. The New Left that emerged in the years that followed defined itself in terms of its interest in culture, and would have a considerable influence on debates about television via the work of Raymond Williams, Richard Hoggart and Stuart Hall.

But 1956 was not important for political reasons alone; that year also saw disturbances elsewhere in contemporary culture. It was the year of Elvis Presley's first album for Sun Records and of the release of Billy Hayley's film *Rock Around the Clock* in the UK, which signified the birth of rock-and-roll and the eruption of the teddy boys, and teenage youth culture generally, into public consciousness. Finally, 8 May saw the opening of the first production of John Osborne's *Look Back in Anger* at the Royal Court Theatre. Although the play was neither

formally radical nor inherently left-wing, it was taken to represent a distinctive, generational consciousness that was opposed to the complacency of traditionalist images of Britain. It also put a new figure on the post-war cultural landscape in the person of its protagonist, Jimmy Porter. The re-alignment of British theatre that followed *Look Back in Anger* had consequences for other media as well in due course – including television.

The year 1956 was particularly important for a younger, post-war generation, of which Garnett was a part. John Caughie has written eloquently about this moment and its legacy:

> For the generation which followed immediately after, 1956 was the year ... in which a political culture began to materialise which was inclusive rather than exclusive, in which being political meant something more that membership of a party, in which politics was part of being an intellectual, and in which culture was at the cutting edge of redefinitions and rebellions. (Caughie 2000: 61)

Garnett was one of a loose group of radicals of the left who began to work in television in the early 1960s. Some, such as John McGrath, Roger Smith and Troy Kennedy-Martin, were writers (although Smith was also a script, or story, editor). Ken Loach, who was to become one of Garnett's key collaborators, was a director, as was McGrath. All had been exposed to the political culture that Caughie describes, though related to it in different ways. Most of the new generation were Oxbridge graduates, whose attraction to television was in inverse proportion to its cultural status. As Caughie has observed, television was not yet 'respectable' and 'was more likely to attract recruits who did not feel themselves to be part of what came to be known in the 1960s as The Establishment' (*ibid.*). Garnett observed that his father was pleased when he began working at the BBC because it was 'a good firm',[1] but this opinion was not widely shared further up the professional ladder. This 'nonconformity' gave this generation a belligerence that was channelled through a belief that 'culture mattered, and that television as a popular form was an arena in which a difference might be made' (*ibid.*). They were also arriving at the BBC at a time of considerable expansion and change.

Television drama in 1955–65: institutions and practices

By the time Newman was writing his memo to Adam, three channels – BBC 1 and 2 and ITV – had been established and television was without

doubt the dominant broadcast medium, its popularity dwarfing that of radio and the cinema. The arrival of commercial television (ITV) in 1955 signalled the first of many transformations on the ecology of broadcasting. The BBC was initially severely shaken by its noisier and flashier competitor, for, by 1958, ITV was attracting 75 per cent of the audience able to receive the signal, and the BBC was forced to compete for the popular audience (see Cooke 2003). By the mid-1960s, however, the BBC had bounced back, recovering its audience share and meeting the challenge of providing popular drama series and soaps with *Dr Finlay's Casebook* (1962–71), *Compact* (1962–65) and *Dixon of Dock Green* (1955–78). It had also, in *Z Cars*, introduced a popular series that began to develop forms of story-telling and represent the new complexities of British society. In addition, the Corporation had a new Director-General, Hugh Carlton-Greene, who instilled confidence in the BBC's ability to meet the twin challenges of commercial television and contemporary social change. Greene had also led the Corporation in its negotiations with the Pilkington Committee, established by the government to investigate and report on the current state of broadcasting and recommend how it might be developed. The Committee's report appeared in 1962, and was read as a clear vindication of the BBC's standards and mode of operation (see Briggs 1995: 294–308).

Alongside this narrative is another, which is a history of evolving practices. The tendency of all new media is to define themselves initially in relation to the old, and television drama owed much to the theatre and radio (see Jacobs 2000: 92) The Drama Department of the BBC recruited heavily from the theatre (if applicants were also from Oxford or Cambridge, so much the better), and most of the dominant personnel had theatrical backgrounds. Michael Barry, a predecessor of Sydney Newman as Head of Drama, was influenced by literary and theatrical traditions. The terminology and practices were also carried over from the theatre, rather than imported from the cinema. Pre-Newman, the roles of director and producer were combined. The writer was also given considerable status, in acknowledgement of his/her position at the apex of the production team (a much higher status than that afforded the screenwriter in mainstream cinema production), and he/she wrote television 'plays' and not films. Adaptations of stage plays, along with those of short stories and novels, continued to provide a significant part of the output of serious drama in the 1960s. Above all, it was the liveness of television drama that connected it to theatre rather than cinema.

This system was, however, under considerable pressure as the drama departments of both the BBC and its commercial rivals adapted

to a new environment, in which demand for drama exceeded supply and there was a need to attract maintain new, popular audiences. The main model of a successful English-language television network that could produce single plays and popular series could be found in North America, and it is, perhaps, no surprise that innovation should come from this source – in the person of one of the most important figures in the history of television drama in the period, Sydney Newman. In 1958, ABC succeeded in attracting Newman to take responsibility for a short series of plays in its prestigious Sunday-night single drama anthology series, Armchair Theatre. Newman was at the time a Canadian producer whose work had been shown within the series; very quickly, he was appointed Drama Supervisor of the anthology, a role he continued in until leaving for the BBC in 1963.

Although the drama output of ITV was most easily, and profitably, associated with entertainment formats, it also established a reputation for contemporary, realist drama. Granada broadcast the whole of *Look Back in Anger* in the autumn of 1956 (the BBC had only shown an extract). Also in 1956, ABC established Armchair Theatre (1956–68), which became the most influential drama anthology of the decade. Armchair Theatre broadcast a mixed diet of adaptations, stage plays and original dramas (by no means all of them social realist). It also screened television films bought in from the USA and Canada (as did the BBC in the latter part of the decade). Crucial to the success of the anthology was its position in the schedules. Armchair Theatre was scheduled after *Sunday Night at the London Palladium*, one of the most popular programmes on television, and inherited much of its audience. This guaranteed high viewing figures for even the most difficult of plays (although Armchair Theatre always aimed to attract a popular audience), and Armchair Theatre plays appealed across the social and geographical spectrum, regularly attracting over 6 million viewers. The importance of scheduling to attract audiences for unfamiliar drama was not lost on Sydney Newman – and indeed Tony Garnett – when The Wednesday Play was being screened.

The central determining factor shaping the production of television drama in the late 1950s and 1960s was the rapid expansion of drama output and the lack of trained personnel – writers, directors, producers, designers – to create it. The task was not only to train people to fill the gaps but also to create a new production system. Newman reshaped drama production at ABC, introducing the key role of script (or story) editor, and separating the roles of director from producer – innovations that he brought with him to the BBC, who succeeded in poaching him in 1963 to run its Drama Group. Newman's innovations at both ABC

and the BBC created a mode of production that was much closer to that of North American television – and, indeed, cinema – than that of the BBC of the 1950s or of the theatre on which it was based. As Shubik has noted, 'ABC was operating a Hollywood studio system, in which a nucleus of directors, story editors, designers and writers were continuously working together under one producer' (Shubik 2000: 43). When Newman established a similar system at the BBC, the culture shock was even greater. At this point, group heads were as powerful as schedulers and controllers. As Garnett has noted:

> ... even though the controllers had the power of the purse, group heads were their equal in the BBC hierarchy ... all drama went through one man and the controllers could negotiate with no one but him ... In the feudal BBC of the time, the Controller was King of the Channel and programme output heads were extremely powerful barons'. (Garnett 2000a: 13)

Newman divided BBC Drama into three sections (series, serials and the single play) each with its own Head, and by separating the roles of director and producer, Newman was attacking both the culture and the structure of television drama production at the time. He was also giving considerable importance to two crucial roles in the system, the script editor and the producer – roles filled by Garnett in rapid succession.

One of the key figures in the Plays division of the BBC Drama Department at the time was Roger Smith, a script editor (or story editor, the preferred term within the BBC) who worked closely with James MacTaggart, one of the most influential television director/producers in the 1960s. It was Smith who identified Garnett as someone who had the potential to move to the other side of the camera and become involved in production. After what Garnett termed 'considerable nagging' Smith's efforts were successful, and Garnett agreed, having also been approached by James MacTaggart, to become an assistant script editor. Several practitioners at the time have commented humorously on the almost casual way in which they were appointed. Irene Shubik, for example, was given her first job (at ABC) by Newman in 1958 because she had 'an intelligent face'; and John McGrath was appointed by Michael Barry to the BBC in 1961 after a casual interview conducted across the barrier of Barry's knees (Shubik 2000: 42 and McGrath 2000: 49). Garnett's account of his interview with Newman suggests an equal informality:

> I remember James MacTaggart inviting me to go and work for him, and I had to have an interview with Sydney. I first met him in his office

which was bigger than most of the flats I'd lived in, having been marched in by Jim MacTaggart and Roger Smith. I expected a big, formal interview but instead Sydney looked at Jim and said 'Hell, I don't know what to ask'. Then at me, 'Oh hell. Did you see the show last night?' The show, as he put it, was *Hamlet*. (Macmurraugh-Kavanagh 1998: 25)

Interestingly, all three were initially appointed as story editors, and the informality of the interview procedures was, in part, an indication that the exact nature of the role was hard to pin down. One aspect – though it would not have appeared in any job description – was that it provided a form of unstructured apprenticeship in television for people new to the medium. There was no training as such: as Shubik has written of her induction at ABC, 'I learned to be a story editor by listening to Peter Luke's [Armchair Theatre producer] conversations with writers and to be a producer by following Sydney around productions and listening to his notes' (Shubik 2000: 43). McGrath has written that his status as a member of the BBC, ill-defined though it was, gave him access to any programme in any department: 'I was able to watch *Panorama* for a while and see what was happening, then … go into rehearsals of plays and see how that worked, and to find out how the BBC worked in general' (McGrath 2000: 50).

The role of story editor soon became pivotal in the seller's market of television drama production as the principal link between writer and producer (which was also a link between the writer and the new medium of television). This was partly because few writers had any real experience of writing for television, and were not always aware of the constraints that this technologically and institutionally constrained medium imposed on them. One anxiety for the putative television dramatist was that writing for television resembled writing for cinema, in that it meant submitting to a process that seemed much more industrialised and impersonal than the theatre or writing a novel. In this context, the script/story editor assumed a key role, delegated from the producer, developing the script for production and negotiating between those centrally involved in the process and the writer, who frequently was not. Although it was a role often given to practitioners (often writers themselves) who were new to the medium, it required considerable knowledge of the demands of production and sensitivity to the requirements of the writer. Garnett was story editor for the second, full series of The Wednesday Play, including *Up the Junction*, the film/play that established his name (see Chapter 2).

One consequence of the success of *Up the Junction* was that Newman asked Garnett to become a producer. This was a logical

progression from his interventionist role as story editor for that film; indeed, as producer Garnett worked without a story editor, absorbing many of the functions of the latter role into his production work, particularly that of seeking out, commissioning and developing projects, and subverting the accepted channels by which drama was often made.

The role of producer, as it evolved in the BBC Drama Group in the 1960s, was new to British television. Garnett was one of the first generation of producers who were not also directors (James MacTaggart, for example, was primarily a director). How Garnett chose to develop that role will inform the chapters that follow, but there are some general remarks that should be made at this point. Newman's decision to separate the roles of director from producer gave the latter considerable creative and organisational power. As Garnett noted, 'having been a producer himself, Newman placed great faith in them' (Garnett 2000a: 13). The system also gave the producer considerable independence, often protected by Newman from the broadcasting hierarchies (see Shubik 2000: 43). The result was an era of 'producer power', in which 'producers, once they had been given a programme slot, were left strictly alone to make their own decisions. There were no committees telling them what to do and no one making decisions for them' (Shubik 2000: 47). This freedom of operation was easier to exercise for producers like Shubik, whose work was not politically controversial; for producers like Garnett, the constraints and pressures were more apparent. Whatever the constraints, however, the role carried considerable creative and – in what amounts to the same thing – institutional power. As Garnett observed looking back at this era, an active and interventionist producer had considerable clout:

> So the producer was in the driving-seat. Any higher in the formal hierarchy and you would find yourself in management, removed from the creative work (if I had wanted to go into management I would have joined Shell): any lower in the hierarchy and you would find yourself waiting on the end of a telephone, unable to initiate anything (I had had enough of that as an actor). If you think of our work as being divided into the 'what?' question, the 'who?' question, and the 'how?' question, I knew that, given the way television was organised then, as a producer I could decide the questions '*what* shall we make?', '*who* will the main people involved?', and through careful selection, I could have a big influence on the 'how?'. (Garnett 2000a: 13)

In taking responsibility for the 'what' and 'who' questions, Garnett is not only indicating a willingness to assume a direct, authorial

responsibility, but also the burdens of negotiating on behalf of writers, directors and all his other collaborators within the institution. It also meant, frequently, being the spokesperson for an often controversial drama to a hostile media.

Garnett operated in different ways to other producers employed in the Drama Group, especially those who worked on The Wednesday Play. He did not, for example, ever become a salaried employee of the BBC (unlike every other producer on the anthology series) but instead negotiated a series of contracts to complete an agreed number of films/plays in a given period, normally four per season. The reasons for this were largely political, and Garnett argued that it meant the Corporation never 'owned' him. It also meant, more pragmatically, that he had a room for manoeuvre that other producers, often struggling to develop a larger number of plays on smaller budgets, often did not have. While Irene Shubik, for example, produced 75 Wednesday Plays between 1967 and 1970 (by which time it had become Play for Today), Garnett produced only 11 for both anthologies in a comparable period (1966–69) (Paget 1999: 82). Garnett also secured a deal whereby, if he came in on budget across the contracted films as a whole, he could 'overspend' on particular films – a freedom that was particularly important, since he became one of the first producers to make television drama primarily in the more expensive medium of film. From the beginning of his career behind the camera, Garnett has worked entirely on film, exploring the possibilities of what might be done when the film camera (and later the digital video camera) is put at the service of a social realist agenda.

Television and social realism: a developing tradition

Newman was taken to see John Osborne's *Look Back in Anger* by Michael Barry, then head of BBC Drama. Newman saw in the play an engagement with contemporary Britain expressed in a direct, emotional language and a familiar dramatic form, that of stage naturalism. He referred to it often afterwards. Newman's own formulation of this 'moment of anger' was 'agitational contemporaneity' (MacMurraugh-Kavanagh 1997), which sought to conjure up the same combination of accessibility, challenge and immediate connection to British society. Towards the end of his memo to Adams, Newman argued that The Wednesday Play represented 'the turning points in contemporary Britain' and that audiences 'want to know about the experiences of people in other occupations and classes, and how they face *their*

problems which may be similar to their own' (BBCWA T5/695/2: 7). This positioned television drama in terms of its relationship to the concerns of a popular audience. In doing this, Newman was yoking television drama to the 'contemporary', aligning it with a powerful rhetoric of 'immediacy', of transparent connection, to 1960s Britain. He was also echoing a longer tradition of dramatic representation, that of realism.

It has sometimes been argued that realism is the 'natural' mode of television drama. This is partly to do with the influence of theatrical tradition on the drama of the new medium in its formative post-war years (and this is one reason why the term 'naturalism', often used interchangeably with 'realism' in the discussion of theatre, is sometimes used as well). It also echoes assumptions about the ontological relationship between television and social reality that shaped arguments about the 'essential' nature of television in the period and the differences between it and radio and the cinema. The sense that television, in both its fiction and non-fiction forms, uniquely conveyed 'the event itself' revealed an early sense of the medium as outside broadcast, most truly itself when showing events that were happening elsewhere, 'in reality', more-or-less as they occurred. It was a characteristic that gave the new medium a clear advantage over its competitors. As John Corner has observed:

> The combined advantages over radio (vision) and cinema (liveness) gave a uniquely high level of 'co-presence' to television programming, the viewer often being put in the position of a witness, *alongside* the broadcasters, to the anterior realities depicted on the screen. (Corner 1991: 12)

Although this was most evidently true of news, current affairs and sports coverage, it carried over into drama, creating a web of expectation in which the immediacy and directness of news coverage connected to 'lifelikeness' and verisimilitude in drama – the territory of the dominant view of realism. The term 'realism', however, has a history that cannot be reduced to an account of the development of techniques to equate to the real; realism has always been as much about intention as about method, as concerned with an engagement with social reality as with a means of representation.

A discussion of social realism in the post-war context will take place across this book, and both inform and develop from a discussion of Garnett's work. Realism in this context is connected to the direct representation of the contemporary world, as both setting and subject matter, and to the representation of the social experience of

marginalised, especially in class terms, social groups (what Raymond Williams has referred to as social extension (1977 and 1990)²). In the context of post-war British theatre (and then film and television), 'working class' and 'realism' have become almost synonymous, often intersecting with 'northern' or, less specifically, 'gritty' and 'kitchen sink', as the realist momentum accelerated across novels, plays, films and eventually television. Television is a significant 'test case' for realist drama, an endpoint of the realist trajectory, with an audience as well as a dramatic action that was now fully socially extended. The taboos surrounding social class have been closely related to those around sex and 'deviant' behaviour, and have frequently been controversial. Garnett's films/series, from *Up the Junction* to *No Angels*, have often been attacked for their explicit sexual content. The willingness to be explicit is sometimes seen as a guarantee of the realism of a text, showing 'how things really are' measured in relation to what has hitherto been permitted. Social extension, therefore, which seemed at one time complete, has been re-invented in each generation in relation to a different social and representational agenda.

Post-war realism has often been connected to politics, in both broad and narrow senses. Williams argued that it is a political perspective that separates realism from other contemporary and socially-extended drama with which it now rubs shoulders, and in a significant and influential essay (1977/1990) used a Loach/Garnett/ Allen collaboration, *The Big Flame* (BBC 1969), as his main example. Williams's argument was an acknowledgement of the political colouring of *The Big Flame*, which was made from a broadly Trotskyist perspective. However, realism always foregrounds the relationship of individuals and groups to their social environment, and this, in turn, will have a political dimension. As Hallam and Marshment have noted, realism is 'a discursive term used to describe films that aim to show the effects of environmental factors on the development of character through depictions that emphasise the relationship between location and identity' (2000: 221).

Realism has been central to post-war culture. Initially, it was the dominant mode of the New Wave in both theatre and cinema. There is a way of writing the history of post-war culture up to the mid-1960s that sees realism, which is defined largely by its relationship to ideas of the contemporary and social extension, as beginning in literary fiction, articulated as an anti-Modernist stance and linked to a revival in the provincial novel (Kingsley Amis and John Waine) and the working-class novels of Alan Sillitoe. It then migrated to New Wave theatre, where it embraced not only Osborne's *Look Back in Anger* but also, amongst

others, the plays of Shelagh Delaney (*Taste of Honey*, 1958) and Arnold Wesker (for example, *Roots*, 1960). From there, realism emerged in a parallel New Wave in the cinema, often based on earlier realist texts (*Saturday Night and Sunday Morning*, 1960), for example, and *A Taste of Honey*, 1961) by directors who also worked in the theatre (Tony Richardson and Lindsay Anderson) or came from the radical documentary movement, Free Cinema, which was a precursor to realist feature films (Anderson and Karel Reisz). Finally – for the moment – it arrived in television. The chronology is not as sequential as this brief account suggests, but the trajectory is clear. When realism surfaced in television with the advent of Armchair Theatre, it took much the same form as its predecessors in other media. A considerable variety of plays were broadcast under the Armchair Theatre banner, but it was the social realist plays – Alun Owen's *Lena, Oh My Lena* (1960), for example – that caught public and critical attention, and which have been constructed as the main legacy of the anthology series since. It is also the case that much of the critical and popular appeal of a range of series from the late 1950s and early 1960s, from *Dixon of Dock Green* to *Z Cars* and *Coronation Street*, lay in the way that they gave form to contemporary working-class experience. These are, to use Garnett's formulation, the 'what' questions: the 'how' questions are also important, however, and the new visibility of the working class on television occurred when the forms of television drama were under unprecedented scrutiny.

Garnett began to work in television at a point where the medium, especially its drama, was not in any sense fully-formed. Until the early 1960s, there seemed few decisions to be made, since the forms of television drama were determined largely by the available technology. A great deal of television, and all television drama, was broadcast live from a studio before the early 1960s, since the technology of electronic transmission did not permit the recording or storing of programmes (at least, not until the mid to late 1950s). Film, in its 35 mm format, was used to provide inserts in television plays, but, significantly, did not replace live transmission. The exception was drama that did not register as 'drama' at the time – popular entertainment series produced by the commercial television companies, such as *The Adventures of Robin Hood* (ABC 1955–59). At this time 16mm film, the technology of most documentary and current affairs, was unheard of in drama production. A process of recording the television image onto screen known as telerecording was available as early as 1947 (see Bryant 1989: 6–7). In the late 1950s this technology was superseded by the arrival of videotape, which was expensive and could not, initially, be edited, except manually

(with a razor). It could, however, be re-used (the wiping of tapes for re-use is one reason why so many programmes from the 1960s and 1970s have been lost). Videotape eventually overcame the lingering attractions of live transmission, and could be more easily controlled in post-production. It also became cheaper, and – most importantly –allowed programmes to become commodities in an increasingly competitive home and international television market. Videotape became, as a result, the dominant technology of television drama production during the 1960s. Significantly, videotape was a studio-based technology.

It is hard now, in an age of global convergence of cinema and television at the aesthetic and institutional levels, to think back to the conditions of television production that pertained in the early 1960s. Garnett dismissed the dominant forms of television drama with reference to outdated stage models:

> One thing we were pissed off with was the way television drama almost exclusively used the kind of naturalism that emerged in the 1890s in the theatre. It was drama seen as a group of people who would occasionally walk in or walk out of a door, but while they were together they would sit around and have conversation. Occasionally, because you wanted a bit of action, they would pour a drink. (Hudson 1972: 19)

This polemical judgement did not describe all television drama, but it did catch something of a persistent grammar of drama production, one that related television plays to a mode of domestic naturalism familiar from the theatre, and which hinted at pre-war, upper-class social values ('country house' interiors). It was a critique that echoed one that was circulating amongst theatre radicals at the same time, and takes its language and terms of reference from, amongst others, Kenneth Tynan's famous attack on the aesthetic limitations and social irrelevance of much post-war drama before 1956. Tynan's polemic (which was more effective than accurate) linked the stultifying effects of upper-class drama to the lack of a contemporary drama that was also socially extended ('the theatre must widen its scope, broaden its horizon We need plays about cabmen and demi-gods ... politicians and grocers' (Tynan 1984: 149)). What Garnett was attacking was not so much the theatre per se as a specific mode of stage drama and the social values that underpinned it, which was not an inevitable product of live, studio-based transmission, as Z Cars proved. Opting for a much more fast-paced, multi-location narrative style borrowed from American popular drama series, and using the studio space in a more fluid manner, Z Cars demonstrated that it was possible to escape the habits of naturalist stage drama within the technological constraints of the

pre-recording age. Cooke (2003) and Jacobs (2000) have also drawn attention to the ways in which producers, directors and actors struggled to discover what the new medium could achieve beyond its debt to theatre. The issue, then, was not so much the problem of theatrical habit, or even technological constraint (though both play a part), but rather aesthetic and political ideology.

There was considerable debate in the early 1960s not only about what kind of stories television should tell but also how it should tell them. This was often ferociously partisan and frequently theoretical. It also took place in boardrooms, pubs, canteens and in the pages of *Contrast* (1961–65), a journal devoted entirely to television, and *Encore* (1957–65), which was closely aligned with New Wave theatre but which also published material on television. *Contrast* in particular was very aware that the expansion of the network in the 1950s had created new possibilities that had still to be exploited. Contributors were drawn mainly from the industry itself (writers, producers, directors and script editors). Many of the articles published in the journal were 'essentialist', in that they were driven by a need to define what was specific to the medium in ways that distinguished it from theatre, cinema and literature. An article by John Maddison from 1963, for example, asked the question 'What is a television film?' seeking to distinguish it from a cinema film. In a prescient aside that points towards the Garnett and Loach collaborations on The Wednesday Play, Maddison laments that 'we are still waiting for the fictional film-maker, who will take his cameras into the streets with the same mastery, and an even greater suppleness, than Rossellini did in *Open City*' (Maddison 1963: 75).

The most focused and influential assault on naturalism was Troy Kennedy Martin's bracing and articulate polemic against the legacy of the form, 'Nats go home', published in *Encore* (1964a). Kennedy Martin's article, which has been much debated since, produced a series of responses in the following issue of the journal (including one by Tony Garnett). Kennedy Martin's critique proceeded from a diagnosis of the (perilous) state of television drama in the mid-1960s and argued that the principle culprit, in a climate where theory was unknown and innovation discouraged, was naturalism. Using the term in the loose, colloquial sense of 'bad realism' that was prevalent amongst theatre radicals at the time, Kennedy Martin agued that naturalism was characterised by its limitations. It could only tell stories 'by means of dialogue' and reduced the complexity of the social world to 'people's verbal relationships with each other ... When it deals with any of the abstracts – fear, impotence, hunger, hate, love or hope it does so

indirectly through dialogue with other people' (1964a: 25). Naturalism was also constrained by the temporal straitjacket of 'Greenwich Mean Time' and chronological and spatial literalness. Naturalist television drama was a 'makeshift bastard born of the theatre and photographed with film techniques ... which can now be seen to be destructive of television' (1964a: 25). The achievements of the American naturalistic drama associated with Paddy Chayevsky and its British counterparts (the social realism of the Armchair Theatre) did not challenge these fundamental limitations of the form and thus did not offer a way out of the naturalist trap. The answer was to privilege narrative over plot, and to free the studio from the demands of scenic literalism (he does not, yet, reject the studio per se).

There were examples of the kind of fast-moving, narrative-based approach to the single drama that Kennedy Martin espoused, and he himself quotes at length from *The Night of the Long Knives*, a play he had written with John McGrath. Sydney Newman, no doubt with series such as Teletale, Storyboard and Studio Four in mind, noted in a short letter published by *Encore* amongst the responses to 'Nats go home' that he had indeed recognised the crisis and had appointed James MacTaggart to deal with it (Newman 1964a: 39). MacTaggart, more than any other producer at the BBC at the time, had done much to encourage the freeing up of the studio space that Kennedy Martin espoused. However, 'Nats go home' did mark a significant shift in thinking, not least because it stated, by accretion rather than explicitly, that the drama it called for was essentially film. The language of the article leaves no doubt about this – its emphasis on the camera, on narrative fluidity, on montage and on editing generally all lead its author inextricably towards a cinematic frame of reference (something that several of those whose comments appeared in the next edition of *Encore* were quick to point out). In his reply to these responses, Kennedy Martin offers further comment on naturalism and narrative that indicates some of the far-reaching consequences that a re-focusing of television aesthetics towards film would entail:

> [T]he best departure *at the moment* for a non-naturalist form [is] the creation of a new punctuation based on editing to get the same kind of fluidity and movement that you get, say, in a novel. This in turn gives the director the major responsibility in the creation of the piece. (Kennedy Martin 1964b: 47)

This suggests not only a new approach to telling stories but also new relationships of production with a more active, authorial role for the director (and possibly producer) in the realising of the play/film.

Tony Garnett was amongst those whose responses to 'Nats go home' were published in *Encore* (indeed, his is by some way the longest). At this point in his career Garnett was still an actor, yet his letter prefigured his thinking as a producer about both the crisis in television drama and its solutions. Garnett echoed the sense of crisis that Kennedy Martin described, though he located it more firmly in a poverty of imagination and an outdated aesthetic ideology rather than skill. The underlying obstacle was the same, however: an outdated form that Armchair Theatre social realism was not able to remedy.

> On the one hand, television drama is obsessed with its false dependence on theatre and its equivocal attitudes towards film; on the other, it refuses to grapple with the real problems of its own existence. The result is an inability to define itself in any way which will encourage independent creative work. Even within television, other fields have made excellent progress by using new techniques and by an irreverent attitude towards traditional programme content ... It is significant that most of the rubbish now is assembly-line dramatic-series production. Whatever qualities the post-'56 Nat boom had, and they were many, it contributed nothing to the development of television drama as such. (Garnett 1964: 46)

The corollary was that the dramatist (and the actor, producer and director) should look not to stage drama but – for their aesthetic and formal vocabularies at least – to other forms of television.

> Nearly all the memorable television I have ever seen has been in the fields of documentary, news or plain talk – the Cup Final, Whicker in Mexico, the Nixon-Kennedy confrontation. The shooting of Lee Oswald on television would have satisfied even Zola. (Garnett 1964: 45)

This was a remarkably prescient comment, which indicates something of why documentary and current affairs influenced Garnett's work as a producer. It also suggests a re-orientation towards debates about the 'essential' nature of television drama, since if non-fictional forms of television were developing their formal vocabularies, and drama might usefully learn from them, then what seemed essential one day may be redundant the next. 'I suggest that most, if not all, of the traditional differences between film (i.e. cinema) and television drama production are not essential differences' Garnett argued 'but accidental, historical or imaginary' (1964: 45). Garnett was clear – and more explicit that Kennedy Martin – where the development of a new vocabulary based on narrative and post-production editing led:

> Once you deny the usefulness of the concept of absolute continuity (the 'live' fiction is taking a long time to die), and admit editing after the event rather than the selection of available shots concurrent with the event, then most people would contend that you were making films. I further suggest that the only useful distinctions between films and television drama arise from the way they are presented and the conditions under which they are experienced; these are the important fields to work in. (Garnett 1964: 45)

Garnett's main priority, therefore, was to position television drama in relation to film and to argue, along with Kennedy Martin, that 'the confused dependence on theatre must be cleared away' (1964:47). 'Liveness', and the studio-based theatrical model, had its defenders, notably Don Taylor, who at 23 became the youngest television producer/director at the BBC. Taylor, who was essentially a literary modernist and had a close working relationship with David Mercer, promoted an aesthetic based on continuous, unedited performance in the studio, the centrality of the actor, and the primacy of words over image. Significantly, Taylor also led the opposition to Newman's appointment to the BBC (Taylor 1990: 186). In arguing as he did, Garnett was opposed both to Taylor (and others), who was deeply hostile to Newman and committed to a different, studio-based aesthetic, and the dominant practices of television drama production, which favoured naturalism. For Garnett, the choice of film over videotape, of location over studio and cinema over theatre, was ultimately a political one. Film, as Williams observed, had the potential to break through the fourth wall of the theatre/studio set and 'move out doors, into the street, into the public spaces which on the whole the theatrical drama had left behind' (Williams 1990: 232). Film could take the action, and therefore the viewer, out into the society that the studio could only represent metonymically, and engage with contemporary social reality in its immediate, surface forms.

The studio-based social realism of Armchair Theatre was mostly concerned with social extension. It was a 'reflective' realism, which provided, in the terms that Marion Jordan used of *Coronation Street*, 'narratives of personal events' surrounding characters who were 'working class or of the classes immediately visible to the working class ... and ... credibly accounted for in terms of the ordinariness of their homes, families, friends' at a time that was recognisably 'the present' (Jordan 1981: 28). This also describes some of the givens of Garnett's television films. However, the more combative realism of the Garnett and Loach collaborations for The Wednesday Play also had a political edge. This proceeded from both their growing socialist political

convictions and from an earnestness, bordering on the puritanical, which comes from a provincial non-conformism: as John Caughie argues in relation to realism across culture:

> [I]t is a kind of ethical seriousness, rather than simply formal realism, which seems to underpin the cultural movements associated with the 1950s and 1960s. This is what gives them much of their power and their value: the sense that these things mattered and that theatre or literature or television drama could do something about them. (Caughie 2000: 70–1)

The sense that 'these things mattered' and that it was possible to use the medium of television drama to effect social and political change is vital to what we might term Garnett's 'analytical realism' – a realism that does not simply reflect the surfaces of contemporary Britain, but rather attempts an analysis of it so that it might be altered. Garnett argued that his and Loach's work was concerned with a 'fidelity to the real' (Bream 1972), a political and ethical commitment to the social experience, culture and politics of those whose stories were being told, represented in a film language that equally signified 'the real'. Garnett described the filmic approach adopted to shoot *The Cops* (BBC2 1998–2001) thus: 'The style is "being there". What is on the screen actually happened and a camera was around to make a record of it. And here it is. That's the conceit, the little game the audience is in on' (Garnett 2000b). This is a clear and consistent project that has run like a spine through Garnett's work over four decades.

In the 1960s, fidelity to the real related to the way in which Garnett responded to Kennedy Martin – that the best available languages through which to develop television drama are to be found on television itself, especially news, current affairs and documentary (connoted by 16 mm technology). Documentary enters the Garnett/Loach collaborations through a repertoire of specific techniques – voice-over, statistics, actual locations, semi-heard dialogue, natural lighting – that create a 'system of looks which constructs the social space of the fiction' and which have 'a prior association with truth and neutrality' (Caughie 1981: 342). The result has often been called drama documentary, although Garnett explicitly rejects the term as misleading. 'Drama documentary' places the emphasis on the noun, documentary, whereas Garnett is clear that he is creating fiction – albeit fiction that wants to be judged in relation to social reality rather than other fiction. In *Up the Junction*, documentary form is linked to a Brechtian intention (see Chapter 2), rather than a mimetic one, and Brecht remains an important influence on Garnett (although more important, in the sense of being directly

useful, in the 1960s). However, borrowing from documentary has proved a controversial strategy, leading to accusations that Garnett and his collaborators have attempted willfully to 'mislead' viewers to mask inadequate research and/or cloak imaginative fiction in spurious objectivity (see Chapter 2). Garnett has always refuted the charge, arguing that it is clear that he is working in fiction, and that audiences understand this perfectly well, even if critics sometimes seem not to. Also, the connotations of documentary techniques in a dramatic context are not fixed; strategies that once signified 'the real' can subsequently, through familiarity, signify a different kind of 'drama' (this is perhaps the situation in the early 2000s – see Chapter 4).

From a different position, Garnett's analytical realism has been criticised for being both politically and philosophically wrong-headed. The criticism here is that the main mode of this form of realism, its closeness to the outward forms of observed reality (its 'naturalism' in some formulations), renders it inadequate to the task of seeing below the surface to the 'real reality' that lies beneath (a version of this argument informs the hotly contested critique of the 'classic realist text' offered by Colin MacCabe and others in the 1970s – see Chapter 3). The argument that reality can be captured in any direct and unmediated sense can also seem naïve; reality can only be made knowable in drama through conventions, even when the conventions concerned are designed to deny their own status. Yet the *continuity* between art and life – however conventionalised – is an important part, not only of realism, but of what Pierre Bourdieu calls the 'popular aesthetic' generally (1992: 32). As the quotation above suggests, for Garnett 'being there' is always a *style* that requires considerable effort and constant renewal, in which the basic 'conceit, the little game' is well understood by the audience.

Garnett has pursed and developed his style of social realism over forty years, largely because realism is a live and developing tradition. One reason why it is still part of the vocabulary of cultural practice is that its elastic and generous nature has absorbed a variety of specific methods and intentions. The particular types of social realism associated with the 1960s have been challenged, sometimes because of developments within the forms and institutions of television drama production (the move away from the single play to the series/serial, for example). They have also been buffeted by the cross-currents of a wider history. Garnett's work in the 1960s and 1970s was preoccupied with social class, and his politics linked to the revolutionary left. However, by the end of the 1970s, the certainty that 'such things mattered' had been challenged. Certainly, the contention that it is possible to effect social

change through television drama has few defenders in the early twenty-first century. As Creeber has argued:

> To put it crudely traditional forms of British social realism (of the 'documentary'-influenced *Cathy Come Home* and *Up the Junction* type) tended to suggest that the problems in a character's life could be remedied by structural changes in society. In contrast, newer forms of realism have tended to reflect a less optimistic belief in the power of political and social change as a whole, forcing a shift towards narratives of a more 'psychological' rather overtly 'political' nature. (Creeber 2004: 13)

The totemic use of Garnett and Loach texts to exemplify a didactic realism is perhaps crude, but the general point is well made, and much contemporary drama – including drama that Garnett has produced since 1990 – seems more concerned with the politics of subjectivity, identity and postmodern uncertainty than with the politics of social class (see Chapter 4). Indeed, class has been a concept under threat.

However, class-based social realism has never disappeared entirely from British television, even if its specific forms have altered to accommodate new agendas, identities and dramatic methods. Lez Cooke (2005) has analysed the ways in which early twenty-first century series such as Paul Abbot's *Clocking Off* (BBC 2000–03) have consciously re-engaged with the social realist tradition, refashioning it in the process. Set in and around a northern textile factory, the series' narratives recognised the changed landscape of a working class no longer living in back-to-back terraced houses in monochrome, and gave space to issues of sexuality, gender and ethnic identity. 'It was an opportunity to write really big quality stories for a massive populist audience' wrote Nicola Schindler, whose Red Productions made *Clocking Off.* 'We talked a lot about Play for Today and The Wednesday Play which more often than not were good blue-collar stories, told properly. They used to get the nation talking' (quoted by Cooke 2005: 183). Getting the nation talking has always been one of Garnett's main objectives.

Notes

1 Interview with the author 7 July 2004.
2 Much of the discussion of realism that follows is heavily indebted to Williams's sustained engagement with realism across his career. See especially Williams 1977, 1981 and 1990.

The 1960s: social realism and The Wednesday Play

The Wednesday Play anthology series has acquired a pivotal role in the history of television drama, providing a showcase for drama that was formally experimental, distinctive to the medium of television and socially and culturally provocative. As such, it is often regarded nostalgically as a symbol of the kind of author-led, issue-based drama that is no longer on our screens. Many of the most widely-discussed plays of the decade – which were also amongst the most significant television events, plays such as *Up the Junction* and *Cathy Come Home* – were produced for it. As MacMurraugh-Kavanagh has observed, from the viewpoint of a de-regulated, multi-channel age, 'it is taken to connote both the Golden Age of British television drama and a lost era of public service vision and integrity' (1997a: 367).

Commencing in October 1964, The Wednesday Play ran in seasons in a regular Wednesday evening slot on BBC 1 until October 1970, when it switched to Thursday and was re-titled Play for Today. There is a danger, as MacMurraugh-Kavanagh has argued persuasively (1997a), of attributing its success to an act of conscious policy-making on the part of the BBC. In fact, the anthology was established in the context of particular struggles within the institution over the future of the single play (and of the power of the Drama Department in relation to other departments in the Corporation) and was treated warily by management, who were sometimes uneasy about its more controversial output, even when they defended it. The Wednesday Play, in any case, sheltered a wide variety of dramas under its wing, with more familiar, theatre-orientated plays running alongside experimental dramas and location-based films.[1]

The Wednesday Play was designed as a replacement for two existing play strands, Festival and First Night. Festival represented the high-cultural aspirations of the Corporation, and consisted largely of adaptations of stage plays from the British and European literary

tradition. It was produced by Peter Luke, who went on to produce similar plays in the first season of The Wednesday Play. First Night, however, was a 'new drama' strand of original plays for television, often by writers new to the medium. Its main producer was James MacTaggart, who had produced Teletale and other new play anthologies for the BBC in the early 1960s. MacTaggart was also an ally of Sydney Newman's and of the new radicals, such as Ken Loach, John McGrath and Tony Garnett.

The tension between different cultural standpoints that was represented in Festival and First Night continued into The Wednesday Play, and was contained in the latter's mode of operation. Each season was broken down into 'mini-seasons' of plays selected and produced by a single producer (although the pattern varied after Luke's departure). The first season (October to December 1964) opened with a series of plays inherited from Festival, which had ended in July, all produced by Luke. The new season, however, which ran from January to December 1965 (and included *Up the Junction*), was, with one solitary exception, produced entirely by MacTaggart. It was his stewardship that gave The Wednesday Play its identity as a promoter of contemporary, socially-extended drama.

The Wednesday Play was a response to a series of pressures that were being applied to the BBC in the mid-1960s. Ratings, especially for drama, had declined, and the Corporation announced all-out war across its schedules on both channels in 1964. The result was that the single play came under scrutiny (see Macmurraugh-Kavanagh 1997a). Neither Festival nor First Night succeeded in attracting the hoped-for audiences, and the latter was criticised heavily in the press for being 'seemy' and relentlessly downbeat (the kind of criticisms that were later applied to The Wednesday Play as well). What attracted audiences at the time were drama series such as *Dr Finlay's Casebook*, *Z Cars* and Newman's first major ratings success, *Dr Who*. The Controller of Programmes, Television (Kenneth Adam), along with the Chief of Programmes for BBC1 (Donald Baverstock), proposed that, once Festival and First Night had been withdrawn, there be no new single drama stand until late 1965. Interpreting this, correctly, as an attempt to remove single plays from the schedule altogether, Newman voiced his opposition vociferously. In a lengthy memo to Adam dated 26 June 1964, Newman argued that 'there is no single activity carried out by the Drama Group that is more important than the original play series' (Newman 1964b). His defence of the single play hinges not on its existing (uncertain) success, but on its potential for securing critical regard, audience approval and – most importantly – the continuing loyalty of writers and directors. 'We [BBC

Drama] now possess the loyalty of most of the best writers in the country' he wrote, and 'it is the lure of the single play in the main which makes the BBC an attractive place for directors' (*ibid.*). He concluded with a scarcely concealed threat: 'I did not become Head of Drama in order to preside over its dissolution' (*ibid.*). Adam and Baverstock relented, and The Wednesday Play was created in accordance with the original schedule.

Under MacTaggart's general supervision, Smith, Garnett and Ken Trodd (later to become a drama producer himself) were given a brief to prepare about thirty plays for the first season of The Wednesday Play. Their approach was distinctive, and driven by a political sense of the need to bring a contemporary, socially extended drama onto the television screen for a popular audience. For Smith, Garnett and Trodd this meant finding new writers:

> We were looking for people who had something to say. I learnt so much from Roger Smith – he would look everywhere for writers ... We wanted news from the front, people who had an experience of an aspect of life and were desperate to say something about it ... Instead of going to the established television writers, many of whom we thought were hacks, we tried to find new ones. (Garnett 2001: 73)

However, The Wednesday Play would not have survived long had the audiences not been there, and attracting a large, popular audience was crucial. Newman's strategy, which was well-understood by those who worked with him, was to protect plays likely to get small audiences by scheduling them next to plays likely to win a much larger audience share. As Garnett noted later:

> Baverstock hadn't wanted the single play because he didn't believe that the anthology series could get the ratings. By and large with The Wednesday Play, we proved him wrong. We deliberately transmitted some that we knew wouldn't attract a big audience but we would always put one in front and one behind that we knew would hold it up. So our ratings went from as low as 3 or 4 million, up to 13 million. (Macmurraugh-Kavanagh 1998: 27)

The first full season of The Wednesday Play signalled clearly that issue-based, contemporary drama would have a presence. As Lez Cooke has pointed out, '[t]wenty-seven writers contributed thirty-three new plays, all but one written especially for television, to The Wednesday Play from January–December 1965. Dennis Potter was responsible for four of them, a phenomenal output in one year, illustrating the opportunities the series offered to enterprising new writers' (Cooke

2003: 68). In the first four months of 1965, three plays on potentially controversial subject matter were broadcast. The first, *Fable* (produced by McTaggart, written by John Hopkins and directed by Christopher Morahan), was set in a future in which a black majority exercised power over a white minority. It was conceived as a parable about apartheid (although, to the horror of its makers, it was read by many as a warning about black immigration). The same writer's *Horror of Darkness* (produced by MacTaggart and directed by Anthony Page) dealt with the terror faced by gay men in a society where homosexuality was still criminalised. And James (Jimmy) O'Connor's *Three Clear Sundays* (produced by MacTaggart and directed by Ken Loach) was a well-received indictment of capital punishment (O'Connor had himself once been convicted of murder). All three productions indicated clearly the direction that this strand of television drama was beginning to take. Although shot in the studio using conventional multi-camera arrange-ments, they attempted to replicate the pace, rhythm and narrative fluidity of film, whilst addressing contemporary social issues in a direct way. Indeed, like *Up the Junction* in relation to the issue of abortion, both *Horror of Darkness* and *Three Clear Sundays* were conceived as contributions to debates that were to lead to legislation (homosexuality between consenting adults in private was legalised in 1967, and the death penalty suspended in 1965). This first season, then, was the product of the post-56 generation, influenced by the cultural politics of the New Left in the broadest sense, and using the relative openness of the BBC to make drama that opened up a politics to the left of the prevailing consensus.

Up the Junction

The best known and most widely debated of The Wednesday Plays in the 1965 season was *Up the Junction*. Scripted by Nell Dunn, directed by Ken Loach with Garnett as story editor and MacTaggart as producer, the play was controversial for its subject matter, its narrative structure, its use of location and the fact that it was shot largely on film. It was also the first of a series of collaborations between Garnett and director Ken Loach that defined their respective careers in the 1960s and 1970s. Ken Loach joined the BBC as a trainee director from the theatre in 1963, and was part of the expansion of the Drama Department in preparation for the arrival of BBC 2 a year later. He and Garnett first met when the latter acted in Loach's first directoral outing at the Corporation, *Catherine* (produced by MacTaggart and written by Roger Smith), broadcast in

1964 under the Teletale banner. Loach directed three episodes of *Z Cars* that year, and all six episodes of John McGrath and Troy Kennedy Martin's *Diary of a Young Man* (produced by MacTaggart). This experience, and his own growing political sympathies, made him a first choice director for The Wednesday Play, and he directed six of them in the 1965 season, of which *Up the Junction* was the fourth (see McKnight 1997). Like Garnett, Loach was interested in cinema and committed to the kind of social realism that underpinned the 1965 season. He also shared Garnett's frustration with studio-based drama. As Garnett was to remark later, 'I often talked to Ken about my frustration with the limitations of the studio and these conversations had made me decide that I wanted Ken and myself to go out and make films on location using 16 mm film' (Macmurraugh-Kavanagh 1998: 27). *Up the Junction*, then, came out of these two intentions – to make contemporary realist drama, not in the studio with conventional cameras, but in the streets, with new, lightweight film technology.

Up the Junction exists in several forms. It began life as a series of articles by Nell Dunn in the *New Statesman* in the early 1960s. Dunn was a writer who was at that time living with her then husband, the writer and journalist Jeremy Sandford (author of *Cathy Come Home*), near Clapham Junction in South London. Initially from a privileged background (and referred to as a 'Chelsea heiress' by the popular press in the furore that followed the play's first broadcast), Dunn's articles were vignettes of everyday social life amongst her working-class neighbours, especially the women. The novel reprinted four of these, each constituting a chapter, and added twelve similar accounts, also linked by character and environment rather than narrative incident. First published in 1963, *Up the Junction* therefore retained the fragmented, episodic form of the original articles, and this proved decisive to the ways in which it was then adapted for television.

Up the Junction was clearly a collaborative project, with Loach and Dunn developing the script and Garnett contributing to both the shape and direction of the adaptation and negotiating over the process of making it within the BBC. (Although nominally the project's story editor, Garnett's role was more like that of a producer, pushing the project forward under MacTaggart's overall control). Loach noted that the form of the novel made it particularly suited to a 'filmic' treatment: 'The script was pieced together more or less directly from the book, which was very visual and quite cinematic' (Fuller 1998: 13). Looking back on the process, Dunn noted that both the adaptation and the filming were done very rapidly and collaboratively (though with Garnett and Loach taking the lead):

I knew Tony Garnett less well, but Ken included me on everything. I wrote the script and Ken asked me to go round Battersea with him and select all the exteriors that I felt were the correct locations for filming. In the end, we sort of did the script together really. It all happened very, very quickly with Tony and Ken picking out the bits from the novel they wanted to keep and with me adding more bits when they wanted a little more dialogue ... The whole thing was incredibly quick, because I think they had a *Wednesday Play* slot free and therefore everything had to be done extremely quickly. (Macmurraugh-Kavanagh 1997c: unpaginated)

The sense of urgency was also the result of the complex negotiations that Garnett was entering into to get the script shot on 16 mm film. In order to make this happen, Garnett had to convince both the BBC hierarchy, in the person of Newman and Michael Peacock, the Controller of BBC1, and the BBC Studios at Ealing (the film-making department within the Corporation). Newman was prepared to let him proceed, but Peacock took a great deal of persuading, and agreed reluctantly to the project as a one-off experiment, arguing that the Drama Department should produce 'A plays rather than B movies' (Macmurraugh-Kavanagh 1998: 27). The situation was made more acute by the fact that the BBC had just invested in new studios at White City, anticipating the increase in drama production with the arrival of BBC2. Peacock's concerns were shared by the Ealing studios, which had to give permission to use film stock. Drama, it was thought, required 35 mm; only news and current affairs used 16 mm (which was, of course, the point). Although permission was eventually granted, there were further complications. Agreements with Equity, the actor's union, meant that a minimum of 10 per cent of all drama had to be shot in a studio, and both *Up the Junction* and *Cathy Come Home* included studio footage. Loach has commented in interview on the complicated and devious procedures he had to adopt to achieve homogeneity of style across two different technologies. Having shot the studio sequences in a way that approximated film and made conventional tape editing (always cumbersome and expensive at this point) impossible, Loach and Garnett, after considerable argument, secured permission to edit and broadcast from a 16 mm back-up print, made for internal BBC purposes. Despite protest, 'they [the BBC1 executives] let us cut on 16 mm in the end because it was the only way they could salvage the material. Now, we'd known of this possibility beforehand, which meant that we could, in effect, make a film. But it was totally breaking the rules' (Fuller 1998: 14; see also Cooke 2003: 73–4).

'Breaking the rules' is what *Up the Junction* did on a number of levels. One of the most challenging aspects of the script was its lack of

conventional narrative shape, and Garnett was certain that MacTaggart, let alone the channel executives, would not allow it to proceed without considerable re-writing. Taking advantage of MacTaggart's absence on holiday, Garnett ensured that shooting plans were so far advanced as to make the project almost impossible to stop. Despite a strong working relationship, and a close personal friendship, 'there was a huge row with Jim when he came back from his holidays ... he was absolutely shocked and affronted that we would consider making this and calling it television drama' (quoted in Cooke 2003: 71). MacTaggart offered to give Garnett producer credentials, but Garnett refused, a decision motivated by personal loyalty and a suspicion that MacTaggart's protection might still be needed: 'He was a BBC man through and through and the fact that he was completely trusted allowed us to get away with a whole lot of stuff' (*ibid.*).

Up the Junction is set in and around the eponymous Clapham Junction, and concerns the lives of its inhabitants, notably three young women, Sylvie (Carol White), Rube (Geraldine Sherman) and Eileen (Vickery Turner). An internal BBC synopsis describes it thus:

> The play is based on the raw side of life in Battersea and Clapham Junction [and] follows the everyday life of three girls in this area and includes their relationships with their boyfriends, an abortion and the death of one of the boys in a motor bike crash. (BBC WAC T5/681)

This is a fair summary of the film's narrative focus and main events, and it connects it immediately to a contemporary sense of a hitherto unrepresented and socially extended reality – and thus to social realism. The film also, controversially, showed an illegal abortion, and was matter-of-fact, if not graphic, in its depiction of the sexual mores of its characters. However, the film is less concerned with its narrative high-points than the synopsis suggests, and is motivated more by the seemingly haphazard interplay of accident and incident. The story of the three women is constantly paralleled with the 'stories' of other women (and, to a lesser extent, men) encountered in a variety of settings – pub, street, workplace, home, café – and set against the background of a changing urban landscape. This latter is a constant presence on the screen, captured by the camera and offered, sometimes as backdrop and sometimes as subject, to the viewer. The film is also punctuated by music, mostly contemporary pop songs (some written specifically for the film) that both anchor *Up the Junction* in 'the present' and comment on the action, one element in a dense, multi-layered sound track. Picking up on pre-transmission publicity, several reviews referred to

the film as a 'free dramatisation, part-documentary and part musical' (Wiggin 1965).

Up the Junction was broadcast on Wednesday 3 November 1965 to 9.5 million viewers and was extensively reviewed in both the national and provincial press (by this point, all Wednesday Plays were receiving regular press attention). The BBC also received a record number of telephone complaints on the night of transmission. This was partly the result of its place in the schedules. Garnett, Loach and Newman all recognised that the single play was not viewed in isolation by the domestic audience, but experienced as part of a flow of programmes. The Wednesday Play benefited from being scheduled directly after the 9.00 p.m. news: as Ken Loach observed, 'we had wanted to make programmes and make plays or films that got the same response as when you saw the news because we came after the news' (quoted in Macmurraugh-Kavanagh, 1997a: 250). This proximity to the 'real' increased the likelihood that *Up the Junction* would be read predominantly through its social agenda, within an interpretative framework shaped by news and current affairs, and this was well understood by those who made it. Garnett and MacTaggart managed to persuade the BBC to run a discussion of the issues raised in the film (especially illegal abortions) on BBC's *Late Night Line Up* and, on radio, the Home Service's *The Critics*, later that same evening. And when the BBC, in a spasm of anxiety, withdrew a planned repeat screening, it was replaced with an edition of the current affairs programme *24 Hours* devoted to the issue of abortion law reform. This ensured that the film would become a television *event*, existing as a statement in a dialogue carried on across a range of television programmes, and with a life beyond the moment of the initial screening.

It was inevitable that the furore over *Up the Junction* would focus to a large extent on the controversial relationship between its dramatic form, documentary look and polemical purpose. However, the film has a number of points of origin, and absorbed many influences from the artistic and political culture that surrounded it. *Up the Junction* was the kind of 'non-naturalist' drama that Garnett had discussed in his contribution to the debates initiated by Troy Kennedy Martin in *Encore* (see Chapter 1). Both Garnett and Loach were influenced by contemporary European cinema, especially the French *nouvelle vague* (New Wave) and the early films of Milos Forman. As Garnett noted later, 'I'd seen *Breathless* [directed by Jean-Luc Godard] and really admired [Raoul] Coutard's work on that, and had a vision of the kind of drama I wanted to do' (Macmurraugh-Kavanagh 1998: 27). Godard/Coutard's use of natural lighting, observational camera work, jump cuts and direct

address to camera find a correspondence in some of the shooting strategies used on *Up the Junction*.

Certainly, the film was the product of a range of impulses and intentions antagonistic to conventional stage naturalism, including some that, paradoxically, were rooted in contemporary theatre. The cultural and social alliances between the New Wave in the theatre and television have already been commented on in Chapter 1, and a specific point of reference was Joan Littlewood's Theatre Workshop, based in the Theatre Royal in Stratford East (see Goorney 1981). Littlewood was one of the most influential theatre directors of the late twentieth century, whose work was rooted in the specific traditions of British popular culture and European theatre practice yet had international significance. Garnett and Loach were regular visitors to Stratford East in the late 1950s and early 1960s. As Garnett later noted, the attraction of Littlewood's work was its unashamed left politics, the clear orientation of the material towards the working-class and the energy and exuberance of the performance style.[2] Littlewood frequently recruited actors who were not 'actors' in the professional sense, in that they had not received conventional training (sometimes no training at all). This directly paralleled the use of 'non-actors' in *Up the Junction, Cathy Come Home* and subsequent Garnett and Loach collaborations. By the time *Up the Junction* was in production, financial crisis had caused Littlewood to leave and many of the original company to disperse, several ending up in television (see Lacey 2005). The kind of realism in acting style (the lack of 'bullshit' as Garnett put it) that characterised Littlewood's company parallels that of both *Up the Junction* and *Cathy Come Home*, largely because many of the actors they were working with then (and later) were 'found and developed by Joan Littlewood'.[3] Amongst the cast of *Up the Junction*, Tony Selby (Dave), Rita Webb (Mrs Hardy) and George Sewell (Barney, the talleyman) had all been Theatre Workshop Company members.

There is another connection to Littlewood as well: like many of their counterparts in New Wave theatre, left-inclined intellectuals working in television were influenced by the theory and practice of the German dramatist, theatre director, poet and theoretician Bertholt Brecht. Garnett and Loach have both acknowledged this debt. Jacob Leigh has argued that 'all Loach's work of the mid-1960s shows the equivocal influence of Brechtian techniques' (Leigh 2002: 23). 'Equivocal' is an interesting qualification, since, compared with the more formalist appropriation of Brecht's theory that informed debates about the 'classic realist text' in the journal *Screen* a decade later (see McCabe 1974), it was pragmatic and often refracted through other concerns and

practices. Brecht was, however, just as important an influence on the specific techniques used to shoot *Up the Junction* as documentary film practice. As Garnett argued recently:

> ... it wasn't because we thinking of documentaries. Ken and I were very influenced by Brecht at the time and we were interested in a sort of alienation effect on film where what was going on the screen would get the *feelings* of the audience, and what was coming on the soundtrack would get the *mind* of the audience – it was trying to do that.[4]

The shooting strategies that lay behind the film were, therefore, heavily influenced by a political practice. *Up the Junction* also acquired a political intention on its journey from page to screen. One of the most provocative sequences in the film (formally as well as thematically) is when Rube has an abortion, which is represented (for the time) highly graphically. The scene gained additional power from the fact that reform of the UK abortion laws was being debated in the House of Commons at about the same time as the first screening, reflecting a wider concern that frequently spilled over into the newspapers (the law was duly amended in 1967). Garnett was particularly concerned that the film should seek to intervene in the debate: indeed, Macmurraugh-Kavanagh has argued that he sought to 'hijack' Dunn's original intentions and impose his own, more propagandist agenda (see Macmurragh-Kavanagh 1997a: 253). It is difficult to argue, however, that the scene as it appears in the play is a distortion of Dunn's viewpoint (it occupies no greater narrative space and the book is actually much more brutal). However, the social context in which it was transmitted and debated, and the domestic context in which it was viewed, ensured that the abortion scene would be one of the most controversial, and would dominate critical and public reaction.

Some of the main difficulties posed by *Up the Junction* to its audience, however, lay not with its content but with its form. The film was experienced as an assault on the accepted idea of what a television play might be, and several reviews asked if it could be thought of as a play at all. Several reviewers noted the 'alienating' affect of the sound track, especially the cacophony of overlapping and sometimes indecipherable voices and the use of music, which caught the reality of situation, yet foregrounded it in unexpected ways. However, the biggest problem for viewers (as evidenced in the BBC's audience research) and critics alike was the lack of an acceptable narrative structure. There is no single protagonist around which the narrative world is organised, or who may constitute the (moral or political) viewpoint on events. Although Rube, Sylvie and Eileen constitute a form of 'collective' protagonist, they

neither dominate the narrative nor give a privileged perspective on it. Instead, the 'collective' is a much wider group of inhabitants of the Junction, whose faces fill the screen and whose insistent and often overlapping voices spill across the surface of the film. This was in itself challenging. The BBC's Audience Research Report noted that many viewers, including some who approved of the film, complained that, with the partial exception of the three girls 'not one of the cast was on long enough to "get going" ... and a sizeable group were clearly disconcerted by the disjointed nature of the programme' (BBC WAC VR/65/169). Behind these comments lay an expectation of a coherent narrative thread and of characters who could be 'known' in the round and identified with. It was this narrative structure as much as the film's visual style that evoked documentary. As Caughie (2000) has argued, *Up the Junction* is constructed through montage, its sense of typicality emerging out of the accumulation of characters, their voices and actions, rather than through the focus on the situation of a single figure. This latter approach is more often associated with fiction (though it may be found in documentary), whilst the former is a strategy associated with documentary, particularly British documentary. Tellingly, the BBC Audience Research Report noted that many respondents felt that 'the continual cutting from one scene to another only emphasised the fact that *Up the Junction* was not "drama" in the usual sense ... and had it been offered as a "dramatised documentary" rather than a play, the response might well have been more favourable' (*ibid.*). This is an early version of the unease that was to emerge subsequently around documentary-drama.

The fracturing of the narrative into distinct, sometimes disconnected sequences produces other important effects. The selection of incident and the elliptical and unexplained jumps in time often denies both the characters and the viewer the expected emotional response to events that in another drama might be significant. Terry's death in a motorbike accident, for example, is shown onscreen, but no-one (not even Rube) is given a 'scene' in which to vent an emotional response. The accident ends with a close-up of Terry's bloodied body and the words 'He's dead'. The next scene, however, is in a café, and the main focus is on Dave and the discussion is about death in general and prison, anticipating the next narrative incident, Dave's appearance in court. The first direct reference to the tragedy occurs only after Dave's trial (though before his sentence), and this (by Rube) is noticeably off-hand.

This refusal to allow the audience an emotional response to dramatic events, or to provide a viewpoint on them, is one of the main reasons

why the scene in which Rube undergoes an illegal abortion occasioned a variety of interpretations. The sequence is shot using montage and jump-cuts, with shots of Rube and Sylvie in Rube's bedroom intercut with interjections from her mother and father (from elsewhere in the house) that undercut the main action's emotional power. A male voice-over gives statistics on the incidence of illegal abortion. The sequence's climactic moments are in close-up, with Rube's face and body de-centred in the frame, her cries of pain dominating the soundtrack. Caughie (2000) uses this scene to support his argument that the film can be related to the modernist wing of the British documentary tradition. As a moment in which there are a variety of discourses in play and the everyday is 'defamiliarised', it is one of the most Brechtian sequences in the film. On the one hand, the voice-over, which draws on the authority of documentary, places the scene in the context of the campaign in favour of abortion law reform, inviting a response that condemns a situation in which women are subjected to the hazards of illegal abortion. On the other, the film does not allow Rube to give a view on what has happened to her; there appear to be no emotional and psychological consequences of the abortion (at least these are not represented), and there is no moment of reflection – as there might be in a more conventional narrative. Instead, a song ('She said Yes') offers an ironic comment and links to the scene that follows, which shows Rube preparing to go out for the evening.

The absence of an explicit point of view from Rube, therefore, did not allow for a clear interpretation of the sexual morality that led to the abortion. *Up the Junction* does not appear to be directly interested in the moral questions, and avoids comment on them, but the openness of the narrative structure allowed others to fill the space with judgements about the film's morality (and moral judgements). Interestingly, these did not always run along predictable lines. For Peter Black, whose review in the *Daily Mail* was hostile to the film, the 'moral line ... was irreproach-able. The terrified screams of the 17-year-old girl experiencing a miscarriage far out-weighed the inducement of the seduction scene. They must have satisfied even the most ardent moralist' (Black 1965). The BBC's Audience Research Report for the film quoted one viewer as saying 'the abortion scene alone, with its implications of "the wages of sin", was enough to put the fear of death into anyone' (BBC WAC VR/65/169).

Recent discussions of *Up the Junction* (Macmurraugh-Kavanagh 1999 and Hallam 2005) have argued that the documentary strategies of the film serve to objectify the intimate experiences of the women represented from the male point of view of the director and producer, for an assumed male audience. (Lying behind this is a broader

argument about the way that The Wednesday Play and its male producers and directors created the single play as a predominantly 'male' space, in which the specific contributions of women were devalued, and this will be returned to in Chapter 3). As Hallam argues, 'the female actors became the objects of a public (male) gaze, part of a probing social enquiry into the lives of working-class people' (2005: 26). Several of the more obvious documentary strategies certainly do operate in this way, particularly the authoritative male voice-over, but it is difficult, if *all* the modes of narrative address are taken into account, to argue that this is a consistent position. Indeed, it is hard to argue for a consistent narrative position per se, and *Up the Junction* is not, taken as a whole, either a 'realism of record' or a 'probing social enquiry' into anything. The documentary strategies, if they are such, do not always keep the viewer at a (constructed) distance, but offer a variety of ways of engaging with the social and personal experience represented, some of which objectify female experience, whilst others celebrate it.

Up the Junction foregrounds 'narrative' and the act of narrative creation itself. The screen is constantly filled with people jostling to tell stories about all manner of topics – sex, death, the neighbours, clothes and fashion, pregnancy, the war. (In the film's communal locations – pubs, canteen, café, streets – stories sometimes supplant dialogue altogether). The stories, which are clearly related to the story-telling that is at the heart of Dunn's original novel, are nearly always a means of relating, and giving shape to, personal experiences. These stories connect the personal to the social, and are a way of giving voice, literally, to a collective experience, particularly of working-class women – and especially older working-class women – that is still fresh and unusual. Students encountering the film in the early twenty-first century are often fascinated not by the abortion scene but by a sequence in the canteen of the sweet factory during a break. Prefaced by explicit stories of sexual encounters, the scene exhibits an exuberance and playfulness that spills out of the screen and affirms a vitality that cannot be contained by stereotypes of either class or gender (interestingly, the scene concludes with the attempts of a male supervisor to control the women in his charge). It is likely that negative responses to the film were shaped by the fact that it is *women* whose sexuality is so openly displayed, here and elsewhere.

As well as opening the door to new possibilities for what could be represented on television, and how, *Up the Junction* demonstrated the new confidence of the Drama Group under Newman's leadership. In addition, the use of 16 mm film introduced post-production editing into the repertoire of drama production techniques. Writing in

Contrast, Kennedy Martin was quick to notice the significance of this: although post-production editing 'did not make *Up the Junction* "FILM", in the sense of creating a product that could be screened in cinemas, it did allow for the kind of narrative style that could, at last, do justice to the intentions of the new generation of writers' (Kennedy Martin 1965–66: 139). It also gave new power to the director, who, as in the cinema, could assume greater authorial control over the eventual product. In retrospect, one of the main legacies of *Up the Junction* may have been the way that it began to re-balance the relationship between writer and director (and producer and story editor) in ways that favoured the director (see Lacey and Macmurraugh-Kavanagh 1999).

Significantly, after *Cathy Come Home*, which, like *Up the Junction*, included some studio footage, Garnett's productions were made entirely on film, that battle having been won decisively. In retrospect, from the viewpoint of an era when film is both a dominant technology and key aesthetic reference point, this seems inevitable. However, it is interesting, perhaps, to speculate what might have happened if *Cathy* had not been the extraordinary success it was.

Cathy Come Home

The status of *Cathy Come Home*, which was first broadcast on 16 November 1966, is now legendary, and it is hard to think of another single play/film for television that has achieved so much prominence, or which has been credited with such influence. *Cathy* made an immediate impact, prompting questions in the House of Commons, and credited with both changing the law governing hostel accommodation and launching the housing charity, Shelter (figuratively, if not literally, in that Shelter used a photograph of Carol White, the actress playing Cathy, in its poster publicity). Although its makers were later to argue that its success had been over-sold (see below), it remains an iconic text. A BFI survey in 2000 of the 50 most popular television programmes placed *Cathy Come Home* at number two (just behind *Fawlty Towers*), and it has been screened on six separate occasions (1966, 1967, 1968, 1976, 1993 and 2006).

The process by which *Cathy Come Home* came to be made illustrates the way in which Garnett operated as a producer, who could unearth ideas that the normal commissioning procedures had overlooked and protect them whilst they were being developed. *Cathy*'s author, Jeremy Sandford, was a writer and documentary journalist who was married to Nell Dunn. Sandford had a long-term interest in the plight of the

homeless, and the research that underpinned *Cathy Come Home* was accumulated over a period of time and had different outcomes. The first of these was a radio programme, *Homeless Families*, the public response to which, according to Sandford, was 'nil' (Sandford 1973: 84). Convinced that the proper response to the desolation of the homeless was a film, he produced a script and attempted to sell it to broadcasters, film producers and charities. 'I had thought there would be buyers for *Cathy*' he wrote later 'but there were none' (*ibid.*). Garnett found the script, at this point titled *The Abyss*, in a filing cabinet, met with Sandford and resolved to make the film. Realising that it might be controversial, Garnett decided to give the project a low profile, a different title and to describe it, when asked, as a 'knock-about family comedy' (*ibid.*: 85). One of the first things Garnett did was to change the title, and until just before transmission the film was known within the BBC as *When Cathy Came to Town*. Ken Loach was taken on as director, and, as with *Up the Junction*, he was closely involved with the re-drafting of the script (both his contract and his fee were amended to reflect his input). *Cathy* was shot very quickly (mostly in London and Birmingham, with some studio footage) in three weeks, its large cast of 50 and multi-location shooting making it expensive.[5]

Under Newman, drama producers were advocates for the projects under their charge, and Garnett became a key mediator between both the film and the BBC hierarchy and its public in the press coverage that preceded transmission. As Garnett said later, 'I only let them [the executives] see it after the *Radio Times* deadline. If it was going to be banned, I wanted it to be a public banning' (quoted by Paget 1998: 80). By the time the film was ready for screening, there was no need to conceal its true intent, and Garnett presented it as an overtly critical and polemical piece. A BBC press release quotes him extensively:

> The play ... is an attack on a society which, in the opinion of the author and producer, has its list of priorities wrong.
>
> Tony Garnett, the producer, looks out of the window of his twelfth floor office overlooking the rooftop factories, car dumps and the railways of Shepherds Bush and says: 'That's what Cathy's about. Out there. Ordinary people wanting to live ordinary lives. We've taken our cameras into the streets, the hostels, the caravan sites and gypsy camps to illustrate the story. The events in the play have actually happened in the course of the last twelve months. See if that makes you proud!' (BBC WAC T/695/1)

The press response to the play often treated Garnett as the film's main interlocutor (he is quoted nearly as often as Sandford, its author), and

this continued after the first – and unprecedented – hastily organised repeat.

Cathy Come Home is focused around a single character, Cathy, who arrives in London as a young single girl from the provinces. Her story is one that echoes a Zola-esque decline from relative optimism and security to despair and destitution, through, the film argues, no fault of her own. The early part of the film charts her marriage to Reg, and is optimistic in tone. The main narrative, however, concerns the couples' increasingly unsuccessful attempts to find a home for their expanding family (at the time of their greatest degradation, they have three children) following an accident that leaves Reg unemployable. Their descent into Part III temporary accommodation (the last stop on the public housing treadmill) is via a rented house, from which they are evicted, a derelict house and a caravan, from which they are hounded by the police and local residents. At the point at which they enter the hostel system, Reg and Cathy are forced to live separately. Eventually, Reg leaves to work in Liverpool, and stops supporting Cathy and the children, precipitating a financial crisis that leads to the final break-up of the family. Cathy's children are removed from her forcibly on a railway station, in a disturbing concluding scene that probably did more that any other to focus the film's emotional desolation. This linear narrative is accompanied by a series of voice-overs: Cathy's own, which tells the story in retrospect; the stories of the inhabitants of the various locations in which they find themselves; and an authoritative documentary-style (and male) voice that anchors the singular story in a general narrative of widespread homelessness. The visual style, which echoed that of *Up the Junction* and drew on the same influences, was widely interpreted as 'documentary'.

Cathy Come Home was, like *Up the Junction*, carefully positioned in the flow of an evening's viewing in such a way as to confirm its status as 'issue-based' drama. The BBC decided to follow transmission with an edition of the current affairs series *Late Night Line Up*, in which the issues raised in the film were debated. Public reaction was immediate, with much of the press registering both the emotional impact and social implications of the central story (although not all sections of the press or public responded positively). The critic of the *Daily Mail* opened his review by placing *Cathy* in the context of expectations of the anthology series as a whole: 'The Wednesday Play set out to shock, to rouse in its audience a burning indignation and sense of injustice. I imagine it reached all these objectives' and concluded it by praising the BBC for 'putting on work like this ... the old Corp did a service' (Black 1966). The *Daily Telegraph* argued that the play was 'a fierce propaganda poster

signalling the distress of the homeless [and] a vivid, noisy, sometimes over-emphatic production, which showed with compassion the raw degradations of hostel life' (Clayton 1966). The BBC's Audience Research Report recorded an unprecedented reaction index of 78 out of a possible 100 (the average for Wednesday Plays in the season up to this point was 54), with overwhelmingly positive comments from individual viewers (BBC WAC T/5/695/1).

Several MPs, including the Leader of the Opposition, Edward Heath, asked the BBC for private screenings of the film, and the Labour MP, Frank Allaun, referred directly to *Cathy* during a speech on the Housing Subsidies Bill in the House of Commons on 15 December. Garnett, Loach and Sandford were invited to the Ministry of Housing on 1 December to discuss the housing crisis, during which, according to Garnett, the (Conservative) minister 'said that although the programme hurt, he was delighted that there are still some people left with social consciences' (BBC WAC T5/695/1). *Cathy Come Home* had clearly become an event, as Macmurraugh-Kavanagh has noted (1997a: 257), a reference point in debates about housing and social change that was to resonate widely in the years that followed.

The film clearly had a wide appeal, and politicians and journalists of all political persuasions could claim its exposure of contemporary housing conditions as their own. The film was also criticised at the time of its transmission for blurring the lines between drama and documentary, with Sandford drawing particular criticism for inaccuracies in his research. This charge dogged Sandford over the years, and found its way into academic accounts. Irene Shubik (2000: 107) called his research techniques 'impressionistic', and her contention that the repeat screening removed much of the documentary voice-over and altered the end credits (which claimed provocatively but accurately that West Germany had built many more houses than Britain since 1945) has been repeated since, despite the vigorous denials of Garnett and others. Paget, however, has argued persuasively that there is no real evidence for the assertion that the film had been altered, and that the film's makers, backed by the BBC, stood firm behind the statistical evidence presented (Paget 1998). Moreover, the argument was frequently not about incorrect statistics, but rather the sense that housing officials had been misrepresented. This response is an indication that *Cathy Come Home* was the first television 'event' to represent an institution of the welfare state in a critical way to a mass audience; quite simply, the state – even in its local and unglamorous forms – was not used to being called to account in this way.

One of the main differences between *Up the Junction* and *Cathy Come Home* is that the latter has a single protagonist, around whom the

narrative is organised (something which gave the film a more accessible narrative shape, from an audience viewpoint). Cathy is its principal subject, and offers viewers a privileged view of events via a consistent, though sometimes oblique, voice-over. Cathy's narration is placed in a filmic 'present' which is not that of the events being portrayed, but rather looks back on them. This sets up, as John Corner has observed, a form of 'then and now' structure, with the viewer's perception of narrative incident influenced, though not determined, by Cathy's viewpoint (1996: 94). Cathy does not so much interpret or explain what happened to her as provide a series of reflections, inner thoughts and feelings not always revealed within the events themselves. She is, as it were, at the viewer's elbow, looking on at the narrative rather than standing between viewer and dramatic incident. The effect is sometimes a curious one and suggests an intimacy that acknowledges the domestic context in which the film is being experienced, and is one way in which the film is televisual.

The identification with Cathy's view of events is also embodied in the wider shooting strategies and political sympathies of the film. As Leigh (2002) and others have argued, Loach's films often portray events and people as the films' protagonists would see them. A recurrent motif in *Cathy* is a series of increasingly desperate interviews with housing officials, in which the latter are portrayed as being insensitive and, once Cathy and the children have descended to Part III accommodation, hostile and patronising. These are shot, by and large, from Cathy's subjective viewpoint, with the camera positioned behind her (though this is sometimes reversed). It is this, rather than factual inaccuracy, that led to the charge of bias in *Cathy* (and in other Garnett and Loach films subsequently), but which is an important means by which the political position of the film is connected to the subjective viewpoint of the characters. Cathy is a representative character in the way that characters in documentaries and naturalist dramas are normally representative, in that she is a 'personalisation' of a social issue that narrative organisation, individual voice-overs (hers and others) and the statistics about post-war homelessness demand that we read as a systemic social problem. Cathy is not so much a symbol as a metonym for a social problem, a particular instance of a general predicament. Indeed, the film works hard to eradicate symbolism of any kind, since this might foreground its aesthetic strategies rather than the reality it depicts. This is evident from the changes that were made as *Cathy* was being prepared for shooting. Whilst still *The Abyss*, Sandford's treatment included a scene in which Reg, Cathy and the children blow 'their last fiver on a night in a Grand Hotel, where they dine as the band

plays' (BBC WAC T5/695/1). This might well have made for a dramatically effective scene, but the symbolic contrasts it suggests would have been at odds with the rest of the film as we now have it, and its omission is an indication of the film-makers' ruthless excision of narrative strategies and dramatic incidents that would work against its core political objectives.

Cathy Come Home functioned politically as naturalism often does; it represented a situation in a way that suggests that action is necessary, engaging the spectator's emotions as well as their reason, whilst not offering a particular view of what that action might entail (this being left to the audience to decide). Depressingly, the situation of the homeless actually worsened in the years following the first screening of the film, despite the outrage and the activities of Shelter. In 1968, prior to a second repeat screening after *Cathy* had won the Prix Italia, Sandford was asked to add a prologue noting that the situation had changed. His reply was that, despite certain improvements in the worst accommodation, the situation had indeed altered, but often for the worse; more children were now in care than two years earlier, and more people were now in Part III accommodation (BBC WAC T5/695/1).

The imagery of social change

Both *Up the Junction* and *Cathy Come Home* were clearly political and cultural events, argued over beyond the canteens of the BBC and the columns of the television critics. Yet their impact came partly from the fact that, despite their distinctiveness, they were in some senses familiar to contemporary viewers, since they could be aligned with other representations of a society recognisably cutting loose from its moorings. Writing in the Introduction to the 1988 edition of the novel version of *Up the Junction*, Adrian Henri noted that 'what it records is a particular moment in English social history: the destruction of large areas of inner-city terraced housing, and with them a whole way of life' (Henri 1988: xiv). Though written in the 1980s, Henri's lament for the destruction of working-class communities had been aired in the 1960s. The main engine for change was affluence which 'is driving all but the wealthiest from Inner London. And, equally, affluence at a lower level, of cheap, mail-order clothes, rented video sets, hire-purchase furniture has eclipsed the sort of street culture celebrated in Richard Hoggart's *The Uses of Literacy*' (1988: xv). The reference points are those that can be traced across a great deal of cultural criticism from the late 1950s onwards – the deleterious affects of affluence and consumerism on

community life, and the dubious social benefits of slum clearance. Hoggart's highly influential account of pre-affluent working-class culture and its demise is referenced as a key statement of what has been lost.

The television version of *Up the Junction* makes social change all the more visible, since the camera shows what the novel hints at. The physical transformation of the landscape, with its rubble-strewn bombsites, half-demolished buildings and tower blocks, is both a backdrop to the main action and occasionally the main subject of the camera's gaze. For example, a sequence between Terry and Rube that shows their developing (sexual) relationship at night amongst the rubble of an empty building site, is abruptly broken by a switch to the same site in the daytime, traversed by bulldozers and workmen and providing a social 'story' to match the personal one. A similar imagery is present on the surface of *Cathy Come Home*, where the family's descent is revealed partly through the environments through which they move – squalid terraces, derelict housing, rat-infested caravan site (though the narrative is less concerned to observe dispassionately the physical transformation of the city than to treat environment as a manifestation of the family's degradation).

The world represented in *Up the Junction* connected to the interpretative context of working-class realism in other ways as well, as it brought class, sex and youth together in a heady mix. The category of 'youth', socially and culturally imprecise though it might be, was important to the way that social change was both managed and understood, even when it could not be contained within conventional political discourse. It is 'youth' that gives the 1960s much of its familiar iconography. The dominant images are of London from the mid-point of the decade (made famous in a special issue of *Time* magazine from April 1966), and resonate across the new forms of youth-oriented popular culture. The phenomenal global success of the Beatles, and (rather less phenomenal) of British cinema, had made Britain in general, and its capital in particular, the centre of Western popular culture. The imagery of sexual and cultural permissiveness, of Carnaby Street hip consumerism, signalled a final challenge to the traditionalist conservatism of the 1950s that began in 1956. As one influential study of post-war youth cultures put it, the idea of youth provided a 'compressed imagery for a society which had crucially changed in terms of basic life-styles and values – changed in ways calculated to upset the official political framework, but in ways not yet calculable in traditional political terms' (Hall, Crichter and Jefferson 1976: 9). *Up the Junction* and *Cathy Come Home* were easy to place on this mid-1960s landscape. On the one hand, Carol White's 'look' as Cathy resembled that of

another icon of 1960s femininity, Julie Christie. Christie's was a more obviously sexualised image, familiar from films such as *Billy Liar* (1963) and *Darling* (1966), but both were 'young' and could be identified with contemporary discourses. On the other hand, *Up The Junction* seemed to wear on its surface much of the popular culture that it was taken to represent – music, informality and openness, 'permissive' attitudes towards sexuality. When youth could be linked to the explicit representation of sexual behaviour the result was a 'moral panic' (Cohen 1973 and Thompson 1998)) of a kind that periodically afflicts post-war society.

Television was particularly vulnerable to moral panics because of its growing omnipresence, especially in the domestic space, the traditional domain of the family. Concern over the destabilising effects of programmes that appeared to challenge traditional Christian values was not slow to appear, nor quick to ebb away. The most high-profile and persistent critic of broadcasters in the 1960s and 1970s was Mary Whitehouse, whose National Viewers and Listeners' Association (NVLA) campaigned vociferously and energetically in favour of an evangelical Christian version of family life and its responsibilities backed by regulation. The NVLA, formed out of the coming together of a loose grouping of Christian campaigners, became active from early 1964. Its efforts were largely directed towards organising public meetings, letters to the press and a Manifesto, which was presented as a petition to Parliament in July 1965. The Manifesto made it clear who the main enemy was – the BBC and its Drama Department:

> Crime, violence, illegitimacy and venereal disease are steadily increasing, yet the BBC employs people whose ideas and advice pander to the lowest in human nature and accompany this with a stream of suggestive and erotic plays which present promiscuity, infidelity and drinking as normal and inevitable. (Whitehouse 1967: 23).

Up the Junction was one of the NVLA's earliest targets, and the campaign tactics were clear – to bombard the BBC and the press with letters of complaint, and ensure that the protest itself became the main story. This proved successful, and much of the press coverage of the film referred to Whitehouse's objections. She was particularly hostile to Garnett, who, though not the film's producer, was its front-man, and the Director-General of the BBC, Sir Hugh Carlton-Greene, who was directly responsible for the liberal policies that allowed *Up the Junction* (and others) to be made. Greene was largely dismissive of the NVLA, under-estimating its power to embarrass, whilst holding the line against its increasingly bellicose attempts to bring the Corporation into

line. Whatever he felt about her at the time, Garnett is now remarkably respectful of her, arguing that she was 'interesting, bright and *very* courageous. You patronised her at your peril' (Macmurraugh-Kavanagh, 1998: 26). Significantly, the consensus within the Corporation was against her: 'The left-wing, liberal, 'permissive' consensus was total, and she, almost on her own, stood up against it to derision and insult and highly abusive personal criticism' (*ibid.*).

Whitehouse and the NVLA recognised two things about television, especially its drama, that were also understood by Garnett and his radical contemporaries. The first was that television was not simply another medium of entertainment, but posed new and complex political and philosophical questions. In the spirit of Walter Benjamin (though she would not have known it), Whitehouse argued that 'new technological advances need a new philosophy to go with them' (Whitehouse 1967: 227). The second was that the real issue was one of power: who controls the broadcasters, especially the publicly funded BBC? Greene was essentially a patrician, an instinctive liberal who liked to position himself alongside the programme-makers against the 'new Populists' of the NVLA. He saw attacks on The Wednesday Play as attempts to establish a new censorship regime:

> These 'new Populists' will attack whatever does not underwrite a set of prior assumptions, assumptions which are anti-intellectual and unimaginative ... In practice it can threaten a dangerous form of censorship – censorship which works by causing artists and writers not to take risks, not to undertake those adventures of the spirit which must be at the heart of every truly new creative work ... I believe that great broadcasting organisations, with their immense powers of patronage for writers and artists, should not neglect to cultivate young writers who may, by many, be considered 'too advanced' or 'shocking'. (Tracey 1983: 241)

Greene's resistance to censorship was real, but it is symptomatic of the tensions it faced in the decade that the BBC should both promote creative freedom and engage in censorship, as the very public banning of Peter Watkins' *The War Game* in 1965 indicated (see Chapter 3).

The struggles represented in The Wednesday Plays between competing values, class and cultural identities and political and cultural ideologies were also played out within the BBC itself. As its creative practitioners were developing new possibilities for television drama, the Corporation was discovering new means of managing them. The conflicts that resulted could be bloody, and, as Garnett and others have repeatedly argued, the 1960s were no 'Golden Age' (Garnett 2000a:

19). On a day-to-day basis, the relationship between programme-makers and the institution was less a war of attrition than a series of skirmishes that could not be 'reduced down to a "young Turk versus reactionary Establishment" equation' (Macmurraugh-Kavanagh 1998: 24). The producer, however, was once more in the front line.

Garnett occupied a singular, indeed privileged, position within the BBC in the 1960s, due to the high visibility of *Up the Junction* and *Cathy Come Home* and the support of Sydney Newman. Garnett was rapidly identified, both publicly and within the Corporation, with the social realist wing of The Wednesday Plays which were important to its identity. In March 1966 (pre-*Cathy*), Newman argued with is bosses for additional funds for 'thirteen Garnett-type productions', indicating that Garnett was already becoming a brand-name within the Drama Department. The additional funds were to meet the costs of making drama on film, which continued to be the more expensive option, but which could be justified because 'the Garnetts were designed to provide the extra flash of orange every three weeks or so'. The consequence of not funding the plays was clear: 'If the money cannot be found ... we may face losing the clear lead we have won in The Wednesday Play field of the single drama' (Newman 1966a).

However, it would be wrong to suggest that Garnett – or, indeed, any drama producer – operated free from control. There may have been flexibility in the ways that the Drama group operated, but there were clear procedures for seeking advice and approval. The system was that each producer, as the member of the production team charged with maintaining overall control and direction, should refer upwards for guidance if there were likely to be any issues. The Head of Plays (Michael Bakewell and then Gerald Savoury) was expected to see both scripts and the finished programme prior to screening, and if in any doubt, Newman could be brought in for advice, as could those above him, such as the Controller of Programmes (Huw Weldon, for much of the 1960s). Garnett's view, ironically expressed, was that television bosses were far too busy to be bothered with trivial problems,[6] so he sought as little advice as possible. As the production histories of both *Up the Junction* and *Cathy Come Home* illustrate, his preferred strategy was to delay letting anyone know what he was up to until the last possible moment, by which time it was likely to be too late for anything to be done. Newman, though generally supportive, was not averse to confronting Garnett, if he thought he was in the wrong. There were, Garnett notes, several occasions when he and Newman fought loudly and there 'was blood on the floor' (the furore over Garnett and Loach's production of David Mercer's *In Two Minds* (1967) being a notable example), which were

nevertheless resolved without prejudicing the basic working relationship. Mostly, this system produced amendments, though occasionally it led to the postponement, if not withdrawal, of a play. Dennis Potter's 1964 play about the election campaign of a luckless Labour Party candidate *Vote, Vote, Vote for Nigel Barton* (on which Garnett was story editor) was withdrawn immediately prior to transmission because it was seen to be too sensitive in the run-up to a General Election. And in the event of a crisis, the Department had a stockpile of Wednesday Plays (normally seven), so that there would never be a hole in the schedules should it become necessary to withdraw a play at the last minute. This policy indicates sensitivities within the Corporation towards its controversial drama that surfaced in other places as well.

The politics of documentary drama: From *Up the Junction* to *Some Women*

The hybrid form of *Cathy Come Home* posed difficulties for con-temporary critics, not least because of claims it made for the reality of its depictions – claims that go beyond the use of statistics and implicit criticisms of the organs of the welfare state to the film's core aesthetic and political strategies. The anxieties *Cathy* provoked usually surfaced as concerns about its use of documentary techniques in a dramatic context – concerns that had already been raised in the furore over *Up the Junction*. The point of view was put most forcefully by Grace Wyndham Goldie, former Head of Talks and Current Affairs for BBC Television and BBC insider, in *The Sunday Telegraph* shortly before the first repeat screening. She argued that *Cathy* 'deliberately blurs the distinction between fact and fiction', and, siding with the supposedly confused spectator, maintained that viewers 'have a right to know whether what they are being offered is real or invented' (Wyndham Goldie 1967). Wyndham Goldie's view that the 'hijacking' of the appeal to documentary veracity to further the ends of dramatic fiction signals a dangerous and unwelcome development, is one that has become familiar. Much of Garnett's work, especially his collaborations with Loach in the 1960s and 1970s, has been viewed through the prism of 'documentary drama', for good or ill, and the resulting arguments and controversies that have swirled around the films have cast a long shadow over both their careers.

It may be that to think of documentary drama[7] as a single 'form' is misleading, since there are many different approaches to combining dramatic and documentary techniques. As Goodwin and Kerr have

argued, 'Television 'drama-documentary' is not a programme category, it is a debate' (Goodwin *et al.* 1983: 1), and one which concerns differences between documentary dramas as well as between them and other kinds of programme. Garnett and Loach's work has been important to the terms in which struggles over documentary drama and drama documentary have been conducted, their films having 'played a key role in the debate' (*ibid.*) whilst attracting the label almost by default. This has been partly due to the slippage between forms of documentary and social realism, a result of a common concern to represent the real in an unmediated manner and, often, mount a polemic.

Drama-documentary was not entirely new to broadcasting at this time. As Jacob Leigh has observed, *Cathy Come Home* owed something to 'the research methods and narrative strategies of the [television] drama documentaries of the 1950s' as well as Sandford's own radio journalism (Leigh 2002: 40). Also, as Paget notes, documentary has often had recourse to the dramatic (Paget 1998: 123). However, what unnerved Wyndham Goldie was not the hybridity of the Loach/Garnett collaborations per se but that it was occurring in the output of the Drama Department. This indicates a more complex problem than that posed by radio drama documentaries, and one that has political and institutional dimensions. Wyndham Goldie argued that documentaries produced by News and Current Affairs were subject to the strict controls that governed broadcast journalism, including a commitment to factual veracity and 'balance', whereas television drama, produced by the Drama group, suffered no such limitations. The point, which was rapidly picked up the press, was made more forcefully the following year by the *Daily Express* during a review of a later Loach and Garnett collaboration for The Wednesday Play, *In Two Minds* (BBC 1967), which explored the progressive psychic deterioration of a young women diagnosed as schizophrenic. 'Once a writer with a bee in his bonnet sat down and wrote a documentary' the review ran, 'which was balanced by an experienced features team to present a fair case. Now he writes a documentary and calls it a play – and under the banner of the drama department he acquires a freedom of expression which could not be tolerated by a current affairs producer' (Thomas 1967).

What began as a debate about programme categories, however, quickly became an argument about the competing ontological and political claims of different modes of representation, what Buscombe *et al.* have called the 'reality status' of distinct forms of television (Goodwin *et al.* 1983: 5). Loach and Garnett's experimental drama challenged the accepted binary oppositions of contemporary criticism and broadcasting policy; that documentary equals 'fact', balanced

journalism and unmediated reality, whilst drama equals 'fiction', personal 'vision' (normally of a writer) and creative invention. In fact, Garnett and his collaborators have always maintained that their productions met the most stringent standards of factual accuracy, whilst the call for 'balance' often led to spurious neutrality that obscured political realities. Sandford defended his research against all-comers, and Garnett often went to considerable lengths to ensure the credibility of the claims made in the plays/films he produced, especially when the result was likely to be controversial (this is a practice he has maintained until the present day). As Garnett has said in different ways on many occasions, 'they [news and current affairs] observe the facts and tell lies; we invent fictions and tell the truth'.[8]

As has been frequently noted, documentary drama is controversial at the point where it is seen to be political. As Loach said of the BBC's unease about documentary drama, 'it is very revealing that their dispute with us was not with the form, but with what we were saying inside it' (Goodwin *et al.* 1983: 2). It was not, however, either of the Loach/ Garnett collaborations in the mid-1960s that demonstrated the singular capacity of documentary drama hybrids to create political controversy but Peter Watkins' 1965 film *The War Game*. Watkins did not work for the Drama group, but was a documentary film-maker who made programmes for Monitor, an arts documentary strand. Drawing on contemporary scientific knowledge and documents already in the public domain, *The War Game* explored what might happen in the aftermath of a nuclear war. Using on-screen statistics, narration and 'what if' dramatic construction, the film was a highly-charged polemic. The BBC refused to broadcast it, though released it for limited cinema distribution; it was not screened on television until 1985.

Another moment at which the unease over documentary drama surfaced in public occurred some four years later. On 16 January 1969, the *Radio Times* published an unsigned article, 'Keeping faith with the viewer', the general tone and argument of which suggested that it had the weight of BBC insider opinion behind it. Voicing the by-now familiar concerns about the 'truth claims' of documentary drama, the article argued that 'the BBC is walking a tightrope, but even in its most experimental programmes it seeks to keep faith with the viewers' and posed the key question: 'Can these new programme techniques be carried too far?' (Petley 1997: 38). The answer, though never given, was probably 'yes'. At the time the letter appeared Garnett was embroiled in a protracted argument with Gerald Savoury, the new Head of Drama, and the BBC hierarchy about a television play that was very much a documentary drama, *Five Women*. Researched and written by Tony

Parker, *Five Women* was produced by Garnett and directed by Roy Battersby, whom Garnett recruited from the Features and Science Department of the Corporation. Shot entirely on film, the drama had been made for The Wednesday Play and scheduled for transmission in August 1967. However, the project was always going to be a difficult one to sell to the BBC, since – more than either *Up the Junction* or *Cathy Come Home* – it challenged the idea of what a 'play' was.

Tony Parker was a writer who described himself as an 'oral historian' (Parker 1999: 241), who also wrote and adapted plays for television (including *Mrs Lawrence Will Look After It* (1965) for The Wednesday Play). *Five Women* was originally a book, published in 1965, that consisted of interviews with a number of largely working-class women recidivists. The appeal of *Five Women*, and of Parker's work generally, is that of socially-aware documentary, which shares the ideological claims of social realism – that it gives voice to the voiceless and brings marginalised social experiences to the attention of an audience that would not otherwise encounter it. The essential structure of the book – of five stories told to an interviewer – was maintained. Five actors – largely unknown to the television audience, their anonymity seeking to guarantee the authenticity of the depiction – improvised a script based on Parker's text. Parker, as interviewer, was included to introduce each woman and prompt through questions. The strategy is explained at the beginning of the film, though not referred to subsequently. Battersby and Garnett adopted a formalised, pared-down approach, with the minimum of stylistic variation and very little sound, treating each interviewee as a 'talking head'. The camera rarely goes beyond the room, which is always the personal space of each woman, and the focus is always on her. Parker's voice can be heard off-screen for the most part, but he is occasionally in view.

The objections to *Five Women* were not explicitly political. The film is not didactic in the way that *The Big Flame* and *Days of Hope* were, although it is difficult to spend time with these five women and not question the way they have been treated, and the film's research methods were not called into question. There was undoubtedly a problem with the nature of the experience being represented, of a kind already encountered (it is significant that it was the interview with a lesbian, Joe, whose attitude was seen as aggressive, that was eventually cut from the film before screening). As is often the case with documentary drama, however, the problems with the film surfaced as unease about its form. Gerald Savoury argued in a memo to the Controller of BBC 1, Paul Fox, that '[t]here is absolutely no drama. It can never be a Wednesday Play' (Savoury 1967). Part of the objection here is

the lack of an acceptable narrative structure that might connote 'drama', and Garnett had protracted arguments with both Savoury and Huw Weldon, over the potential for confusion caused by the film's combination of dramatic and documentary strategies; in other words, precisely the kind of objections, voiced on behalf of the audience, that were raised in the *Radio Times*.

The increasingly heated arguments between the production team and the BBC hierarchy began to spill over into the press. Garnett and a large group of television practitioners circulated a letter to Weldon and Fox requesting a viewing of both *Five Women* and a documentary film, *Hit, Suddenly Hit*, also directed by Battersby, that had not been given a transmission date. The letter acquired some prestigious signatories on its journey, including those of Raymond Williams and George Melly.[9] There was no response until the article in the *Radio Times*. Garnett, along with Battersby, Jim Allen, MacTaggart and Loach, saw the article as a challenge and decided to reply with a letter of their own to the *Radio Times*, signed by them all, taking issue with the original piece. Published on 13 February, it argued that concerns about confused audiences were essentially a mask for political anxieties about content:

> The important thing for viewers to understand is that this is an argument about content, not about form. We are told that 'what he sees must be true to fact or true to art' but there is no acknowledgement of the *fact* [original emphasis] that the screen is full of news, public affairs programmes and documentaries, all delivered with the portentous authority of the BBC and riddled with argument and opinion. Some are acceptable: some are not. (Petley 1997: 39)

Appended to this letter was a reply by Paul Fox arguing that *Five Women* was 'rejected as a play and turned down as a documentary because it is neither one thing nor the other' hinting that it might yet be screened 'subject to some modifications' (*ibid*. 40–1). The film was indeed 'modified' and transmitted, not as a Wednesday Play, but in a late-night slot (at 10.40 p.m.) on 27 August 1969 with a new title, *Some Women*. By this time, Garnett and Trodd had left the BBC to set up Kestrel Productions.

Politics and social realism: *The Lump* and *The Big Flame*

The controversy over *Some Women* came at a time of increasing politicisation, both within and beyond the BBC. Garnett's own politics were likewise hardening under the influence of wider political and

historical events and because of the people he was collaborating with. Not long after *Cathy Come Home*, Garnett met with a writer with whose work he would become increasingly associated in the 1970s, Jim Allen. Garnett made four films with Allen, all for the BBC: *The Lump* (1967, directed by Jack Gold), *The Big Flame* (1969, directed by Ken Loach), *Days of Hope* (1975, directed by Loach) and *The Spongers* (1978, directed by Roland Joffe). It is not the number of collaborations that is significant as the particular, and more overtly political, complexion that Garnett's work with Allen acquired. Allen was a Marxist and a member of the Socialist Labour League, later the Worker's Revolutionary Party, which was revolutionary and Trotskyist (see Chapter 3). The collaboration included Ken Loach, who directed not only the films mentioned above but also others written by Allen but not produced by Garnett. Garnett introduced Allen to Loach in 1967, and the resulting partnership was fruitful and satisfying to all three. 'I had at that time no special theories about drama' Allen wrote 'but I knew instinctively that these were the sort of people I wanted to work with' (Orbanz 1977: 157).

Jim Allen was born in poverty in Manchester in 1926, left school at the age of 13 and worked in a wire factory before serving in the army and the Merchant Navy in the aftermath of World War II. Returning to work in the mines, he ran a newspaper with fellow miners (*The Miner*), spent a short time in prison and worked on building sites and in the Liverpool docks. Journalism became fiction, and Allen joined the writing team on *Coronation Street* until 1965, and had his first television play produced a year later (*The Hard Word* for BBC 2's Thirty Minute Theatre). Allen was introduced to Garnett by Jon Finch, a fellow writer from the northwest. Despite an almost comical first meeting during which, according to Garnett, they were 'prowling round each other' (Garnett 2001: 74), they agreed to collaborate on what became a Wednesday Play, *The Lump*. For Garnett, Allen was that rare thing, a working-class writer, with an ear for the everyday cadences and speech patterns of working people, who had not been educated out of his class (unlike Garnett himself, as he readily admits). Allen was also well-connected, and had the means of providing his collaborators with direct access to the contexts that he was writing about – the Labour Movement, the building trade and the docks.

Although the specific subject matter of Allen's plays varied, there are nonetheless recurring themes. Whether writing about conditions on the building site (*The Lump*) or in the docks (*The Big Flame*) or recent working-class history (*Days of Hope*), narratives revolve around questions of political organisation and leadership, with the spectre of betrayal by the reformist leadership of the working class, the Labour

Party and the Trade Unions in particular, haunting attempts to create revolutionary change. 'The election of a majority Labour Government in 1945 raised the hope of millions of people that they would live to see socialism' he argued, and its historical role 'was to ameliorate the lot of the working man, but not to change the social order' (Orbanz 1977: 154). The motif of the revolutionary energy of the working-class consistently deflected by a leadership anxious to accommodate itself to capitalism is one that runs deep in left politics in the late 1960s and 1970s, both within and beyond television.

The Lump was developed in discussion between Garnett, Allen and Jack Gold (a documentary film-maker, who had been an editor on Tonight, the BBC's prestigious current affairs programme) who was brought in to direct it. The Lump was Gold's first fiction film, and bore traces of his formation in non-fiction journalism and film-making, using a rough-and-ready hand-held aesthetic. The title of the film refers to a system, the lump, in which labourers in the building trades were treated as self-employed workers, responsible for their own tax and insurance, with no security of employment and at the mercy of the arbitrary power of unscrupulous employers. The film follows two characters, Yorky (Leslie Sands), who is a militant building worker, and Mike (Colin Farrell), a student who finds himself working temporarily on the building site. The narrative begins with Yorky leading an unsuccessful strike and walk-out on a building site over safety standards, and ends with his death during a fight with the site foreman when a trench collapses on him. The Lump has, in the words of its director, 'a conscious dramatic shape, even slightly melodramatic' (quoted in Madden 1981: 43). It works in the way that many social issue melodramas do – by using narrative to align spectators emotionally and politically with its protagonist, and by doing so aims to give access to the issues (the press response suggests that the film was largely successful in this).

However, the narrative of The Lump also pulls in other directions, since much of it concerns issues that are not directly related to the lump per se but rather connect to debates on the left about the nature of leadership and the necessity of militancy. The narrative trajectory might be described as a journey (Mike's) from ignorance to knowledge, and from disinterest to engagement. This is crystallised in a scene mid-way through the film, in which Yorky declares his revolutionary politics to Mike and explains the necessity for proper organisation. The final sequence makes this clear: Mike is left facing fellow workers across Yorky's corpse, claiming the latter's tools – and by implication his role as militant organiser – as his own. A voice over (Yorky's) repeats a

phrase used earlier in the film, that Mike should have 'a few gold nuggets' to take away with him. Mike's journey, therefore, is intended to be the audience's, and it is through his – and our – radicalisation that the problem of the lump and the 'rotten' system it represents can be addressed. This, however, raises further questions about the film's naturalist form, and what can be explored within it, that were also confronted in *The Big Flame*.

The Big Flame was Garnett's second collaboration with Allen, and the first to involve Ken Loach. The film came out of Allen's experience of working in the docks in Liverpool, and, like *The Lump*, was interested in revolutionary political action and questions of leadership, but pursued this in a narrative form that was not locked into melodrama. *The Big Flame* is contemporary in a very direct way, and its narrative of a dockyard strike and occupation is set in the context of the 1966 Devlin Report into working practices in Britain's docks: its opening sequence contains a voice-over by Harold Wilson, then Labour Prime Minister, condemning worker militancy. The story follows a group of dock workers who, in opposition to their union, take industrial action over pay and conditions. In a key scene that parallels the one between Mike and Yorky discussed above, the strike leaders are introduced to Regan, a political activist and organiser, who places their struggle in the context of revolutionary politics and persuades them to occupy the docks. The occupation, which initially goes well, is eventually defeated by the brute power of the state, aided by the media. In the final sequence, the strike leaders are imprisoned, but the implication is that a 'big flame' of the title has been lit, and the next generation of activists will emerge from the shadows of the old.

The Big Flame was written in 1967 and shot between February and March 1968, though it was not shown until nearly a year later. Its delay was a result of the BBC's increasing nervousness about how to handle a play that seemed to advocate occupation and revolutionary action. Political events made the issue of when, or if, to screen it more difficult: in May 1968, Europe erupted in a wave of occupations, strikes and demonstrations, focusing on Paris (see Chapter 3) but also involving the UK, and the film seemed prescient as well as inflammatory. The row over the film's fate simmered throughout the year and lay behind the refusal to screen *Five Women* and *Hit, Suddenly Hit*. Garnett, whose fury over the delay in the film had been expressed at the highest levels within the Corporation, went public in a *Guardian* interview four days later, stating as a fact what his strategy hoped to achieve:

> Tony Garnett ... claimed last night to have manoeuvred the corporation into a position in which it could not cancel a controversial play about

a workers' takeover of the Liverpool docks, due to go out this Wednesday.

Mr Garnett said that a protest letter about BBC 'censorship' of two programmes, one also produced by himself, which appeared in the latest *Radio Times*, was partly aimed at ensuring that the BBC did not cancel or postpone this Wednesday's Play.

He said: 'One of our intentions was to make it very difficult for the BBC to stop putting on *The Big Flame* on Wednesday, and I think we've got them nicely boxed in now'. (Woollacott 1969)

Whether or not the BBC had intended to withdraw the film, it certainly could not appear to be engaging in what would have seemed to be a concerted attempt to muzzle its radical employees.

The Big Flame sits, stylistically, between Loach and Garnett's earlier, Brechtian work for The Wednesday Play and a later, more observational style. As Leigh (2002: 93) has noted, the film uses some of the documentary and modernist strategies familiar from earlier plays. There is voice-over from occupying workers, for example, commenting on the smooth-running of the docks under their stewardship, and montage of voice and image. The extended first sequence, consisting of a meeting between workers, union leaders and bosses, is shot in documentary style, the camera positioned on the edge of the space, capturing the action as best it can. However, the most significant innovation in *The Big Flame* was not its mixture of drama and documentary but in its essential narrative conceit. The film does not so much record an event – which much of its camerawork might suggest – as hypothesise one, since there had not been any occupations of docks, or indeed anywhere else in the UK, in recent history.

Raymond Williams drew attention to the significance of this dramatic hypothesis in the course of a lengthy and important analysis of *The Big Flame* (Williams 1977). The film, without disrupting its essential realist frame, poses a question, which it then explores dramatically:

> What would happen if we went beyond the terms of this particular struggle against existing conditions and existing attempts to define or alter them? What would happen if we moved towards taking power for ourselves? What would happen in specific terms if we moved beyond the strike to the occupation? ... [It is] a hypothesis which is played out in realistic terms, but within a politically imagined possibility. (Williams 1981: 234)

What lies behind this argument is a question about the political potential of realist forms. For Williams, contesting some of the more

formalist criticism of contemporary realism (see Chapter 3), this was not an abstract question that might be settled singly and for all time but one that could be answered differently in different narrative and political contexts. The problem concerns the familiar criticism of realism in its mimetic form – that it cannot admit a viewpoint of events that lies outside of the central dramatic situation. A wider history and politics enter only to the degree to which they can be refracted through the situation and personality of the characters. A film about a strike cast in the conventions of mimetic realism can only show the strike itself, not the underlying causes or possible solutions.

For Garnett such problems were not so much formal as political and ideological – yet they clearly have formal implications for how, and in what terms, the realist narrative can be opened up. Commenting on how he might re-think *Cathy Come Home* in 1971, Garnett argued that the problem with the film is that it does not 'lay the blame or show how it [the housing problem] can be solved' and should 'be reframed altogether' (Levin 1971: 101):

> It's not just a question of adding a few lines. I think one would take that situation and restructure it, tell the story very differently. One would try to avoid the situation where an audience could get out of their moral difficulty by blaming a few local officials on the periphery of the system. You've got to blame the system at its base ... One would also have to make it very clear what the solution to the problem would be, in terms of political analysis. This would then engage one not just in a discussion of how many houses should be built to what standards, but what is the political and economic structure behind all this. (*Ibid.*)

The problem with *Cathy*, then, is that it does not allow 'complex seeing', as Williams put it (1981: 235), that might provide a range of perspectives on events. *The Big Flame*, however, does achieve complex seeing, and not only through the insertion of Brechtian techniques such as voice-over as had been the case in earlier Loach/Garnett collaborations. Initially, Allen does this by introducing a character, Regan, who provides an alternative viewpoint to that of the strikers, one that places their struggle in a wider historical context and poses a strategy to develop it. Like Yorky in *The Lump*, Regan is a seasoned militant who offers a resolution to the conundrums facing the less politically sophisticated strike leaders, who cannot see beyond their immediate actions. It is Regan who introduces the 'what if' question, and it is this dramatic hypothesis that enables the film to transcend the limitations of the familiar realist narrative, which is why Williams gave it such importance. There are other ways in which it attempts to do this, too. There is a scene, which Williams also draws

attention to, in which the habitual practices of the media are questioned. The ending of the occupation is filmed not from the point of view of the police – as it would normally be – but from that of the dockers, and this literal shifting of point of view is linked to a political one in a way that questions the supposed objectivity of the news camera. Another example: at a key moment towards the end of the occupation, a docker sings 'The Ballad of Joe Hill'. This song about the legendary murdered American Union organiser echoes the mood and theme of the final sequence, where temporary defeat will lead to eventual renewal and victory.

However, the effort to achieve complex seeing within the constraints of this form of social realism is not without cost, and the surface credibility of the film is sometimes stretched. The significance of 'The Ballad of Joe Hill', for example, has to be explained by one docker to another. This may be read, plausibly, as a politically-educated worker educating a comrade, yet it also seems like the insertion of an authorial discourse necessitated by the audience's own likely ignorance of US labour history and draws attention to the realist frame. A more significant example is the trial scene, which leads to the imprisonment of the leaders of the occupation. Regan is allowed to deliver a stinging rebuke to the judge, which, although it may be defended as being plausible in the terms in which Regan has been defined, can also be seen as authorial intrusion, in that it articulates very clearly the point of view not only of the strikers but also of the film itself. Garnett was later to dismiss the charge that *The Big Flame* was propaganda (*Afterimage* 1970), by which he meant that it refused to reduce a complex dramatic situation to political rhetoric. However, the tension between the need to provide an explanation and the constraints of naturalist plausibility are real. But this form of social realism – and this political perspective – is not all that Garnett explored in the late 1960s.

Social realism: playing with form

Up the Junction and *Cathy Come Home* represented a particular kind of social realism, though they did not exhaust its possibilities, and Garnett's career in the decade shows a willingness to experiment with dramatic form in the service of realist objectives. On the one hand, there is a continuing interest in the use of – and interrogation of – documentary strategies in a dramatic context (*In Two Minds*, 1967, for example, *Drums Along the Avon*, 1967 and *Some Women*, 1969), but on the other were experiments with comic and dramatic forms (Nemone

Lethbridge's trilogy on the workings of the law screened between 1966 and 1967, and David Mercer's poetic reflection on the relationship between generations (*The Parachute*, 1969).

The Lethbridge trilogy, which set out to expose the way that the legal system allows corruption to thrive, is an apt illustration of the ways in which comedy might be used to further the analytical aims of social realism. The first part of the trilogy, *The Portsmouth Defence*, was produced by Peter Luke, directed by James MacTaggart and transmitted in March 1966. Garnett picked up the project on Luke's departure from the BBC, and the second play, *The Little Master Mind*, was transmitted in December 1966. The third, *An Officer of the Court*, was shown a year later (December 1967). MacTaggart remained as director. A BBC synopsis describes the trilogy as 'a series of plays about the law and those who make and break it' (Garnett 1967c). The plays told the story of an East End lawyer, Plantagenet King, whose criminal activities bring him into conflict with both the law and other villains. All three plays aimed for satirical comedy, and this was reflected in the casting. King was played by Tommy Godfrey, whose background was in the music halls rather than the theatre or television. Garnett also used several of Littlewood's Theatre Workshop stalwarts, including Yootha Joyce and Bryan Pringle, and the trilogy shows Garnett's continuing debt to Littlewood and the theatrical and political traditions she represented. For Garnett and Littlewood, comedy was another way of engaging with contemporary social reality, and the gallery of comic grotesques that peopled the trilogy existed in a Jonsonian world of greed and venality. The BBC's Audience Research Report for *An Officer of the Court* suggests that, as was often the case with Littlewood's stage productions, comedy could be combined with an underlying plausibility that guaranteed a connection to the contemporary world. Although judged the weakest of the three in terms of its satire, the acting was deemed wholly successful, and 'several of the sample [of viewers] declared they sometimes forgot they were watching a play and not the real thing' (BBC WAC T5/1,738/1).

The ambition to represent 'the real thing' in experimental forms can be found in both *The Gorge* and *Drums Along the Avon*, both of which revealed an unexpected self-reflexivity. *The Gorge* (transmitted on 4 September 1968, directed by Christopher Morahan and written by Peter Nichols) concerned a middle-class family's day-trip to Cheddar Gorge, its encounter with another family and other assorted visitors. Nichols was an established playwright with a reputation for West End success, who was persuaded by Garnett to write for The Wednesday Play. *The Gorge* adopted a conventional narrative that focused on a

comic romantic entanglement between two teenagers to provide a viewpoint and (implied) critique of bourgeois values. It was rather less conventional, however, in being made entirely on film, exploiting the fluidity of narrative construction that location shooting made possible. Several reviewers commented on this, indicating that, by this point, arguments about television form were beginning to shift decisively in the direction of location shooting and film. The critic of the *Sunday Mail* observed that *The Gorge* was 'almost totally liberated from the confines of the studio' (Anon 1968). It also incorporated the home movie being made by its teenage protagonist in sequences that were both novel and self-referential.

A playful and more thorough-going self-reflexivity can be found in the interrogation of documentary techniques in Charles Wood's anti-racist 'fable' *Drums Along the Avon* (directed by James MacTaggart and first screened on 24 May 1967). Self-consciously experimental, the play crystallised the difficulties of accepted dramatic categories. It was described in a BBC synopsis as a 'wild romantic comedy', yet this in no way captures either the narrative's complexity or its shifting viewpoints. It was, on one level, a spoof tourist documentary, in which an actor playing the Mayor of Bristol (and who announces himself as an actor) sold the benefits of the city direct to camera, making racist comments on the way (the Corporation of the City of Bristol complained that it was slandered by the film). However, it was also a satire on liberal attitudes towards racism, with its central character, Mr Marcus (Leonard Rossiter), attempting to 'identify' with 'coloured people' by blacking-up. This story, which embraced many twists and turns, was further juxtaposed with that of an arranged marriage between second-generation Indians. Several other interludes, with no obvious narrative connection to anything else, punctuate the story (drug-dealing, and a black prostitute who causes a motor-bike accident, for example). *Drums Along the Avon* was in fact a rare attempt in television drama to create the kind of experimental montage that was also evident in *Up the Junction*. MacTaggart, although he did not use the term, confirmed the production team's view in a letter to an irate viewer that the play 'depends on splitting [the] story into its elements and rearranging them to discover unexpected and illuminating juxtapositions' (BBC WAC T5/1,300/1). In his briefing for the *Radio Times*, Garnett described *Drums* as 'a jig-saw puzzle' that asked its audience to become involved, playfully, in the process of construction.

> The pieces you will hold in your hands if you decide to play are not in themselves surprising or amusing or shocking. A rather fine English city. An Empire on its uppers. A slum. A very beautiful Indian girl. A

handsome and intelligent Indian youth. A brothel. Drugs. A police raid. A wedding. And an outrageous comic figure who takes our bland and arrogant assumption that integration must precede toleration to its logical conclusion. (Garnett 1967b: unpaginated)

The writer, Charles Wood, wrote the screenplay for the Beatles' second film, *Help* (1965), and the film adaptation of Anne Jellicoe's *The Knack* (1965), both of which were considered experimental. They also epitomised the increasingly confident and internationalised 'swinging sixties', and Garnett tried to capitalise on this by asking Paul McCartney to write the music (he declined). *Drums Along the Avon*, therefore, linked two kinds of experimentalism, a self-conscious 'fantasy' associated with an emerging youth culture that came to characterise the decade with a more rigorously political and Brechtian disrupted narrative.

A different kind of experiment with documentary can be found in Garnett's first collaboration with writer David Mercer. *In Two Minds* was controversial, raising increasingly familiar questions about 'confusion' and political misrepresentation, and led to serious arguments between Garnett and Newman over both its status as 'drama' and its factual accuracy. The film was directed by Loach and transmitted as a Wednesday Play in March 1967. It was later filmed as *Family Life* (1971). The film tells the story of Kate Winter (Anna Cropper), who is diagnosed as schizophrenic and suffers a progressively severe breakdown, leading to her incarceration in a mental hospital. She undergoes electro-convulsive therapy and is left a virtual vegetable. A chilling final sequence sees her used as a 'case-study' during a lecture given by a psychiatrist to his students, during which she is objectified as a bundle of symptoms, for which there is no real hope of a cure. The film, however, has demonstrated that Kate's problems are mainly to do with her family's, especially her mother's, repressive attitude towards her; not permitted to define herself in her own terms, she is left no identity at all. In a letter to a hostile psychiatrist written after the screening, Mercer defended the film thus:

What I tried to do was present a particular nexus of family relationships ... in which a person's attempts to discover and assert her own identity were systematically invalidated and mystified by those around her. Further, this invalidation and mystification is continued – even confirmed – by the kind of relationships established all too often in mental hospitals between patients and staff. (Mercer 1967: unpaginated)

In Two Minds sets itself against dominant psychiatric explanations of mental illness, and this is indicated by Garnett's pre-screening account in the *Radio Times*, in which the medical language normally used to describe metal illness is replaced by that of crime and detection:

> She [Kate] is trying to become herself – not somebody else's self – just her self. But she confronts very powerful institutions. All seemingly benign. The State would talk of justice, the hospital of treatment, the parents of love – but other voices are being raised, Mercer amongst them. They talk of violence and murder. (Garnett 1967a: unpaginated)

Aware that the film was likely to prove controversial, Garnett insisted that press interest be discouraged and that all publicity must go through him (*ibid.*).

In Two Minds is based on a case documented in R.D. Laing and A. Esterson's *Sanity, Madness and the Family*, a study of the social, familial and psychic roots of mental illness. Ken Tynan introduced Garnett and Mercer to Laing and David Cooper, both controversial figures in contemporary psychiatry with a large following amongst the counter culture. Laing's existential and political approach to the subject rejected conventional treatments, especially drugs and electro-convulsive therapy, and blamed the bourgeois family, and the social institutions that support it, for the mental instability of its members. Laing acted as adviser to the programme, with Cooper arranging access for Mercer to hospitals and other clinical settings. The involvement of such controversial figures, whilst helping Mercer to get the medical details correct, did not protect the film from charges that it was 'biased' and unbalanced (the hostility to Laing amongst the psychiatric profession was mobilised against the film as well).

In Two Minds was challenging at a formal as well as a political level. Shot with a hand-held camera and using interview as a recurrent narrative strategy, the film connotes 'documentary' whilst at the same time undermining its claim to objectivity. The psychiatrist/interviewer is never seen but only heard, a presence – sometimes ominous and sometimes reassuring – that shadows the first part of the film. The camera seems to adopt his point of view for much of the time, confirming his status as authoritative, male 'voice'. However, this is a role the psychiatrist resolutely refuses, and the omniscience of the documentary strategy is undermined by his oblique questioning and refusal to interpret. Kate's psychic state remains enigmatic until the end. In many of his plays and films, Mercer experiments with a slippage between the 'real' world of concrete social relationships and the inner, subjective worlds of memory, dream and fantasy, in the

manner of the *nouvelle vague* French cinema of Alan Resnais, to which he owes a conscious debt (Caughie 2000: 169). In a startling manoeuvre, the psychiatrist leaves the film as Kate enters the mental hospital, and for a brief time the camera replaces his point of view with hers, in a disorienting sequence that takes the viewer inside Kate's terrified subjective experience of the 'treatment' she endures. The lecture with which the film concludes places the camera in a different point of view again, this time the familiar but problematic 'objective' viewpoint of the observational documentary camera, looking at, but not seeing, observing but not understanding, a young woman whose subjective experience is now closed to the viewer.

Garnett's second, and final, collaboration with David Mercer on a television play was *The Parachute*, directed by Anthony Page and transmitted as a Play of the Month on 21 January 1968 and then as a Wednesday Play in August 1969. The play/film was shot both on location and in the studio, indicating that this was not a typical Garnett production. *The Parachute* tells the story of a young German aristocrat, Werner von Reger (John Osborne). reflecting on his life from the viewpoint of a training camp for paratroopers towards the end of World War II. The play moves between this present to a past of dream and memory, in which Werner remembers/fantasises about his relationship with his aloof and repressive father (Alan Badel), his repressed mother (Isabel Dean) and his cousin/wife (Jill Bennett). The play concludes in the von Reger's country home, Laugstein, with Werner in a wheelchair (having been disabled in a parachuting accident), his father dead, his mother mad and Anna, a communist, probably in a concentration camp. Soviet paratroopers parachute into the estate grounds. The play is a reflection on pre-war history that merges past with present, the historical reality of war, militarism and fascism with the subjective and private experience of those events and forces, played out in the context of family relationships. To describe the narrative in this way suggests a symbolic intention (Werner's crippling connoting that of Nazism itself, and the Soviet invasion of the von Reger estate signalling the wider invasion of Eastern Europe), but this does not really catch the rich, elusive and enigmatic qualities of the play, which finally avoids easy symbolism just as it resists a rigid separation of historical and subjective worlds. *The Parachute* is less concerned with an investigation of a particular historical moment than with an exploration of the power of fascism to re-imagine the self. As Caughie has argued, the play is 'a psychic history, overlaying a narrative situated within a historical period with a psychic reality of power and class which transcends that period' (Caughie 2000: 170).

By the time of the repeat screening of *The Parachute*, Garnett, along with other stalwarts of the BBC Drama Department, had left for the hitherto unforeseen opportunities of commercial television and cinema. This was a time of change, not only for Garnett but for the BBC in general and its Drama Department in particular. Like several of the younger members of the Drama Department, Sydney Newman had an ambition to produce films and left the BBC in November 1967, at the end of his contract, to pursue a career as an executive producer with Associated British Productions. An unsatisfactory eighteen months later, Newman returned to Canada to become a Special Advisor to the Canadian Radio and Television Commission, from which position he developed a career in the upper reaches of the Canadian film and broadcasting industries. Hugh Carlton Greene, who in many ways embodied the BBC of the 1960s, also left (1969), and his successor, Lord Normanbrook, was an altogether more conservative figure. The decade that followed proved to be a difficult one for broadcasters, caught between declining revenue (a problem for both the BBC and its commercial rivals) and increased competition in the one hand, and an increasingly polarised political situation on the other: as in the 1950s and 1960s, the possibilities for radical drama were intimately connected to a wider political and cultural history.

Notes

1 A full list of Wednesday Plays, along with details of their authors, directors and producers, can be found in Shubik (1975, 2000).
2 In conversation; 7 October 2004.
3 I am indebted to Lez Cooke for access to the transcript of an unpublished interview conducted with Tony Garnett on 29 February 2000.
4 *Ibid.*
5 In a memo to the executive in charge of budgeting dated 19 July 1966, Garnett noted that the film was 'about £1,000 over our latest estimates' and blamed his inexperience. He guaranteed, however, to keep to a promise made at the beginning of his contract that he would meet the agreed 'average' costs when the budgets of his contracted projects were taken as a whole (BBC WAC T5/695/1).
6 In interview with the author, 7 July 2004.
7 I will use 'documentary drama' to refer to Garnett's work in this context in preference to 'drama documentary', to indicate (following Paget 1990 and 1998) fictional drama produced by the Drama Department as distinct from documentary films that use fictive strategies, normally produced by documentary makers.
8 In conversation, 7 October 2004.
9 I am indebted to Karen Shepherdson (2004) for reprinting this letter in full.

Plays for today: representing 'managed dissensus'

It was not only British television that was undergoing a period of upheaval; by the late 1960s, many of the tensions and contradictions that had been forming beneath the skin of British society broke to the surface. British society and culture opened up throughout the decade, epitomised by a programme of liberalising legislation initiated by the Labour governments of 1964–70 that saw abortion legalised (1967), theatre censorship ended (1968), racism criminalised (1968) homosexuality (partially) de-criminalised (1967) and capital punishment suspended, prior to abolition (1965). However, in the same period, the consensus that dominated British political and economic thinking for much of the post-war period was threatened. As Hall *et al.* have noted, the late 1960s and 1970s represented 'a watershed: the whole fulcrum of society turns, and the country enters, not a temporary and passing rupture, but a prolonged and continuous state of semi-siege' (Hall *et al.* 1978: 251). The same government that liberalised British culture and society also supported the increasingly unpopular US presence in Vietnam, and attempted to intervene directly in industrial affairs (through the ill-fated 1969 White Paper, *In Place of Strife*).

The key year was 1968, when revolutionary forces of the left – though not the orthodox Marxist left – challenged the status quo across Europe, led not by the political institutions of the working class but by student radicals. Student groups in Paris and elsewhere in France occupied universities, the streets and other centres of state power in May, threatening for a time to pull the French working class into an improbable alliance that would signal a new French revolution. 'May '68' quickly became important for intellectuals and cultural practitioners of the left, and was the summation of the 'decade of youth'. However, the political fragmentation that followed also favoured the right, which was resurgent in France and across the globe. In the years that followed, the

post-war consensus broke to both right and left, with political instability exacerbated by economic crisis (low growth, high inflation and oil crises; Kavanagh and Morris 1995: 22) as Britain entered a period of 'managed dissensus'(Hall *et al.* 1978: 238). To the right, the Conservatives returned to power in 1970, and the casual and endemic racism of British society found a champion in Enoch Powell, whose warning of racial warfare addressed directly some of the visceral fears of the white working class. Racism found electoral expression in the rise of the National Front, which took the anti-immigrant struggle to the streets and the ballot-box. To the left were political groupings – the anti-Apartheid movement, for example – operating outside the charmed circles of power; most important of these was the Women's Movement in its many political, cultural and economic forms. Most disturbing of all were 'The Troubles', Britain's 'backyard "Vietnam"' (Hall *et al.* 1978: 260), in Northern Ireland, which produced a severe, prolonged and violent challenge to the British state.

By the late 1960s, industrial militancy increased dramatically: two to three million days were lost through strikes between 1964 and 1967, but by 1970 this had risen to seven million (Seed 1992: 32).The militancy of the trade unions from the late 1960s through the following decade dominates the domestic political landscape in the period, providing much of the imagery – of strikes and mass pickets, mostly connected to the miners' strikes of 1973 and 1974 – through which the 1970s has been interpreted. The response of the political and cultural right was to bring all challenges to the status quo together as a single, undifferentiated 'threat'. Thus, left-wing teachers, union activists, television producers all found themselves branded, in a much quoted phrase, as the 'enemy within'. In this climate, conspiracy theories abounded; indeed, conspiracy, and its twin, betrayal, run through much discourse off both right and left in the decade; it is not surprising that they also surface in television drama, both on and off the screen.

In the late 1960s, at about the time that Garnett was extricating himself from the BBC, he and Clive Goodwin, a radical theatrical agent, publisher and critic, met regularly to talk about politics in the aftermath of May '68. This rapidly expanded to include other friends and colleagues, who were anxious to open up political territory to the left of the Labour Party that was not occupied by the Communists. This was essentially the same project as an earlier generation of post-war socialist intellectuals, 'New Left' writers and thinkers such as Raymond Williams and the historian E.P. Thompson, but pursued in a new, more openly militant context. Garnett offered a room at his offices, where he was also living, for regular open meetings on a Friday night. As Garnett explained:

I said we will have regular meetings and we will invite speakers, particularly to the left of the Labour Party, to come and speak, and anybody can come and I'll just lay on a few drinks ... So we asked the IMG [International Marxist Group], and Tariq [Ali] came once or twice – all sorts of people came ... Ronnie Lang was there [R.D. Laing, the radical psychotherapist], Ken Tynan used to come.[1]

At about the same time, Garnett was working with Ken Loach and writer Jim Allen on *The Big Flame*. As part of Garnett's customary exhaustive research methods, he was introduced to Gerry Healy, leader of the Workers Revolutionary Party (WRP), a small Trotskyist political group. After a while, Healy also came to the meetings, and, in Garnett's recollection, soon began to take over: '[after] three or four weeks [Healy] had totally dominated the proceedings and more or less driven away other political elements, and he was holding court mesmerising a lot of people – and then started to recruit from those meetings'.[2] Marginalised on the post-war British left by the Soviet-dominated Communist Party, Trotskyism emerged in the late 1960s and 1970s to bid for leadership of the non-Labour, anti-Soviet Marxist Left, both within the Labour movement more broadly (Trotskyists were active in the Union movement, especially at shop-floor level, and prominent in the industrial struggles of the early 1970s) and amongst intellectuals. The attraction of Trotskyism was partly the appeal of Trotsky himself. One of the original creators of the Bolshevik revolution in Russia in 1917, but persecuted and martyred on Stalin's orders in 1940, Trotsky's reputation was not contaminated by the perceived failure of Soviet communism. Also, Trotskyist groups, though small, had clear roots in the working class. Both these factors made Trotskyism attractive to intellectuals, often, like Garnett, of working-class origin, politically aligned with the traditional politics of the working-class, but now removed from their origins by education and profession. The Trotskyist analysis was clear: the collapse of consensus was perceived as a crisis of capitalism, to which industrial struggle, rising inflation and economic collapse bore daily witness; the working classes, newly militant and prepared to take action, required leadership, which the Party would provide. Amongst the many recruits from the ranks of the media and theatre were Roger Smith, Garnett's mentor in his days as a script editor at the BBC, and Roy Battersby, a television director and regular collaborator of Garnett's, both of whom became full-time organisers for the WRP.

Garnett, like many others at the time, was influenced by the analysis of the political and economic crisis that Healey and other Trotskyists were offering, but (also like most others) never became a member of the

WRP, maintaining a respectful distance. Reflecting on this period recently, Garnett argued that the main difference between himself and Healey was that he had 'never been a Bolshevik, and he [Healy] was a Bolshevik. I have always been something that he despised, which is a democratic socialist, and that was always something that kept us apart'. The issue for Garnett was the role of the party, which, as the Soviet example demonstrated, 'ends up substituting itself for the class ... [the party] may be very good for discipline and as a means for getting power, but is very dangerous afterwards for wielding power ... I worry about Bolshevism turning into intolerance and tyranny'.[3] There was more than just a personal disagreement at issue here, however, since the fault line between Bolshevism (Trotskyism) and democratic socialism is one that runs through post-war left politics and much of Garnett's work for television in the 1970s.

Another take on these times was provided by Trevor Griffiths in his 1973 play for the National Theatre, *The Party*. Set in the London home of Jo Shawcross, a radical television producer, as the events of May '68 are unfolding on large television screens, the play dramatises a meeting of left-wing intellectuals, much like the ones Garnett hosted (Shawcross was said to be based on Garnett). At the centre of *The Party* is a set piece confrontation between a protagonist of the student revolutionary left, Andrew Ford, and a Healy-like figure, John Tagg, who defends the revolutionary potential of the working class in the terms of the Trotskyist left. Underpinning the political debate lie the political anxieties of intellectuals like Jo, newly-liberated from his northern working class origins yet seeking a connection to the revolutionary politics of the working-class, and uncertain of the validity or radicalism of his work. The particular complexion of Jo's anxieties are Griffith's invention rather than a description of Garnett's, but the dilemma the play poses for radicals working in the media at the time was widely shared: was it possible to work creatively and politically within the media, especially the BBC, and not become contaminated by, and incorporated into, the ideologies of the ruling elites? The question was not a rhetorical one, since the day-to-day business of producing frequently posed the dilemma in an immediate form.

Kestrel Productions

Kestrel Productions was the first independent drama production company in British television, and had its origins in the shake-up that followed the re-franchising of commercial television in 1967. As a

result of a desire to make the commercial sector less London-centric, the London franchise was split into two, with the weekend schedules being awarded to the London Weekend Consortium, later London Weekend Television (LWT). LWT was distinctive, being the brainchild of some of the leading figures of the liberal, not to say high-brow, wing of British broadcasting. Established by David Frost and Clive Irving, LWT soon attracted many high-profile and well-regarded figures, some from the BBC, including Michael Peacock (then Controller of BBC1). LWT's ambitions lay in the high-quality, prestige end of the programming spectrum, with an emphasis on the traditional arts and culture, prestige drama and documentaries. It is not surprising, therefore, that LWT looked to replicate the success of the Wednesday Play by recruiting some of the key figures associated with it – notably Garnett and Kenith Trodd.

LWT first approached Garnett and Trodd separately in 1968. Without any real expectation that the suggestion would be accepted, they proposed that LWT take them on, not as single salaried producers, but as an 'autonomous collective' (Cook 1995: 62) that would include others, and would negotiate directly with LWT. This audacious manoeuvre was done partly, according to Trodd, to dissuade LWT from pursuing them further; but it also indicated that if this group of known radicals were to lend their names to commercial television there would be a price to be paid in operational freedom and control over program- ming. It was also a logical, if innovatory, consequence of the strategy of working within and against, rather than outside, the broadcasting institutions that both Trodd and Garnett had consistently pursued. To everyone's surprise, LWT agreed to the proposal, and Kestrel Productions was established with an initial group of five members (Garnett and Trodd were joined by James MacTaggart, David Mercer and Clive Goodwin).

Kestrel made seventeen dramas for LWT over the next two years, including plays by Dennis Potter, Colin Welland and Jim Allen. The arrangement, however, did not go as smoothly as Kestrel's founders had hoped. As John Cook has noted, 'In practice, "the Wednesday Play rebels" (as the press dubbed them) encountered just as many restrictions at LWT as they had at the BBC' (Cook 1995: 63). The deal with LWT compelled Kestrel to use the company's studios for most of their productions and record the work on videotape, which seemed a highly retrogressive step for producers who had fought the BBC tenaciously to be allowed to shoot on location and on film. There were also high-profile disagreements over what was acceptable as drama. A film by the revolutionary French film-maker Jean-Luc Godard, *British*

Sounds, part documentary and part polemic, was commissioned by Kestrel for LWT, but withdrawn from the schedules, in an echo of the struggle over *Five Women.* Garnett and Loach also suffered from the increasing nervousness of the LWT management. In 1969, they and Jeremy Sandford were reunited for a commission by LWT on behalf of the charity Save the Children. The charity thought they were getting a sympathetic account of their work with the African poor in Uganda and Kenya. However, the eventual film, *In Black and White,* was critical of what its makers saw as Save the Children's neo-colonial attitude towards indigenous cultures and was withdrawn.

The friction that developed between Kestrel and LWT was indicative of the problems that the latter was facing in general. LWT's flagship programming, seen as increasingly idealistic in the harsher economic climate of the late 1960s, came under fire, as the broadcaster lost ground to the BBC in the competition for audiences and failed to persuade other commercial broadcasters (at home and abroad) to buy its programmes. The Board of LWT reacted by sacking its chief executive, Michael Peacock, in late 1969, and many others went with him. Both Trodd and Garnett, out of personal loyalty to Peacock, and recognising that his removal would lead to a new programming regime, led Kestrel away from the table – and, very quickly, away from television entirely. A period of chaos and uncertainty ensued at LWT, which was not resolved until one Rupert Murdoch, a relative outsider to British broadcasting at this time, was persuaded to join the company's board: by the end of 1971, he had become Managing Director, consolidating, symbolically and actually, the shift to a more commercial, entertainment-driven ethos.

The break with LWT was not as disruptive for Garnett as it had been for others. This was partly because Garnett did not associate himself closely with the LWT deal, but rather pursued film projects for the cinema (*Kes,* (1969); *The Body,* (1970); *Family Life,* (1971) and *Black Jack* (1978)). Kestrel was also a means of maintaining a collaboration with Loach (of the films Garnett produced at Kestrel only *The Body* involved another director, Roy Battersby). After the abortive *In Black and White,* Garnett produced only one film for LWT, *After a Lifetime* (1971) by Neville Smith, with Loach as director (and by the time it was screened, Garnett was working for the BBC once again). The film, shot in colour on locations around Liverpool, concerned the death of a working-class activist (based on Smith's father). There were several reasons why Garnett chose to make films for cinema rather than LWT at this time. There were, as he noted at the time (Bream 1972), certain projects that worked better on the big screen, partly because of the scale and impact

of the image, and partly because, liberal though it was, British television was still constrained by its domestic viewing context and there were some subjects, and some approaches, that were taboo.

The Body, which was a direct response to the counter-cultural preoccupation with sexuality and representation, was a good example of what could *not* be made for television. This loose adaptation of Anthony Smith's book of the same name is a materialist exploration of the human body that utilised both experimental photography and innovative narrative and scripting techniques. As Garnett said at the time, 'all the time we were trying not to detach the body in a physiological, anatomical or biochemical sense, but to place it in the world. The basic assumption is not "I have a body" but "I am a body"' (*Afterimage* 1970: unpaginated). The central strategy of *The Body* was to film the interactions of a group of about 20 people chosen to represent a cross-section of ages, classes and ethnic and racial backgrounds, who had been brought together for the purpose: 'We put them all together and said, "find out about yourselves; look at each other, sniff each other, touch each other and try to get in touch with each other"' (*Afterimage* 1970: unpaginated). The film also used experimental camera techniques that, for the first time, revealed the interior of the human body via a 16 mm camera fitted to a tube and then inserted into a living person: 'One of the exciting things' Garnett noted in a newspaper interview at the time 'is the quality of the film that's come up working with medical specialists and giving them resources they've never had before'(Anon 1970a). This radical experiment proceeded from Garnett's fascination with the technology of film-making. It also produced memorable images, and *The Body* includes both a birth and a death. The film was also controversial in that it showed a heterosexual couple making love.

Garnett's last film for the cinema before his return to the BBC was *Family Life*, a revised version of David Mercer's The Wednesday Play of 1967, *In Two Minds*, directed by Loach. The film was not a happy experience for those who made it, and proved to be a commercial disappointment. Garnett noted later that he had been the driving force behind the project, and Mercer and Loach had gone along with it for his sake; in retrospect, this was a mistake and he should have 'left it alone'.[4] Garnett wanted to take the story to the big screen and an international audience. He also had a personal experience, through a family member, of mental illness at the time. The film told the same story as its television counterpart, but reworked some of the central narrative devices: its central Laingian premise, that the family could destroy as well as nurture its members, remained intact. *Family Life* is a much more conventional

narrative, and the unseen therapist/interviewer of *In Two Minds* is now visible. The play with documentary form and point of view is also absent, and the result is a more straightforward, and didactic, attack on the bourgeois family (singled aptly in the changed title).

There was also a personal reason why Garnett chose to make films at this time. The haemorrhage of experienced personnel from the BBC to LWT had been difficult, especially for those who remained. Garnett, who had fought with nearly everyone at a senior level in the Corporation, felt under obligation to some of them, especially Huw Weldon. Weldon, who was Controller of Programmes at the time, was both an old adversary – especially over *Five Women* – and a firm supporter, for whom Garnett had both affection and respect. 'Huw and I got on very well personally,' he reflected later 'we were chalk and cheese, but I loved him really because he was a man who was vulnerable emotionally ... he was a man who could be hurt, and God save us from those people, particularly management people, who can't be hurt'.[5] Realising that his defection to commercial television would be particularly difficult for Weldon, Garnett agreed that he would not put his name to work done for LWT for two years:

> The main reason why I didn't personally produce anything until towards the end of the two years [1969–71] was because I promised Huw I wouldn't. So it was a compromise: I said I was going to set this [Kestrel Productions] up ... but I won't have my name on the screen – he didn't want my name on the screen on ITV, and that really wasn't a problem.[6]

Ideally, Garnett wanted to see his films released in *both* media; 'our attitude is that we want to make films. Television is a way of exhibiting those films and cinema is a way also and we would like our films to be shown in the cinemas and on television' (Orbanz 1977: 63). He had, in fact, sounded out an independent distributor about the possibility of contracting *Cathy Come Home* for a limited theatrical release. This did not progress very far, but as his reputation for producing films on television grew he was approached directly. Contemporary Films, an independent distributor, wrote to Garnett in 1967 to set up a deal to screen *The Lump*. Garnett responded positively, wanting to link this with the theatrical release of *In Two Minds*. He took the proposal to the Head of Productions, Television Enterprises, who, despite Garnett's customary persistence, repeatedly blocked it. The issue was primarily one of BBC policy, dictated by nervousness about being seen to undermine the British film industry. This was a fear that only gradually receded and which seems quaintly groundless in an era of cross-media production.

Kes: social realism and critical naturalism – the development of a political aesthetic

Based on *A Kestrel for a Knave*, a novel by Barry Hines, *Kes* marks a pivotal moment in Garnett's career (the same is true of the careers of its director, Ken Loach, and cinematographer, Chris Menges). It was his first project as producer away from the embrace of the BBC, yet is clearly connected to the social realism that characterised his contribution to The Wednesday Play. It was also a means of continuing his highly productive collaboration with Ken Loach, but in a new context, outside the tight deadlines and small budgets of television drama of the time. *Kes* was developed in much the same way that Garnett's BBC projects had been, in that it was scripted by Hines in collaboration with Loach and Garnett (who are both credited with Hines as authors of the screenplay), following an approach from Garnett. It was Hines' first novel, *The Blinder*, about football, which first drew Garnett's attention. Hines showed him the manuscript of *A Kestrel for a Knave* and Garnett, with great enthusiasm, then showed it to Loach, who was equally positive. 'It was a terrific piece of writing,' Loach recalled, 'it had a very good balance, it was neat and well-shaped, and everything about it had a rightness' (Fuller 1998: 42).

The story of *Kes* is a simple one, though rich in its social and cultural implications. The film is set in a coal-mining town in the North of England and was made on location in and around Barnsley. It follows the life of one boy, Billy Caspar, who is poised to leave school and enter the workplace. Billy finds and trains a young kestrel – Kes, of the film's title. Much of the film concerns this process, and what Billy, with the help of a book on falconry stolen from a local bookshop, has to do to ensure that the bird is properly trained and looked after. The remainder, which occupies more screen time, follows Billy through the rest of his life – with his family (mother and brother Judd), at school, delivering newspapers on his bike. The narrative concludes when Billy fails to place a bet on a horse for Judd; the horse wins, and Judd, furious, kills the bird in revenge.

In one sense, *Kes* was not an easy film to produce, as Garnett was attempting to secure finance at a time when Hollywood's temporary flirtation with the British film industry was coming to an end. Eventually, the film was made with support from United Artists via Woodfall, an independent British production company established by Tony Richardson and John Osborne. Woodfall had made many of the British 'New Wave' of social realist films in the late 1950s and early 1960s and acted as a provider of British-made independent films to

United Artists for the international market. The budget of £157,000 was, for United Artists, minimal (though it was considerably more than the budgets that Loach and Garnett had at their disposal at the BBC). This meant that the film slipped below the radar and producer and director received little interference. However, the studio was not sure what it had got, or what to do with the final product. Reflecting on this at the time of the film's re-release some thirty years later, Garnett noted the response of an executive at a private screening, who snarled that he 'would have preferred it in Hungarian'(Ojumu 1999). UK distribution was eventually secured through the Rank Organisation, which initially refused to grant it a national release. Rank's reluctance, which echoes the problems faced by much social realism when it is exposed to the commercial logic of national and international distribution, came from its judgement that the film was so densely local that it would not have an appeal – would not, literally, be understood – outside of the North of England. Garnett argued furiously with Rank in private and went public with a much-publicised screening for a handpicked audience that put Rank on the defensive (it was a tactic that, with variations, he would use when other projects were threatened in the 1970s). Rank gave way, and the film was successful, both critically and commercially.

Kes (1969) is arguably the most achieved result of Garnett's long-term collaboration with Ken Loach. In several important ways *Kes*, as Leigh (2002) has argued, marked a significant change in Loach's approach to filming – and a new stage in his collaboration with Garnett – signalling the end of their more Brechtian phase. The aesthetic he developed in *Kes* became characteristic of his subsequent work, and can be traced to his discussions with Garnett and his collaboration with his cinematographer, Chris Menges. Menges had recently worked with, and been very influenced by, Miroslav Ondricek, on Lindsay Anderson's *If...* (1968). Ondricek had shot Milos Forman's *Loves of a Blonde* (1965), one of Loach's favourite films, and was a direct link to the Czech New Wave. Loach characterises the results of this collaboration thus:

> [We] decided that the effort shouldn't be to make the camera do all the work, but should be to make what is in front of the camera as authentic and truthful as possible. The camera's job was to record it in a sympathetic way and to be unobtrusive, not to be slick. So when we came to do *Kes*, there was a conscious move away from newsreely, chasing kind of photography to a more reflective, observed, sympathetically lit style of photography. (Fuller 1998: 39)

This was achieved by the use of a long-focus lens that allowed the camera to follow, discover and frame the action in a medium close shot,

and an approach to lighting that was both as natural as possible, as close to how it would be in reality, and which focused on the space itself rather than the shot. This, in turn, freed the actors from the necessity of obeying the normal requirement to 'hit the mark' (that is, find a pre-determined spot within a composed frame), and 'liberated them to move about at will' (*ibid.*). This approach to film-making is one that foregrounds the actor/character rather than the shot, and has become an integral part of Loach's characteristic approach to social realism – indeed, it has defined his film style ever since. Although it is most often associated with Loach, the same observational approach to filming is apparent in much of Garnett's subsequent work as well. This is apparent in his films as director and writer as well as producer (*Prostitute* and *Handgun*). It is also the main approach adopted – though often explored through rather different specific 'looks' – in the popular drama series he has originated with World Productions since the 1990s (see Chapter 4).

Acting, and working with actors, is central to Garnett and Loach's approach. It is often remarked that Loach uses 'non-actors' in his films (and not only those made with Garnett), but this needs qualifying. Often it is simply that the actors used are not well-known. In the realist series produced by Garnett for World Productions, for example, Garnett is reluctant to use actors that the audience might recognise, and who might be associated with a particular role, or type of role (World uses well-known faces for other of its dramas). The critical response to the performances of non-professional actors is sometimes to regard acting as one aspect of the authenticating processes of the film; that is, semi-improvised and occasionally overlapping and/or inaudible dialogue, ambient sound, an anti-dramatic and unstructured delivery of text and physical awkwardness are seen as a means by which 'realism' is signalled and conventionalised. It is important to be reminded that reality does not 'speak for itself' but is always coded and mediated by the rules of dramatic form. However, this is only part of what is at stake, since the reality of what is presented for mediation is also affected by the kind of actor used. At the time *Kes* was filmed, Loach and Garnett showed a certain wariness towards professionally trained actors, arguing that the kind of film they wanted to make required the actor to represent a 'truth' that could not normally be accessed by the techniques of the professional actor, no matter how much research was conducted, or how far he/she tried to 'live' the part. The problem is more acute on screen, since the camera catches the detail of performance, especially what is revealed through the human face. As Garnett has argued, the most interesting landscape in any film is the human face,[7] and inauthenticity betrays itself there first. 'We try

to get people who can draw on their own lives, on their experience,' Loach argued, 'so they bring it in, so they're not emoting, not a blank sheet of paper on which you and they write the part' (Levin 1971: 99).

Casting actors who can bring their own social and personal experience to bear suggests a deliberate blurring of the distinction between acting a part and representing a real experience: the character becomes a way of framing and articulating personal experience, and 'by revealing themselves, [actors] reveal the character' within 'the life of the script'.[8] The resulting performance brings additional layers of meaning to the film and, in its 'naturalness', seeks to guarantee its truth. Professionally trained actors, often required to play parts that are beyond their social experience, find this difficult, especially if they are of a class that is not that of the character (neither Loach nor Garnett cast actors out of their social class). This is not hostility to actors per se, but suggests that more than professional skill is required.

One result has been the casting of people who are not actors in roles that are close to the people they play. This is true of the cast of *Kes* (with the exception of Colin Welland, who played Mr Farthing, a sympathetic teacher, and who was familiar to British audiences from his appearance in *Z Cars*). Dai Bradley, who played Billy, was a pupil from a local school; the head teacher, Mr Gryce, was a local head teacher, and Brian Glover, who played Sugden, the games teacher, was a teacher at another school (and a part-time wrestler). Billy's mum and brother (Lynne Perrie and Freddie Fletcher) were local club entertainers, and Loach and Garnett (independently and together) have often looked to performers from the variety and club circuits. The problem was partly one of Equity restrictions, which constrained their ability to cast their films as they wanted (a particularly acute problem for left-wing film-makers with an ideological allegiance to the Trade Union movement). Club performers, however, were Equity members and were usually of the same class as the characters they were portraying, and understood performance (their comic skills are often of particular use).

Kes marks, therefore, a key moment in the development of a social realist film aesthetic with considerable ideological and political implications as well. In turning the camera into a 'sympathetic observer', Garnett and Loach used an approach to story-telling and to the detail of the everyday lives being caught on screen that could be related to both contemporary left politics and to naturalism in its historical and political senses. It is possible to argue that *Kes* sits not only within the broad stream of social realism, but also within the narrower tributary of critical naturalism. As Raymond Williams has argued (1977 and 1981), naturalism may be seen as either a synonym

for realism (especially in its nineteenth-century manifestations) or as a distinctive variation within the general realist movement, one which emphasises the way that social environment shapes and determines the actions of individuals. There is not the space here to unpick what are complex and lengthy arguments, but this second sense of naturalism is the more productive, since it links the observational style to a politics, capturing the way that *Kes* places its characters within a web of constraining social forces made manifest in the institutions and practices of school and work. As Deborah Knight (1997: 64) argues, naturalism adopts 'third person', observational narratives that avoid dramatic excess and emotional hyperbole and often deny emotional identification and release. It is a narrative stance that aspires to objectivity, since it denies any privileged access to a subjective point of view (Knight 1997: 72). As in most naturalism, the social reality of *Kes* is represented, not in terms of subterranean shifts and hidden, long-term social and economic forces, but rather in its surface appearances, caught at the level of the everyday. Garnett commented on the politics of this approach at the end of the 1970s:

> We're interested in conveying what it's like to live the life of the boy in *Kes* ... The left often forgets to attend to the living details of working-class life. In our films, however, we see a fidelity to the texture of the everyday as an act of political respect and solidarity. (Quart 1980: 28)

Fidelity to the everyday links to both a specifically naturalist approach and to the politics of social extension, since the everyday reality to which *Kes* bears witness is one that is normally hidden from view, unobserved and unremarked amidst post-war affluence. It is also a reality that is both concrete and detailed, there 'for itself', and which metonymically stands in for a complex social world.

Garnett, Loach and Hines were unanimous that *Kes* was not simply about Billy and his kestrel. Billy Caspar stands in for others like him, a representative of a class and, more specifically, of many young, working-class people leaving school with few prospects, products of a system that requires nothing more from them. As Garnett explains:

> The sub-text ... was really the seventy per cent of the kids of this country thrown onto the scrap heap at fifteen, which is a very sad situation, not in economic terms, but in human terms. We have a terrible education system from top to bottom. The majority of kids are taught the bare necessities to be thrown onto the labour market, and this little lad is really one of those, so we thought it would be a good idea to do a film about that. But not explicitly about that, except that we were informed by that social attitude. (*Afterimage* 1970 unpaginated)

It might seem an odd thing to claim that Billy is a representative of a class, since raising a kestrel is not typical, in the sense that it is not usual. (It is possible to read *Kes* as being about a boy who is 'exceptional', and the original cinema trailer picked Billy out as 'not like one of the others', placing the film in a familiar generic framework.) In fact, the film plays with different levels of typicality. Billy is, in one sense, a 'statistical average', who is in no important sense different from others in the densely realised world that the film creates (a common strategy within naturalist narratives). This is established by the everyday activities that he engages in – delivering newspapers, talking to the milkman, going to school – and which occupy much of the early part of the film. It is also evident in the way that he is treated by the figures of authority with whom he comes into daily contact; the owner of the newsagents, for whom Billy works, for example, and his head teacher both treat him as a representative of a resentful, and resented, youth. The path that is mapped out for Billy on leaving school, and which is to be taken by all his friends, is made clear in the first scene, even before the credits have rolled. Rousing his brother from the bed that they share, Billy is reminded that 'in a few weeks, you'll be getting up with me' to go down the pits. To leave school, however, is not seen as a new challenge so much as the next stage in pre-determined process, and a later sequence juxtaposes Jud walking to work in the mines with Billy in the school assembly in a way that invites comparison.

In other ways, *Kes* wants to challenge the typicality that is thrust upon its protagonist. Billy's point of view is privileged, and there are many examples of him asserting his individuality (not always in approved ways; he steals chocolate from his employer and milk from the milkman). By placing the narrative alongside Billy, as it were, Loach allows us to see events from his point of view, and this is a narrative strategy – and, indeed, a political strategy – that is common to several Loach/Garnett films from *Cathy Come Home* onwards (and in many of Loach's films since). We are also allowed to see events, and hear conversations, that other adults are not privy to, and the aspirations as well as the humour of Billy's school friends are foregrounded. In this context, the training of the kestrel, far from being untypical, is an example of Billy's imagination and that of his social class. A sympathetic teacher, Farthing, makes Billy talk to his classmates about Kes and how he trained him. The attentive questioning that he receives is one of the few times in the film that young people are allowed to show real creativity and enthusiasm; they may tease Billy, but at this point they understand what motivates him and seem to recognise it in themselves.

The ending of *Kes* seems to fulfil the inescapable logic of late nineteenth-century realism, or 'high naturalism' in Williams' terms, in that it ends in defeat for its protagonist, crushed by the forces of environmental determinism. However, it also seems to resist this – though this may seem to an odd thing to say if one simply describes the ending. The final sequence is shot in mid- or long-shot, without the editorial accompaniment of music and with no clear emotional response from Billy himself; in denying his emotional release, the film-makers have also prevented ours, and our distance from the event works against reading the death in metaphorical terms. The ending is not, therefore, simply a bleak defeat, and the knowledge of Billy that we have acquired through the film is not obliterated by a single act. In this way, the film is clearly materialist, anchoring its characters' situations in an inescapable social and economic system, but avoids the impasse of deterministic defeat.

'Still the best firm in the world': back to the BBC

Garnett was not the only radical figure to leave the Corporation in the late 1960s. Peter Watkins had not made any films for the BBC since the banning of *The War Game*, and John McGrath had left the BBC, stopped writing film scripts and had embarked on a career in alternative theatre by the end of the 1960s (with the 7:84 theatre company England and its sister company in Scotland) (see MacGrath 1981). The preference for alternatives – to established institutions, hierarchical working practices and bourgeois audiences – was particularly strong in the theatre, but reflected a wider Zeitgeist. Kestrel Productions was one manifestation of the attempt to find a 'middle way' between the institutions of mainstream commercial production and opting out altogether. Kestrel relied on established sources of finance, including the major studios, and its members were committed to working in the mainstream of both cinema and television, aware of the limitations of independence. An independent film company can be 'quicker on the punch' as Garnett once put it, able to respond to audiences' tastes more rapidly than the major studios, but it could never be 'harder on the punch' (*Afterimage* 1970: unpaginated). This was not just a question of financial viability but of challenging some of the main tenets of commercial film-making. Both Garnett and Loach were acutely aware of cinema as a capitalist enterprise, subject to the same pressures towards monopoly and commodification as other forms of capitalist industry (see Bream 1972 and Orbanz 1977).

Dominant film genres are, from this perspective, a means of maximising audiences, and one that was failing. Independent companies like Kestrel could provide a source of renewal by outflanking the conservatism of the studios and connecting directly with audiences in new ways. The success of *Kes* was a good example of one way in which this might happen. Success, however, was not guaranteed: as Garnett noted at the time, 'the categories are shrinking all the time ... it's really only possible to get films set up which fall within these categories ... The category I'm sure they had in mind for *Kes* was a children's film' (Bream 1972). At the time he said this, Garnett was about to rejoin the BBC: despite his efforts to make accessible and political films, it was television that gave him the popular audience.

By the end of 1969, with the contract between Kestrel and LWT summarily ended, Garnett was back in negotiation with the BBC. An article in *The Times* in early January noted that Garnett had been 'talking terms' with Shaun Sutton, the recently appointed Head of Drama (Anon 1970b). It was clear at this early stage that this did not mean the end of Garnett's ambition to continue making films for the cinema, nor the necessary end of Kestrel, but that he wanted to 'keep one foot in TV' (*ibid.*). Interviewed a short time later, Garnett reiterated the point: 'I'm hoping to divide the next couple of years into making films both for the cinema and television ... our television films are easily as important to us as our cinema films' (Bream 1972: 37). As in the 1960s, Garnett did not become a staff producer but negotiated a contract to produce a specified number of films per year for each of the BBC channels, an arrangement designed to maintain a measure of independence from the Corporation. In practice, nearly all of Garnett's work in the decade was for the BBC, with only *Black Jack* (1978), Garnett's last collaboration with Ken Loach, and *Prostitute* (1980), which he also directed, produced for Kestrel for theatrical release.

Garnett's return to the BBC was propelled by an increasingly political analysis of the way the Corporation was operating under the pressures of declining revenue and a colder political climate. Garnett continued to argue that the BBC was 'the best firm in the world' (Levin 1971: 104), whilst at the same time confronting the Corporation on a number of fronts. The BBC's status as a public corporation, free from the requirement to return a profit and with a certain legislative and cultural distance from the state, he maintained, allowed those within it a space not possible elsewhere. Garnett articulated this clearly in an interview in 1971, which roots the analysis in the politics of power and class:

[A]s a public institution, although it is tied very closely to the state, and is governed by the state just as is every other public corporation in the world, there is a liberal tradition in this country which is sustained – except in times of danger to the system – and reflects the security that the ruling class in this country has compared with a lot of other countries ... And part of the genius of the British ruling classes, feeling as secure as they have, is to allow an institution like the BBC to develop seemingly independent of the executive, although it isn't at all. (Levin 1971: 104)

The BBC, like other institutions, could also buy off its critics: 'You can be promoted out of trouble, and cosseted out of trouble, and flattered out of trouble, and materially rewarded out of trouble, and it's a delicate system of checks and balances that works' (*ibid.*). Indeed, as Rolinson has pointed out (2005: 85), the BBC was proud of its noisy, radical fringe, seeing in their tolerance proof of its own virility. Only in times of crisis – and it seemed at times as though the early 1970s were in perpetual crisis – were the true power relationships revealed – 'the iron fist within the velvet glove' (Levin 1971).

The BBC was, in this analysis, not an ideological monolith, nor a univocal carrier of the values of the establishment – any more than other media institutions or organs of the welfare state. It was possible to create radical, if not revolutionary, work – to intervene ideologically and politically as well as aesthetically – provided one was prepared to accept certain limitations, particularly with regard to form. Trevor Griffiths once again provides a close parallel, occupying the same general position on the cultural left as Garnett and with the same commitment to realism. 'I simply cannot understand socialist playwrights who do not devote most of their time to television ... It's thunderingly exciting to be able to talk to large numbers of people in the working class, and I just can't understand why everybody doesn't want to do it' (quoted in Wolff 1978: 57). For both Griffiths and Garnett, the struggle was for 'the popular imagination, which has been shaped by Naturalism. I am not interested in talking to 38 students in a cellar in Soho. It's my guess that we still have to handle realism' (*ibid.*). The approach, which Griffiths called 'strategic penetration', meant using whatever political space could be won from the broadcasters to take the struggle to the mass audience. Like Griffiths, Garnett has always been committed, artistically and politically, to seeking popular audiences within the mainstream: 'Our ambition always' he has argued 'has been to try to do serious work and make the work available to a very large audience' (Bream 1972: 39). Neither he nor Loach were tempted to work in the underground independent networks of the early 1970s, committed to

radical and often difficult and experimental work; 'if you make underground films' he argued in the mid-70s, 'you are in danger of making inadequate films, and you're showing them to your friends who are convinced anyway' (Orbanz 1977: 63). Or as he put it as he was about to return to the BBC: 'Why should the devil have all the best resources?' (Levin 1971: 109).

Although it is often the collaborations with Loach and writer Jim Allen that receive the most attention, he produced a range of films with different directors and writers. This included a Brecht adaptation, *The Gangster Show: The Resistible Rise of Arturo Ui* (1972, directed by Jack Gold, adapted by George Tabori); Mike Leigh's first work for television as director and devisor, *Hard Labour* (1973) and *Five Minute Films* (1975); three other projects with director/devisors Les Blair, *Blooming Youth* (1973) and *The Enemy Within* (1974), and Brian Parker, *Stephen* (1974); the four-part *Days of Hope* (1975) with Loach and Allen; a further collaboration with Allen, *Spongers* (1978, directed by Roland Joffe); and a two-part film reuniting the team that made *Kes*, *The Price of Coal* (1977, director Ken Loach, writer Barry Hines). Garnett's last project for the BBC in the decade was the four-part *Law and Order* (1978, director Les Blair, writer G.F. Newman). This work was almost exclusively social realist, in one form or another, although there is a variety of theme and approach, including experimental devised work with actors pioneered by Mike Leigh and Les Blair. There are also signs of what was to mark out Garnett's work on his return to British television in the 1990s; a movement away from the single play/film towards long form drama.

The single play continued to enjoy a high profile in the decade, despite economic recession, diminishing budgets at the BBC and political turmoil (this was a stimulus to many). The BBC continued to be the main source of single dramas and of high-profile, authored drama generally. The Wednesday Play ended in May 1970, and its successor, Play for Today (the name change necessitated by a switch to transmission on Thursdays), was widely perceived to have continued the tradition of radical and challenging drama, both in film and studio form. There was, for example, a strand of formal as well as thematic experiment evident in Dennis Potter's *Blue Remembered Hills* (1979) and John McGrath's *The Cheviot, the Stag and the Black, Black Oil* (1974). Contemporary and political drama continued throughout the decade, despite political controversy, achieving a visibility in public debate out of proportion to the number of plays/films produced. In addition to *The Big Flame, Days of Hope, The Price of Coal* and *Spongers*, Play for Today screened Jim Allen's *Rank and File* (1971) and *United Kingdom* (1981); Trevor Griffiths' *Through the Night* (1975), *Comedians*

(1979) and *Country* (1981); David Hare's *Licking Hitler* (1978); John McGrath's *The Cheviot, the Stag and the Black, Black Oil* (1974); and David Edgar's *Destiny* (1978). This list is not exhaustive, though it includes the most obviously political dramas of the anthology series, and indicates that the single play anthology series continued to provide the kind of political and creative space for both writers and directors that it had in the previous decade

ITV, meanwhile, dropped Armchair Theatre, its celebrated single play strand, in 1971, and replaced it with the very popular and enduring drama series *Upstairs Downstairs* (LWT 1971–75). It was both a symbolic and actual victory of the serial form over the single play; the latter might still obtain high viewing figures (Jeremy Sandford's *Edna the Inebriate Woman* (BBC 1971) gained an audience of ten million), but success for the commercial broadcasters was increasingly being measured against the appeal of popular drama series, which regularly attracted audiences of over fifteen million. However, the potential of drama series to explore controversial and political material was demonstrated by Trevor Griffiths' *Bill Brand* (Thames 1976), a thirteen-part series about a left-wing Labour MP that used the series form to focus on the relationship between the private and the political in the context of a contemporary parliamentary soap-opera.

Politics and institutional practice

Radical television drama did not go uncontested, however, and there were high-profile cases of dramas being challenged across the media and other public discourses, and in some cases withdrawn from the schedules before screening. This was the fate of Potter's *Brimstone and Treacle* (BBC 1976) and of *Scum* (BBC 1977), written by Roy Minton and directed by Alan Clarke (see Cooke 2003). The banning of these plays was not an isolated event; indeed, it can be seen as the most extreme example of the increasingly charged and sometimes hostile relationship between the BBC and its more radical practitioners.

Although the most visible struggles were waged over programmes that had already been made, there were battles of no less importance being fought within the institution over who would make those programmes. Although it was suspected in the 1970s, it was not until the mid-1980s that it became public that the BBC, in determining who and on what terms it would employ people, was in collusion with the British state security services, MI5.[9] Security vetting was established at the BBC in 1937 as part of the preparations for a possible war. It was

done with the active support of Sir John Reith, the first Director-General and main architect of BBC policy, and its aim was to control access to 'sensitive' security information. The process continued after the War and became formalised in employment policy:

> All BBC employees had a personnel file which included their basic personal details and work record. But there was also a second file. This included 'security information' collected by Special Branch and MI5, who have always kept political surveillance on 'subversives in the media'. If a staff member was shortlisted for a job this second file was handed to the department head who had to sign for it. The file was a buff folder with a round red sticker, stamped with the legend 'SECRET' and a symbol which looked like a Christmas tree. On the basis of the information in this file, the Personnel Office recommended whether the person in question should be given the job or not. (Hollingsworth and Norton-Taylor 1988: 99)

'Security information' was a euphemism for political affiliation, since few of those who were singled out for attention had any real access to sensitive material. In the conspiracy-ridden climate of the 1970s, MI5 focused increasingly on high-profile radicals in the Drama Department. As Hollingsworth and Norton-Taylor pointed out, 'MI5 reserved their strongest objections to BBC drama producers in the early and mid-1970s [and] By the mid-1970s MI5 and the Personnel Department were clearly out to purge the BBC's radical dramatists' (1988: 114–15). Evidence consisted of known or suspected political affiliation to subversive or revolutionary groups, and attendance at WRP meetings and the Friday-night gatherings at Garnett's flat were seen as proof enough of this.

Garnett, as one of the most vocal of the radical figures working in the BBC, was an obvious target. In 1970 his contract to return to the BBC was delayed, and, according to Shaun Sutton, questions were raised by a Personnel Officer, who complained that he was too 'left wing' – an objection which Sutton brushed aside. Other people were not so lucky; Roy Battersby was effectively a 'marked man for thirteen years' (1988: 116), his contracts as a freelance director repeatedly challenged from 1972 to 1985 (when the system was abandoned after being exposed by the *Observer*). Ken Trodd also faced problems, and his freelance contract with the Corporation was terminated in 1976 (Trodd himself has since said that he thought the security officers had confused him with Roy Battersby[10]). It was only after the intervention of the Head of Plays, James Cellan-Jones, that the contract was pushed through.

As a producer, Garnett was both the target of security vetting and a defender of people being vetted. On one notable occasion, the director Roland Joffe, whom Garnett had appointed to direct Jim Allen's *The*

Spongers in 1977, suffered the inevitable delays to his contract. Garnett was summoned to Sutton's office where he was informed that Joffe was a 'security problem'. Furious, Garnett went directly to Alasdair Milne, the Managing Director of BBC Television, threatening to resign and go public if Joffe was not employed. The battle lines were clear, and Garnett demanded to be able to exercise his right as a producer to employ who he chose. Milne, and then Sutton, capitulated.

Security vetting exposed the vulnerability of the BBC when faced with the power of the state, and seemed to prove right those who had always argued that the Corporation was in the pockets of successive governments. Even when the exact procedures were not known, those who suffered at the hands of vetting, or were charged with dealing with its consequences, were aware of the pressure being exerted. However, many executives – especially within the Drama Department – successfully defended those whom the security services targeted. Like Garnett, both Cellan Jones and his predecessor Christopher Morahan won many of their respective battles with those above them, as did Shaun Sutton, the Head of Drama, with those above him. The pressures were real, but it was sometimes possible to resist them.

New collaborations, new methods: devised work with Mike Leigh, Les Blair and Brian Parker

Although Garnett's work with Loach and Allen gave him the most visibility in the 1970s he continued to nurture other collaborations and to develop new ways of working, repeating a pattern begun at the BBC in 1966–68. During the mid-1970s, Garnett began a series of projects with writer/directors new to television that explored the possibilities of devised work within the conventions and practices of television drama. In 1973, Garnett produced the first television play by Mike Leigh as devisor and director, *Hard Labour*. The film has Leigh's trademark ensemble cast, which includes Alison Steadman, Bernard Hill and Ben Kingsley, but centres on one character, Mrs Thornley (Liz Smith), a Salford housewife who works as a cleaner. 'Mrs T' is largely silent, seemingly a passive victim, who is bullied by her needy and inarticulate husband and exploited by her employer, in a narrative that shows relationships that are shaped by economic dependency rather than emotional belonging. Leigh and Garnett went on to make a series of *Five Minute Films* in 1975, conceived as observations on everyday situations and relationships and designed to be dotted around the

schedules. The concept, although supported by Garnett and the Head of Plays, Christopher Morahan, was not popular elsewhere in the BBC, and the films were not broadcast until 1982.The titles – for example, *Old Chums* and *Probation* – suggest the subjects.

In 1973, Garnett also produced *Blooming Youth* with Les Blair as devisor and director, which, in a deadpan, observational style, followed the inconsequential interactions of a group of students at a northern university. A year later, Blair and Garnett collaborated on *The Enemy Within*, a film set in a Midlands comprehensive school in which the everyday routines of school life are structured around the conflict between a reactionary, Christian women teacher (Elizabeth Choice) and a young, male socialist housemaster (Christopher Martin). In 1974, Garnett collaborated with Brian Parker on *Stephen*, a play about the economic and emotional struggles of a child with learning disabilities and his mother.

Both Leigh and Blair (who had been friends since childhood) began their careers in the theatre. Leigh trained as an actor at RADA in the early 1960s and attended a course at the London Film School (Clements, 1983, and Coveney, 1996). He had already begun to develop the particular brand of actor-centred improvisational drama that would become his hallmark when Garnett encountered him through his first film, *Bleak Moments* (1971), and the play it was based on. Garnett was an early supporter of Leigh's work, writing on his behalf to Huw Weldon, Controller of BBC Television, when Leigh had been turned down for a trainee directorship with the Corporation. Garnett also intervened directly with Albert Finney, whose Memorial Films provided most of the funding for *Bleak Moments*, to make up a last-minute budget shortfall. 'I could see that [Leigh] would never be able to do what he wants to do in the cinema,' Garnett later said, 'I knew nothing would happen for him until he got established. So I decided to give him one of my last available slots' (Coveney 1996: 89). It was a perceptive comment, since it was only after Leigh had established a substantial reputation on television that he was able to build a career in cinema.

Blair had studied at Liverpool University, attended the London Film School along with Leigh, acted in several of his improvisational plays and produced and edited *Bleak Moments*. 'I'd phoned Tony Garnett when we were looking for money,' Blair later said in interview, 'Mike got to know him, and Tony had asked Mike to do *Hard Labour*. Tony saw an improvised lunch-time show I was doing and asked me later if I was interested in doing anything on the telly, and *Blooming Youth* resulted' (Madden 1976: unpaginated). Parker, a writer, had approached Garnett with the idea for *Stephen*.

What marks out these collaborations from others is that they were with newcomers to television and that there was no pre-existing script. The mechanics of commissioning and developing a drama project at the BBC (and elsewhere) nearly always required a script as guarantor of the nature and quality of the eventual product, particularly if the author/originator was unknown. That Garnett was allowed to proceed is an indication both of his status within the Drama Department and that the commissioning procedures were still relatively open (for him at least). Garnett later caught this openness in an anecdote:

> There was a young film-maker called Mike Leigh, and I thought I could give him and Les Blair a kick start. When the Head of Plays [Gerald Savoury], the head of department, asked me what I was doing, I told him, 'I'm doing a couple of films with these two lads.' 'What!' he exclaimed, 'Who's done the script?' 'Well, there's no script,' I said. When he wanted to know what it was about I replied, 'They just work it up with the actors, and you don't know until you make it.' So he asked 'Who's in it?' 'Nobody you've ever heard of!' But I was allowed to do it. (Garnett 2001: 77)

Although devised drama was becoming increasingly common in the theatre, all four films were experimental in television terms, exploring an approach to actor-centred improvisation that became associated particularly with Leigh. Les Blair describes the process of creating *Blooming Youth* as a series of encounters between him and the actors:

> A rehearsal becomes a long series of private chats between me and each actor, where we hammer out what's going on in that character's mind and how he might react to one thing or another ... So I'm looking at things which are going to be interesting to use and at the same time making my own assessment of the validity of what's happening. (Madden 1976: unpaginated)

The development of *Stephen* relied even less on a written script, which was only produced as a transcript from the film a week before screening. The narrative was not fixed until shooting began, by which point 'the scenes were decided, the part of each character had been plotted, but no lines had been fixed' (Bakewell 1974: 755). Three weeks before the filming of *The Enemy Within*, the entire crew (including Garnett) went to Birmingham and attended the school where the film was shot as part of the research process; 'the actor playing the French master taught French. Garnett himself taught economics'. (Bakewell 1974: 755).

In many ways, however, the devised television play as represented in these Garnett-led collaborations is a logical extension of the ways of working that Garnett had developed with Loach and others since 1965, and occupied some of the same thematic territory. Garnett, like Loach, contributed directly to the development of the scripts he worked on, subsuming the role of script editor into that of producer, as we have seen. The improvised play marked a further dispersal of the authorial function amongst the production team, with the actors now assuming a key role in the development of the script. Although there is no single devising 'method' linking these films, Garnett occupied a similar role in all four projects, instigating the research process as well as controlling the budgets, and acting as a guide and sounding board for inexperienced directors. 'Tony Garnett's whole thing is to create the set-up which is going to let you get what you want from everyone, and he'll stick by that' Blair observed. 'He's great at creating an environment for you to do things in' (Madden 1976: unpaginated).

Devised work of this kind, which is so clearly on the territory of the everyday and the unremarkable, tends towards naturalism, in several senses in which the term has been used here. The observational film style, with the camera seeming to record and document the action rather than create it, was one of Garnett's contributions, which is another link to other work. The narratives also tend towards the behaviourist model outlined by Knight (1997), being non-interventionist and descriptive. The approach to acting in Leigh's work, for example, focuses on character detail which the camera records as 'behaviour', laid out in a densely realised world of aural and physical detail, which is itself a principal carrier of meaning: 'in scene after scene, truth is a product of characters' body language, vocal tones, pacings and timbres' (Carney 2000: 52). As Carney observes, it is also a world that is almost entirely without metaphorical or symbolic significance; characters, sequences and details do not stand in for anything else, but are what they are.

These narratives are also naturalist in that they are often elliptical and episodic, with all the signs of the 'dramatic' stripped out. As Bakewell noted, Garnett's input at the editing stage was to remove anything excessive or 'over the top' (1974: 755). Certainly, the working process produces rich characterisation and an authenticity of emotion and setting rather than a detailed plot and a traditional narrative arc. But the fact that little happens at the level of plot does not mean that nothing happens thematically. The appeal of all four films is that of social realism which aims to counter dominant assumptions about social groups and issues, or bring hitherto unremarked social experience into the light. *Stephen* explores the particular difficulties of

surviving on a low income with a mentally disabled child. It was remarked by one reviewer that the film's impact lay in the problems the family faced were seen to be social rather than personal and emotional (Bakewell 1974). Blair said of *Blooming Youth* that he was aware of countering a prevailing view of student life, which was bound by stereotypes of pre-war Oxbridge or of post-'68 student revolution. 'The idea was simply to do something which put students on the screen in a way that I felt made them into people, rather than cardboard characters called students' (Madden 1976: unpaginated). And *Hard Labour*, though it has no discernable story and no final resolution, observes social relationships through the prism of economic dependency and alienation, and the inarticulacy of the characters arises from fear of reprisal as much as innate emotional barrenness. *The Enemy Within* has the clearest political schema, and is the closest to the more overtly political work with Loach and Allen. There is a central binary opposition between the two teachers, who represent two political and cultural philosophies, which is played out across the narrative. The film is increasingly on the side of the progressive stance represented by the socialist housemaster, but it ends with him being promoted out of trouble, taking a deputy headship elsewhere, effectively accepting a defeat that has been carefully planned for him. *The Enemy Within*, with its focus on the school as a metaphor for society and its narrative of individuals shaped and constrained by institutional pressures, looks forward to later Garnett films.

Days of Hope: the limits of social realism?

Despite the variety of projects that Garnett was involved with in the 1970s, it is his collaborations with Ken Loach that, once again, achieve the highest profile, and which focus debates about social realism and documentary drama. The most important of these was *Days of Hope* (1975), which united Garnett with both Loach and writer Jim Allen in a four-part series that proved one of the most controversial drama events in the decade, and one of Garnett's few excursions into history. The script was developed by Allen, with Loach and Garnett contributing. The series began as a projected feature film on the 1921 Durham miner's lockout. It is an indication of the difficulty of making political films in the chilly climate of the British film industry of the time, and of the relative openness of the BBC Drama Department, that the project was picked up and extended into a narrative that spanned ten years of Labour history.

At the centre of the narrative of all four films are three characters: Philip Hargreaves (Nikolas Symmonds), his wife, Sarah (Pam Brighton) and her younger brother, Ben Mathews (Paul Copley). In episode one, '1916 – Joining Up', Philip, a Christian socialist and conscientious objector, is imprisoned for desertion, taken to the front line in France, tried and found guilty; only a last-minute reprieve saves him from execution. Ben, who does not share his sister and brother-in-law's politics, joins the army, is posted to Ireland, and much of the film takes place there. In episode two, '1921', the narrative focus stays with Ben, who has deserted and taken refuge in a Durham miner's village at the time of the employers' lockout (the subject of the original film treatment). Whilst trying to hold onto food donated by fellow workers and threatened with confiscation, Ben and the miners who protect him take several soldiers hostage – an action that leads to an invasion of the village and Ben's arrest. Episode three, '1924', picks up the wider historical narrative with the election of the first majority Labour government in history: as the opening caption puts it, 'many feel that the task of legislating socialism into existence can now begin'. Ben has been in prison for three years and has become a communist, whilst Philip has become a Labour MP. Much of the episode concerns the complicity of the Labour government in accepting secret strike-breaking plans, drawn up by Lloyd George's government and passed on via an outgoing Conservative minister. The duplicity of members of the Labour government echoes the betrayal of parliamentary socialism itself, and this political motif is mapped onto the personal narratives. Ben and Sarah are increasingly aligned with the revolutionary option against Philip, who identifies with the reformist position. We are informed by a closing caption that the plans became the basis of the strike-breaking force that defeated the General Strike of 1926, which is the subject of the fourth episode. This follows the course of the strike, called in support of the miners, faced with an industry-wide reduction in their wages. The episode consists mainly of a detailed account of the negotiations (much of it based on transcripts and first hand accounts) between the miner's union, the leadership of the TUC and the Conservative government immediately prior to, and during, the strike. Ben, Sarah and Philip occupy less space in this episode, commenting on, and reacting to, events as the strike unfolds. The struggle ends in defeat, with the miners left to negotiate with the mine owners alone (they remained locked out until November, and were forced to accept reduced wages).

Days of Hope is probably the most politically explicit and revolutionary film that the Garnett/Loach/Allen team made. At the

centre of the narrative of all four films are the questions that drive most of Allen's work; the shape and political colouring of recent working-class history, the inevitable corruption of parliamentary socialism, the creative and revolutionary energy of the working class when roused and the betrayal of that energy by its leadership. These themes were not simply historical either, since the films were made with a sharp sense of their contemporary resonance. As Garnett, Loach and Allen argued in the *Radio Times* in the week the first film was screened, 'Our motive for going to the past is not to escape the present; we go into the past to draw lessons from it. History is contemporary' (quoted in Bennett 1981: 302). *Days of Hope* was filmed during, and screened shortly after, another period of industrial militancy and unrest, once again initiated by a dispute involving the miners. The three-day working week called by the Conservative government in 1973 in response to a miners' strike (supported by the power workers), and the miners' strike of 1974, both contributed to a highly-charged political atmosphere. *Days of Hope* was not, therefore, simply a re-telling of recent history but rather an intervention into contemporary political debate. This was the major reason why the films attracted concerted criticism from the right-wing press, which rapidly became criticism of the BBC itself. The *Daily Telegraph* attacked the 'left-wing consensus' at the Corporation and argued for the 'ending of a situation in which this is the dominant political philosophy put out by a semi-monopolistic state service' (quoted in Goodwin, Kerr and MacDonald 1983: 21). The current affairs programme, *Tonight*, devoted a programme to considering the issues raised by the films, during which familiar concerns about the 'truth status' of documentary drama stood in for anxiety about politics.

 It is ironic that *Days of Hope* should attract opprobrium for blurring the line between drama and documentary since it belongs to the more observational style of film-making that Loach had been developing since *Kes*. Shot in sepia-tinged colour (not black and white) it has no documentary insertions, apart from captions at the beginning and end of each episode (though it has other connections to documentary record that will be returned to). Elsewhere, for academic critics and theorists, the concern was not so much about supposed documentary elements as the implications of the observational style, for which realism (and sometimes naturalism, since there was frequent slippage in the terminology) functioned as a convenient short-hand and scapegoat. *Days of Hope* generated considerable heat amongst left-wing intellectuals and academics, caught in wider debates about realism and its political – or 'progressive' in the terminology of the times – potential.

The potential of realism to be a revolutionary form was first questioned by Colin MacCabe in the film journal *Screen* (MacCabe 1974) and returned to in later interventions, where *Days of Hope* is the main issue.[11] Using quotations from Brecht as his starting-point, MacCabe's argument was essentially that realism – or the 'classic realist text' – was best understood as a formal structure, rather than a historically variable practice, that derives from the nineteenth-century novel and which was linked to a particular, and fixed, notion of 'the real'. The classic realist text is a 'closed' discourse. Whilst it might be opposed to dominant ideologies (and MacCabe cites *Cathy Come Home* in this context), it is compromised by its form, since it its impossible 'for the classic realist text to offer any perspectives for struggling due to its inability to investigate contradiction' (MacCabe 1981a: 225). The politics of the classic realist text is never more than social-democratic. This description of *Cathy Come Home* is one that Garnett and Loach might well have agreed with, but *Days of Hope*, which is also a classic realist text in these terms, is a far more problematic case.

Returning to these debates more than thirty years later is to be made uncomfortably aware of the brutal formalism of MacCabe's initial formulation, which has been comprehensively challenged since (Knight 1997: 68–9 and Caughie 2000: 105–9). At its simplest level, the theoretical accuracy, not to mention the analytical usefulness, of a category that cannot make any useful distinction between *Toad of Toad Hall* (MacCabe's example) and *Days of Hope* must be questioned. The classic realist text is essentially a concept that applies to the single cinema film, and which recognises neither the different viewing conditions of television drama nor its place in the flow of an evening's entertainment. As Pawling and Perkins have argued, it was a particularly narrow position to take when popular television was under consideration: 'the refusal to countenance a progressive drama based on forms of emotional identification between audience and characters was debilitating in that it inevitably meant that the vast majority of popular television drama was automatically categorised as reactionary' (Pawling and Perkins 1992: 47).

That critical engagement with forms of realism should turn away so decidedly from the popular, and should so completely avoid an engagement with the specific forms of television, was a missed opportunity in many ways. The privileging of avant garde practice was also, in certain respects, 'un-Brechtian' since Brecht himself was strongly interested in popular forms, linking them directly to his conception of realism (see Brecht 1977). This places Garnett, and others like him, much closer to Brecht's actual position than the *Screen* contributions allow.

Some of the most interesting observations on the films were made in the margins of the main arguments. MacCabe returned to *Days of Hope* in an article for *Edinburgh '77 Magazine* and gave a more nuanced account of the text that focused less on notions of the classic realist text and much more on the political arguments of the last two episodes. He argued that by focusing so completely on the detail of the events surrounding the strikebreaking plans ('1924') and the negotiations to end the General Strike ('1926'), the films had refused to subject the institutions of the working class – and the state – to effective scrutiny. 'To change institutions it may be necessary to understand them but simply to condemn them as false is to ignore their reality. In *Days of Hope* institutions have no reality over and above their ability to produce individuals who are betrayers' (MacCabe 1981b: 318). It is a point well made, and there is little in either episode (certainly the last) that places the characters, many of whom are also historical figures, in a context in which their actions might be understood. Betrayal is a fact within the films – of the miners by the TUC and the TUC by its General Secretary – that is neither explained nor analysed. It is also a direct consequence of the film-makers' – and especially Allen's – preoccupation with the motif of political betrayal and the way that this is given form in narrative. The causes of betrayal are not shown, nor its roots in the structures of political and institutional power, only the actions of betrayers, from which it is hard to draw general conclusions. This is emphasised by the reliance on documentary record; much of the dialogue in episode four comes from published sources, especially the biographies of the chief participants (this was a large part of Allen's defence against his critics). As Allen said later, 'I stayed too close the documentary evidence, but I was afraid of being picked up for accuracy' (Madden 1976: unpaginated). The danger was that *Days of Hope* remained locked into the past, unable to provide a clear connection to, or lesson for, the contemporary world beyond the implied injunction 'don't let this happen again'.

The first two episodes, however, are significantly different, and in the opinion of many critics more successful. The narratives, like the shooting style, are much closer to that of *Kes*, and the films have a clear relationship to observational realism. For example, within the over-arching historical and personal narrative that unites all four films there is a much more episodic structure of individual scenes that involve a large and changing cast of characters, and which are offered as self-contained moments that relate thematically to the main narrative but make an impact of their own. (It is a structure that owes more to the novel than to film.) Towards the end of '1916', for example, a young

Irish boy befriends and then taunts Ben and his fellow soldiers, luring one of them into a wood where he is blown up by a mine. The scene is one of several that seem to contribute to Ben's political education (though he does not comment on this directly), and which have contemporary resonances, echoing similar incidents in Northern Ireland in the 1970s. These scenes also fulfil an almost gestic function, in the Brechtian sense that they show a political point embodied in a specific action.

The Price of Coal and *The Spongers*: the politics of characterisation

Allen noted in relation to his decision to portray a group protagonist in *The Rank and File* that 'if you don't take an individual you lose the thread', arguing that 'to express political ideas you need to fuse the individual and the collective' (Madden 1976: unpaginated). But what kind of individual, and how are they placed in the narrative? It may be that the realist text, in its observational or naturalist form,[12] cannot permit 'complex seeing' of the kind Williams argued for (and Brecht created). One of Allen's solutions to the problem – and it is one that is found in other naturalist texts with political ambitions – is to create characters that have a superior knowledge of the situation, an awareness of what is happening that is denied others, and who provide the analysis that the narrative cannot represent in other ways. Regan in *The Big Flame*, Yorky in *The Lump* and Ben in *Days of Hope* are important examples. This means of escaping the limitations of naturalism is a correlative of Allen's Trotskyist political position as embodied in these films, and his protagonists become leaders of, and spokespeople for, their class. There is a tension between these two functions which runs throughout Allen's scripts; indeed, it is a tension that cuts across all naturalist narratives, since the voice of the protagonist can be read as the voice of the writer, and the analysis can seem like an intrusion from outside the fictional world. The problem of characterisation, which is also a problem of narrative, is not Allen's alone, but is a problem of the form, emerging in other Garnett and Loach films in the period (see the discussion of *The Big Flame* in Chapter 2) that wrestle with the ambition to analyse as well as reflect the real.

The Price of Coal (BBC 1977) was one approach to working through this problem. Produced by Garnett, directed by Ken Loach and written by Barry Hines, the film re-united the team that had made *Kes*. Hines approached Garnett with the idea of a making a film that satirised the

preparations for a royal visit to a northern coal pit in the year of the Queen's Silver Jubilee (1977). Garnett persuaded him to expand it into two films, the second of which would look at the same characters and community through the prism of a tragedy. The result was two linked dramas, broadcast on consecutive weeks as Plays for Today. The first, *Meet the People: a Film for the Silver Jubilee*, is a comedy that exposes the pretensions of both managers and union officials as they prepare for a Silver Jubilee visit by Prince Charles; the second, the aptly-titled *Back to Reality*, explores the aftermath of a pit explosion that kills two miners and seriously injures others. *The Price of Coal* contains in its title a dual meaning of the word 'price', and the coal in question comes with a cost that can be felt in economic and human terms. The politics of *The Price of Coal*, however, do not just emerge from the events of the narrative, but are also articulated by a privileged character (in narrative terms), Sid (Bobby Knut). In *Meet the People* the managers and officials seem increasingly absurd in the lengths they are prepared to go to make the celebrations succeed, and it is left to Sid to provide an alternative viewpoint. He is accused of being a 'troublemaker', but is carefully established as a decent man, good father and dependable worker. The political and representational strategy is to take someone demonised in the wider contemporary world – a militant and republican – and invite the viewer to align him/herself with him, at both political and personal levels. However, the danger is that Sid's perspective might be read as the author's – that his analysis appears as a didactic intrusion into the dramatic world.

The Spongers provides a different and more complex case. Broadcast in 1978 as a Play for Today, *The Spongers* was written by Jim Allen, produced by Garnett and directed by Roland Joffe. Like *The Price of Coal*, *The Spongers* took as its contemporary reference point the celebrations to mark the Silver Jubilee, which provides a back-drop against which the main action develops. This concerns a single mother, Pauline Crosby (Christine Hargreaves) and her four children, one of whom, Paula (Paula McDonagh), is a teenager with learning difficulties. In a time of cuts to social service budgets, which provides the real, and largely ignored, political context to the Jubilee celebrations, Pauline faces increasing difficulties keeping her family and home together. She is in arrears with her rent, and Paula's residential school is closed down because of budget cuts. Paula is relocated, supposedly temporarily, to an old peoples' home that is entirely inappropriate. Unable to meet her mounting debts, and with her application for additional assistance turned down, Pauline is faced with the prospect of her daughter deteriorating and her family being taken away. The situation is similar

to that faced by Cathy in *Cathy Come Home*, but the outcome is different. Pauline commits suicide and murders her four children.

The Spongers asks who the 'real' spongers are, making it clear that in its view the answer is the Royal Family, not people like Pauline. This is obvious from the beginning. The pre-credit sequence shows Pauline chaotically negotiating with council bailiffs, who have come to assess her meagre furniture in lieu of rent, whilst calming her distressed family. This is juxtaposed with the credit sequence, where, against the background of a giant Union Jack, council workers are attempting to erect two larger-than-life portraits of the Queen and Prince Philip, inadvertently placing the Queen's head upside down. With both heads comically centre frame, the title of the film comes into view below.

Unlike some other Allen protagonists, Pauline is neither articulate nor in possession of a privileged viewpoint from which she – and we – can judge and analyse her situation. Pauline is essentially a likeable and well-meaning woman, who is no match for circumstances which she can neither understand nor alter. She is often passive, silent and confused when faced by officialdom. Joffe's direction, which extends the observational style to ever-longer takes, often in mid-long shot, keeps us at one remove from his protagonist: the viewer is invited to observe and sympathise, but not align him/herself with her. Pauline becomes an object of the camera's gaze, a recipient of our sympathy, perhaps, but not a channel for our anger. This leaves a vacuum in the film where – given that this is a Jim Allen film – political comment and analysis might be, which is partially filled by two other characters, her father (Peter Kerrigan) and a voluntary worker, Sullivan (Bernard Hill).

In one key sequence, Pauline is interviewed at an appeals hearing, which is assessing her claim for exceptional help with her rent arrears. The hearing invites comparison with a similar situation in *Cathy Come Home*, where Cathy is being interviewed by a housing tribunal. In both interviews, the narrative sees the officials from Cathy/Pauline's point of view – that is, our view of them is that of the protagonists, and there is no question of 'rounded' or sympathetic characterisation. The camera, however, focuses on Pauline, who is shot almost entirely in long takes from a position behind the head of the Chairperson. One central difference between the two scenes is that Cathy faces the tribunal alone, and gives vent to her anger. Pauline, however, can offer no real resistance, and this role goes to her father. In a hesitant and low-key testimony on her behalf, he places her difficulties in a personal and historical context: 'we've always been grafters and workers ... After 1945 I said "Well, that's it" with the war and everything – that I wouldn't be

seeing a daughter of mine coming to this place'. He draws attention to rising inflation and declining benefits, asking 'how can you juggle what you haven't got?' He is unsuccessful, and Pauline is denied additional help: her rent will be deducted from her allowance, which the audience already knows is inadequate.

Sullivan plays a more active role in the latter part of the narrative, intervening on Pauline's behalf with Social Services and the Council. At one point he confronts the leader of the Council, which has closed Paula's school. The argument that ensues is couched in familiar Allen terms, with the Council leader putting the case for 'realistic' Labourism, which must accept a difficult situation and make the best of it, and Sullivan arguing for a more active political resistance. As with all such characters, it is possible to read Sullivan as either a credible political voice within the narrative or as an authorial intrusion, which the failure of the naturalist form makes necessary. Sullivan is no Yorky or Regan, but his intervention opens the argument up beyond Pauline and her family, inviting the viewer to see the wider context. By this point, he has become the voice of the film, and provides us with a point of view from which the events can be evaluated. As *The Spongers* ends, it is Sullivan who is left silently in the frame as the coffins are carried away.

The film's resolution raises questions about plausibility and typicality. Suicide and the murder of one's children are undoubtedly extreme acts, which cannot be justified in terms of sociological veracity, even whilst the scene has an undoubted emotional power. It could be read as melodrama, with reality twisted to fit the requirements of a pre-existing and highly pessimistic schema. However, the ending acquires a powerful symbolic force that escapes the constraints of naturalist credibility. Joffe films the preparations for suicide in a way that maintains the distance that he has established throughout. Following a street party mounted as part of the Jubilee celebrations, Pauline takes her family home. She carefully puts pills in their bedtime drinks and we watch the children through the open door of the bedroom, which the camera refuses to enter, as they sip them. The literal distance that this establishes between viewer and action may be read as an act of respect: it is also a strategy that does not invite emotional participation. Indeed, the remainder of the film gives an alternative, more critical, perspective on her actions: 'She had no right to do it' her distraught father says; 'She should have stuck it out like the rest of us' says one of her neighbours. These responses do not undermine the bleak, understated power of the ending, but they do suggest that Pauline's actions are not inevitable and should not be excused as a melodrama of defeat.

Law and Order: the politics of institutional corruption

> If the police are dishonest there will be no security for the people of this
> country. (from the Judge's summary, episode three of *Law and Order*)

Garnett's final project for the BBC in the 1970s was *Law and Order*
(BBC2 1978), a four-part mini-series about the workings of the criminal
justice system; it was also to be Garnett's last project for the BBC as an
individually contracted producer. Whilst the series was clearly linked to
his earlier work, provoking considerable controversy when it was
broadcast, it also looks forwards, in its form and concern with the
workings of institutions, to his work in the 1990s. *Law and Order* was
written by G. F. Newman and directed by Les Blair. Newman was an
established crime writer, who by the time he came to write *Law and
Order* had attracted critical and popular success. He had written about
police corruption before, though not for television (the films were later
turned into three novels). He was approached directly by Garnett with
the idea of the series, and developed the scripts out of meticulous
research with input from Garnett and Blair.

The four films that comprise *Law and Order* have interlinked
narratives, with a main story arc that is seen from four different
positions, signalled in the titles: episode one is 'A Detective's Tale',
episode two is 'A Villain's Tale', with episodes three and four entitled 'A
Brief's Tale' and 'A Prisoner's Tale' respectively. The central narrative
concerns a corrupt detective, Fred Pyle (Derek Martin), who decides to
go after a known criminal, Jack Lynne (Peter Dean). When he can't find
the evidence, he decides to 'fit him up' (frame him) for a crime he has
not committed. This includes the planting of 'evidence', the
manipulation of an identity parade and the harassment of a petty
criminal to give false testimony against Lynne for an armed robbery.
The trial occupies most of episode three, and Lynne is found guilty and
sentenced to fifteen years. As the prisoner of 'A Prisoner's Tale', Lynne
fights for the right to appeal and against the prison authorities, who are
determined to break him. The appeal leads only to a small reduction in
his sentence. Lynne is subjected to a regime of physical harassment,
psychological torture and illegal sedation, and eventually pacified. In a
telling final sequence, Lynne plants a sapling in the prison gardens; he
is informed that by the end of his sentence it will be a fine, mature tree.

Recounting the central narrative in this way gives only a partial sense
of the density of the world of the films, and the inter-connectedness of
the characters, events and processes they represent. The early episodes
in particular are teeming with incident and digressions that establish a
universe in which everyone – detectives and lawyers as well as

criminals – are corrupt or complicit in corruption. The series is shot in the observational and unobtrusive style of Garnett's brand of social realism, giving rise to familiar press challenges that its documentary gloss was a dishonest attempt to mask its fictional status (though there is little in any of the episodes that directly references documentary). It also proceeds by way of a complex narrative structure that contains an overlapping chronology, with certain events played twice in different episodes, the changing context confirming or challenging the viewer's perspective. Suspense is maintained to the end, and there is a possibility that Lynne's appeal will be successful and the police involved will be indicted for corruption.

The response to *Law and Order* was immediate and hostile (for the most part). The Home Secretary, Merlyn Rees, attacked the series for representing individual acts of corruption as systemic, and Mary Whitehouse demanded an inquiry. The police also raised strenuous objections and the Prison Officers Association banned the BBC from filming inside prisons for a year. The BBC refused to repeat the series or sell it abroad (a position that they eventually reversed; *Law and Order* was repeated and sold well in Europe (Woodman 1983: 24)). Garnett's response was to adopt a high profile, giving interviews to the press in which he defended the series as a 'right of reply' to a dominant view of the criminal justice system. It was also, in its form as well as its political stance, a deliberate challenge to the prevailing view of the police as represented in popular television, especially *The Sweeney* (Thames 1975–78) (see Cooke 2003: 118–19). Garnett's view was clear: 'I do not believe it is enough of a social criticism to obey the convention that in each police series you have a single episode about a bent copper, the idea of the one bad apple ... we are telling the truth as we see it, about detectives, a high proportion of detectives. It is our version of the truth' (Jackson 1978). Adopting a strategy he used at other times, Garnett invited penal reform groups to the press screening, after which a number of them produced a statement 'that could confirm from first-hand experience or reliable sources, everything that was shown in the programme' (Potts 1978).

One of the striking things about *Law and Order*, which distinguishes it from crime melodrama, is that it portrays virtually *everyone* as culpable in a system in which corruption is endemic. Pyle is not the only policeman we see accepting bribes, and it is suggested that even the unit investigating police corruption is itself corrupt. Lynne's brief (solicitor), Alex Gladwell (Ken Campbell), is also implicated, negotiating a bribe on behalf of a client in episode two and suggesting to Lynne that he may have to offer a bribe to Pyle (£1,500) if he is to escape the

charges. The series also resists easy and consoling binary oppositions, and there is no attempt to represent criminals as victims. Jack Lynne may have been wrongly imprisoned, but it is made clear that he is a career criminal who is guilty of several other crimes. 'The attitude the audience might have about the detective' Garnett argued 'is not going to be reinforced by us being sympathetic to the villains ... It really is left-wing infantilism to get sentimental about crooks' (Radin 1978). Newman has said that Garnett and Blair thought his draft scripts 'too strong'. However, after doing his own research, 'Tony looked at the scripts and asked me "Do you think they're strong enough?"' (Woodman 1983: 24). The only censorship of the eventual scripts was the removal of the profusion of swearwords, which although realistic would have 'given the BBC a valid excuse to shelve the programmes' (*ibid.*).

In an interview at the time, Garnett observed that 'I used to think I knew all the answers; now I only hope to ask more intelligent questions' (Radin 1978). This almost throwaway remark signals an important reorientation of Garnetts' political aesthetic. Certainly, compared with Garnett's collaborations with Jim Allen, *Law and Order* is not explicitly didactic, and this is partly because of Garnett's increasingly pessimistic view of the failure of left-wing politics as the decade drew to a close (to which we will return). Garnett's comments prefigure a concern with institutional politics and practices that were developed more fully in his work with the dominant genres of popular drama series in the 1990s. Garnett returned to the criminal justice system and questions of police corruption in *Between the Lines* (BBC 1992–94) and *Outlaws* (BBC3 2005). *Law and Order* was his first attempt at a series that treated the police, judicial and prison systems – not to mention the criminal fraternity – as a single institution and explored the ways in which it operated in these terms. It is remarkable, for example, how far everyone (with the exception of the Judge) speaks the same language of 'blaggers' (criminals), 'the filth' (the CID, or plain-clothes detectives), 'briefs' (lawyers) and 'screws' (prison officers). Language here fulfils an ideological function of connecting everyone to the same value system, which is then further explored in the allegiances that are formed, the trade-offs that are made and the bargains that are struck between characters across the boundary between the law and criminality (which is constantly blurred in any case). Police activity, as represented here, is mostly about finding 'grasses' (informants) and squeezing them for information: a grass gives a name in exchange for being let off another crime; one detective's informant is protected, whilst another's is beaten up. In this way crimes are 'solved' within the closed world of intense

and self-confirming power relationships, justified in terms of 'getting on with the job'. Revealed by a shooting style that maintains an aesthetic and political distance, such practices become the 'common sense' of the criminal justice system. The singular achievement of *Law and Order* across its four episodes is to unmask this common sense as an ideology of power.

By the time *Law and Order* was transmitted, Garnett had already announced publicly that he would not seek to renew his contract with the BBC and would be looking to work elsewhere. He was to be away from British television for a decade; indeed, he was away from Britain itself for most of that time, choosing in 1980 to go to the USA to work in cinema. In the intervening two years, Garnett was, briefly, in contract to Euston Films to, in the words of the company, 'develop properties for use in films' (Murtin 1978), although nothing followed from it. He also completed a film for children with Ken Loach – their last collaboration – *Black Jack* (1978). In 1980, he wrote, produced and directed a feature film, *Prostitute*. Neither project was successful enough to persuade him to stay in Britain.

His decision to decisively move away from television was taken for a variety of personal and political reasons. There is no doubt that a decade of struggling to create political and aesthetic space in the BBC had left him physically and emotionally exhausted. He was also creatively 'wiped out'; as he put it recently, 'I couldn't stand the thought of being responsible for one more scene in a pub'.[13] Garnett's position at the BBC laid him open to political and personal criticism:

> I would sign, say, a two-year deal with the BBC to do two films a year on each channel, so that would be eight films on an agreed budget. So I had in my gift things that everybody wanted. And I was making decisions about what I wanted to do and with whom and everybody else was furious with me. (Shepherdson 2004: 158)

Like many turning points in Garnett's career, the personal and the political are interconnected. Along with many on the left, Garnett could see that the political climate was changing. By late 1978, the Labour government led by James Callaghan was lurching from one crisis to another, with the 'Winter of Discontent', in which local government workers brought key public services to a halt, producing a crisis from which it could not recover. In the general election of the following year, the Conservatives were returned to power under the leadership of Britain's first woman Prime Minister, the determinedly anti-union and anti-consensual Margaret Thatcher.

The crisis of the Labour government was also a crisis of the left generally, even for those who were some way to the left of the Labour Party. As Garnett has said on several occasions, he felt that by the end of the decade the left 'blew it', and he felt implicated in this failure. 'We indulged ourselves in the '60s at the end of the boom' he later said, 'In the '70s, when Keith Joseph [a Tory intellectual and Education Secretary] was embarking on his long march through the universities, all people did was throw tomatoes at him ... When Arthur Scargill was strutting with hubris after the famous victory over Heath at the Saltley coke plant, Ridley [Home Secretary in the 1980s] was quietly preparing his plan to destroy the miners' (Garnett 2001: 79). Even the most overtly oppositional drama ever seen on television had failed by its most important criteria; not only had radical reform, let alone revolution, not happened, but Britain had elected the most right-wing government since World War II. In an interview shortly before leaving for the USA, Garnett reflected self-critically on the shortfalls and omissions of his work in the 1970s:

> We've tried in our films to give a sense of the complexity of the working-class – you can't understand a group of people without comprehending their social conditions and context – and to communicate faith in the power of the workers to provide leadership, organisation and discipline. It wouldn't surprise me, however, that our portrait of the working class was, at moments, a sentimental one. We've never rigorously analyzed the conservative strains in working class culture. And we've been too facile about placing the sole blame for union conservatism on the trade union bureaucracy. In addition, a couple of our films can be seen as advocating a form of anarcho-syndicalism, and we've never really grappled with that political concept. (Quart 1980: 29)

The criticisms apply mainly to his work with Loach and Allen, rather than to, say, *Kes* and *The Body* or even *Law and Order*. However, Garnett is aware here of the limitations of a politics that was also under fire from elsewhere on the left, and which is an undercurrent in the arguments against *Days of Hope*. In the course of a study of the work of Trevor Griffiths, Poole and Wyver argued that the moment of revolutionary possibility had already passed by the time *Days of Hope* appeared. There was instead 'a widespread sense of defeat and indirection on the Left after the militancy of the early 1970s ... In this climate Labour governments and films about working-class history were likely to seem all of a piece: political dead-ends. Was not *Days of Hope* itself about a massive defeat?' (Poole and Wyver 1984: 104). This may be premature, but by the end of the decade the argument was

more persuasive, and was rooted in a re-thinking of the concept of class itself:

> Much of the crisis on the Left had in fact been generated precisely by the growing realisation that it was no longer possible to think in terms even of a unified working class. As structural unemployment began to bite, creating a new labour aristocracy out of those in work and turning those without a job into a new underclass; as anti-racist campaigns began to reveal the scope of the problem within the working class itself; and as women struggling against sexism in the workplace increasingly ran up against opposition from their own male trade union colleagues, it became clear that the working class in the mid-1970s was not just divided but divided against itself (Poole and Wyver 1984: 105)

The references to feminism and anti-racism are pertinent, since there is little in any of the television films with which Garnett was associated in the mid-1970s that recognises or engages with either sexism or racism, and this is a blindness that was common to the Trotskyist left as much as the Labourist right that it despised. Significantly, and indicative of Garnett's increasing distance from Trotskyists, his next two projects, *Prostitute* and *Handgun*, in which he was writer and director as well as producer, are both women-centred and have a proto-feminist politics.

The achievements of The Wednesday Play and Play for Today were significant, and the move from studio-based to all-film drama seemed complete by 1980. However, some things were lost on the journey, and others happened that were not intended. Macmurragh-Kavanagh (1999) has argued persuasively that the rise of predominantly male producers, epitomised by Garnett, helped to establish the single play as a predominantly male space, both in terms of its working practices and the kind of drama that was made. Fay Weldon, an established writer, found herself marginalised, whilst Julia Jones, whose plays were popular with the television audiences, could not establish a career in the anthology series. The demise of the studio play itself, Macmurraugh-Kavanagh argues, was a victory for the 'public' world of 'real' politics, associated with film, over the emotional and 'personal' realities, associated with the domestic world of the studio play. As the political space for analytical realism retreated in the 1980s and 90s, television drama discovered the politics of the personal in newer forms of popular television (see Chapter 4).

The crisis on the left coincided with a crisis in television drama itself, particularly the single play. Although in rude health through much of the decade, the single play, along with the anthology series

such as Play for Today that had defined and promoted it (and in which Garnett had made his name), was under fire as the 1980s arrived. In an influential essay first published in the official programme of the Edinburgh International Television Festival in 1980, Carl Gardner and John Wyver (1980) argued that the single play was effectively dead as a presence in the television schedules (and for these purposes, though not for others, the term also embraced the kind of mini-series that Garnett had produced). Recognising the value of the single play and anthology series as a site of original, innovative and radical work, Gardner and Wyver see no chance of its survival and are pessimistic about the possibility of anything taking its place. Garnett seemed to share this pessimism and left to make films for the cinema.

Excursions in filming 1978–1990: from Balsall Heath to Hollywood

As we have already seen, Garnett has always had the ambition to produce films for both television and the cinema, but there were no cinema films between *Family Life* (1971) and *Black Jack* (1978). This is partly a result of the difficulties of funding commercial film production in the UK, and also because of Garnett's success as a television producer, enjoying a privileged space within the BBC. Garnett continued to be drawn towards cinema production, however, despite the difficulties, and kept his involvement with Kestrel Productions. Cinema film-making gave him a creative autonomy that seemed very attractive after the war of attrition that sometimes characterised his relationship with the Corporation and the press. *Black Jack*, however, was neither a commercial or critical success, and was not a happy experience for either producer or director. After its completion, Loach and Garnett ended their thirteen-year collaboration, and have not worked together since. The break was amicable – the two are still friends – and the result of Garnett's disillusion with left politics and a desire for change rather than any personal disagreement with Loach.

Garnett's next film, *Prostitute*, his last before going to the USA, was happier and more consistently well-achieved (though still not a commercial success). It was made with an anonymous gift of £400,000, which guaranteed Garnett's autonomy and control over the entire creative and production process (he was producer, writer and director). *Prostitute* was in fact more like a film for television than one for cinema, and was shot in six weeks on 16 mm film. It was connected to his work for television in other ways as well: based on meticulous research, the film is a materialist account of prostitution as labour that

is very much in the tradition of social realism that reclaims marginalised experiences and groups and challenges dominant viewpoints. It also engages directly with the experience of women and a feminist agenda.

Garnett researched the project over four years, basing the script on interviews with prostitutes in London and Birmingham. *Prostitute* is rooted in a specific social context, that of Balsall Heath, an area of Birmingham that is noted for prostitution and social deprivation. The film operates at different levels, representing the collective experiences of prostitutes through a large cast of characters (some of whom were played by actual prostitutes) firmly located in their context. The opening sequence shows women being picked up by anonymous 'punters' filmed in long shot against the background of urban wasteland, and the motif is repeated several times. Some organise themselves, with the help of a social worker, to publicise their rights and campaign to change the laws on soliciting. The viewer constantly eavesdrops on conversations about working conditions, how the punters have 'behaved', how the money is better than working in a supermarket and when the children have to be picked up. At each point, the dominant representation of prostitutes – as 'fallen' women in need of reform, as embodiments of desire, as the 'whore' to be set against the Madonna – is challenged. Their image is repeatedly de-sexualised; prostitutes in this film come in all shapes and sizes, and are generally clad in cheap, everyday clothes. The sexual imagery that the film displays is unerotic; a prostitute removes her top to masturbate a client (Garnett wanted to show the actor's erect penis, but this was not allowed); a fake lesbian scene staged for an upper-class stag party is undermined by one participant urging the other to 'make it look real'. Sex is banal and commodified, and the nudity on display is largely that of men, who are, in all their imperfections, made vulnerable rather than objects of sexual desire.

Set against this story of the collective experience of working-class prostitutes are two narratives centring on individuals. One concerns the social worker, Louise (Kate Crutchley), who works, against the wishes of her superiors, to support prostitutes and help them organise. She is the lodger of Sandra (Eleanor Forsythe), a prostitute who provides the main narrative impetus. Sandra is offered the chance to work in London with a 'Madame' who pays good money and offers guaranteed clients. This Madame is more a headmistress of a modest girls' public school than a conventional brothel keeper, yet her relationship with the women is exploitative. The story is the reverse image of a common post-war narrative, where the (normally male) hero goes to London to seek his fortune, usually successfully. In this version, however, Sandra is

asked to perform offensive and dangerous acts (although these are suggested, disturbingly, rather than shown) and leaves her employer. Attempting to set up for herself, she is victimised by the local Vice Squad and forced to perform fellatio on a police officer, who also takes protection money. Disillusioned, she returns home to Birmingham.

Garnett's interest in prostitution was partly sociological, in that it represented a world that even 'punters' knew little about. However, prostitution is also a metonym of capitalism, a particularly apt example of a trade that demonstrates the workings of the labour market. The film implicitly asks if all labour isn't a form of prostitution (the parallel is explicit for Louise). As Garnett said in interview at the time, 'I was obsessed with it because it represented a completely closed world, and also it seemed a rich symbol for things in all of us beyond the narrow definition of selling sex for money' (Anon 1980). Prostitutes sell their labour in a market that is structured by the laws of supply and demand, yet are rarely free agents. As self-employed workers they are vulnerable, and as employees of the brash, 'new' metropolitan capitalists they are more so. Louise's campaign is to help these working women become more aware of market realities. There are no magical solutions to this situation, and no clear resolution to the narrative. The film ends with Louise showing a female television reporter, who is planning to make a film about the prostitute's campaign, the streets in which they work (and which we have seen in the opening). This closing sequence makes an unexpectedly ironic and self-referential comment on the way that poverty and social issues can become aestheticised under the camera's gaze and on the power relationships between reporter and reported; 'What an amazing sky-line', the reporter says, looking across a scene of desolation to the city centre landscape beyond, 'what wonderful tower blocks'. The final lines of dialogue, delivered across scenes of prostitutes plying their trade, voice Louise's concern that the film should not 'reinforce stereotypes'. This particular accusation could not be levelled against *Prostitute* itself, which counters dominant expectations at every turn.

Garnett was in control of *Prostitute*, from research through to post-production, taking explicit responsibility for functions he had frequently fulfilled as part of a team. The film is shot in the kind of observational style that became associated with Loach's work, and which came out of their collaboration; a camera that 'holds back' and 'captures' rather than 'creates' the reality it shows, ambient sound and extensive use of medium and long shot. Indeed, the style is extended at times, especially in the opening, to include long shots that frame individuals from across a busy street whilst we hear their dialogue –

almost drowned by the cars that threaten to fill the screen – as if we were standing next to them. The effect is to place characters within a detailed social environment, located visually and amplified aurally, before we are introduced to them as individuals. It is one of the most fully realised techniques for representing the 'social' in social realism that Garnett was able to develop. However, his next films, shot in a very different context and in response to very different political and institutional pressures, were to be very different. In 1980, Tony Garnett went to Hollywood.

In the ten years that Garnett lived and worked in the USA he made four films. The first of these, *Handgun* (aka *Deep in the Heart*), was the project that enabled him to move to Hollywood and he began working on it as soon as he arrived there. Financed by Universal Studios through Kestrel, *Handgun* was Garnett's second, and last, opportunity to make a film as writer and director as well as producer. In 1985, Garnett produced a children's film, *Follow that Bird*, the first film from the popular Sesame Street television series and made by the Children's Television Workshop with additional funding from Warner and World Film Services. His third feature was *Earth Girls are Easy* (1989), and his last *Shadow Makers* (1989 aka *Fat Man and Little Boy*). This book is primarily about Garnett's work on British television, and only *Handgun* and *Shadow Makers* will be considered here. However, it is important to make some observations about Garnett's time in America and what he took from it.

Although it may seem an odd decision for someone so embedded in British culture – and so out of sympathy politically with American capitalism and the commercial film-making ethic in particular – to decamp to Los Angeles, Garnett joined a long line of British film-makers to make the journey. Dennis Potter also worked substantially in the USA during much of the 1980s, though he did not live there. Not all British migrants took up residence in Los Angeles, as Garnett chose to do, and it was a more familiar journey for directors, who were more used to being 'for hire' in an open market, than producers (Hillier 1993). However, Garnett had made many connections with the American film world during his time at the BBC, and his experience of working as an independent producer was largely positive, despite the legendary ruthlessness of the system. 'People were very kind to me,' he noted recently 'very supportive'.[14]

Garnett went to the USA at a time of structural and cultural change in the American film industry. After a decade in which high-profile independents (directors such as Steven Spielberg, George Lucas and Francis Ford Coppola) had made the running, the studios had regained

pre-eminence, and by the early 1980s, 90 per cent of North American rental revenues (from theatrical release) were collected by six major studios. The process of consolidation of ownership, often into conglomerates with interests that were much wider than the movies, accelerated, with Coca-Cola buying Columbia in 1981–82 and Rupert Murdoch's News Corporation purchasing Fox in 1985. At the same time, the interpenetration of the film and television industries was virtually complete, with practices, practitioners and products increasingly common to both. One result of this was an expansion in the market for films caused by the growth of cable television in particular (by 1985 there were some forty million subscribers to cable stations in the USA), which meant that studios were more disposed than a decade earlier towards financing low-budget films that would be likely to cover their costs from television.

Against this background of institutional and economic change, the pattern of film-making also began to alter, with the newly-confident – and newly-profitable – majors investing in large-scale projects, whilst the independents remained associated with low- to mid-budget films. This took place on a landscape of political and cultural change in the USA. The 1980s were characterised by a swing to the political right (replicated in the UK) and associated with the anti-welfare, anti-big government, low-tax republicanism of Ronald Regan, who was President for most of the decade. Conservatism at home was matched by expansionism and aggression abroad, which found expression in big-budget action films. 'The American cinema in the '70s had been very open minded and fairly progressive even into the heart of Hollywood' Garnett noted later, 'but the American cinema in the '80s was high concept, action movies. It was Arnold Schwarzenegger and the big action heroes ... very difficult for someone like me'.[15] The increase in scale of film-making in the decade is indicated by the fact that average production costs increased from ten million dollars in 1980 to twenty-three million dollars in 1989 (Hiller 1993: 17). It is these very cultural and political difficulties that Garnett's first film in the USA, *Handgun*, confronted.

Handgun acknowledges both Garnett's long-term concerns and his new working context. The film centres on a young Boston teacher, Kathleen Sullivan (Karen Young), newly-arrived in a Texas High School. Befriended by a fellow teacher, Kathleen meets and is dated by a local lawyer, Larry Keeler (Clayton Day), who, having given her dinner, decides to take what he feels he is owed and rapes her at gunpoint. Enraged, Kathleen reports him to the police, who, though sympathetic, dissuade her from taking her case further, fearing that she will be humiliated in court. Kathleen cuts her hair short, takes to wearing plaid

shirts and enrols at a local gun club where she soon becomes an expert shot. It is soon clear that her actions are not defensive, and she tricks Keeler onto the gun range where she stalks and shoots him – though not with the expected bullet but, in a surprise twist, a sedative dart, which leaves him humiliated and Kathleen revenged. Although not a major success in the USA, the film got good reviews on its release in the UK, which may indicate that it was more familiar, in its subject matter and visual style, to UK audiences and critics.

The narrative of *Handgun* draws on two kinds of familiar Hollywood story. On the one hand, it was a narrative of the woman-as-victim of a predatory male, whilst on the other, it was a story of a protagonist who is wronged, but can find no redress through the processes of the law, and enacts a revenge of her own. In fusing the two, Garnett challenged the ideological underpinnings of each. Kathleen responds to being raped with rage, and directs it out towards the world and her rapist rather than in towards herself. In the context of early 1980s cinema, this is quite a bold and unusual position, and in no sense is she a passive victim. Its feminist logic may, perhaps, be compromised by the fact that in order to become 'active' she becomes more 'male' than the men around her, donning masculine clothes and learning to shoot. However, there is a clear but understated sense of the consciously performative about this: her hair-cut and dress in the days after the rape are exaggerated, deliberately denying her femininity as an act of self-protection. At the moment of revenge, when Kathleen tricks Keeler onto the firing range, she wears black shirt and jeans with a red handkerchief at her neck, and this seems like a deliberate reference to the costume of a cinema cowboy. There is a self-awareness of what she is doing suggested here, that is underscored by the ending, in which she reverts to something liker her earlier appearance.

In *Handgun*, rape is not an abnormal act committed by a disturbed outsider, but a logical outcome (not *the* logical outcome) of a particular value system. Keeler subscribes to the myths of the old West, tamed by the famous Colt revolver. 'You can't understand this place [Texas] without knowing about guns' he tells her early in the film. Kathleen invites him to lecture her class on American history, his view of which is concise: 'The guy who had the best weapon changed the course of history' (later Kathleen gives an alternative view to her pupils – Texas was 'conquered in a race war'). The values that saturate gun culture are laid bare during the lengthy sequence when Kathleen learns to shoot. This is the most didactic part of the film, which several reviewers thought almost like a documentary. The ethics of gun culture are directly connected to a wider politics. Keeler sneers at blacks, who are

all 'on welfare', and espouses self-reliance and 'frontier values', whilst a fellow gun club member warns of the encroaching breakdown of civil society when the federal government can no longer afford welfare payments. The politics of the film resist this and are echoed in the final image where a freeze-frame captures Kathleen holding up a black child.

Handgun is shot in an observational style familiar to viewers of Garnett's other films, though different from the familiar rhetoric of most Hollywood cinema. Garnett uses long takes to particular effect, allowing his actors time and space to develop character, situation and argument. Compromises are made, however, with the practices of mainstream filming, and the film has a non-diegetic music score that cuts in at moments of tension (during the climactic scene in particular) in a way that never happens in earlier work. The decisions over what to represent are perhaps unexpected, given the mainstream context of the film. The rape itself is not shown, but the build up to it is revealed in a detail that is harrowing and refuses to exploit any potential for eroticism (Garnett had confronted similar issues in filming sex scenes in *Prostitute*). Noting that the distributor claimed that the rape was disappointing because 'it wasn't a turn on', Garnett argued that 'traditionally films about rape have been intended to give the male audience a pleasurable experience' (Shepherdson 2004: 166). As a statement about American popular cinema generally, this is debateable, as Shepherdson points out, but it makes the position of the film, and how it wishes to address its audience, clear. That rape is not here a product of aberrant psychology is further demonstrated by Garnett's decision to suggest that Keeler rapes her a second time on the same occasion, having shifted the blame onto her for not submitting to him. Keeler feels that he has done nothing wrong, allows her to go home without hindrance and even calls her later to suggest another date. That he clearly has done something wrong, and that his attitudes are reflected in a wider politics which are similarly wrong, locates the action of the film in ideology and value systems rather than deviant sexual psychology.

Garnett's last film in Hollywood was his most expensive and, in terms of its theme, scale and cast, his most ambitious. *Shadow Makers* (1989) concerns 'the Manhattan Project', the race to develop the atom bomb at Los Alamos towards the end of World War II. It was directed by Roland Joffe and co-written by him and Bruce Robinson.[16] The idea for a film on the Los Alamos project and the scientists who developed the atom bomb – especially the leader of the project, Robert Oppenheimer – had been touted in Hollywood for some time. Joffe's involvement in the project was crucial: since last working with Garnett, he had made

several high-profile, critically and commercially successful films, notably *The Killing Fields* (1984) and *The Mission* (1986). Garnett encouraged Joffe to write his own version of the story based on their discussions, and it was this that sold the film to Paramount, which eventually backed the project, but within a strictly limited budget of eighteen million dollars.

For Garnett, the political contours of the project were clear:

> One of the things that struck Roland and I very strongly was that, if you are going to pick an historical moment when scientists lost their independence, it would be the Manhattan Project. Before that, for some centuries, there had been the liberal notion of the lone genius with the Bunsen burner making scientific breakthroughs. Now the state and arms of the state like the military took over the soul of the scientist. The image we came up with was of Faust and Mephistopheles. (Bygrave 1990)

Faust was Oppenheimer (Dwight Schulz), with the part of Mephistopheles accorded to General Groves (Paul Newman), the military co-ordinator of the Manhattan Project. Most previous versions of the story had concentrated on Oppenheimer's role and the post-war investigation into his liberal-left politics. The innovation in the Garnett/ Joffe version, however, was the foregrounding of the role of Groves, who emerges as the dominant character in the drama, and the main embodiment of the politico-military values that determined how, and on what terms, the bomb would be developed and used. The conflict between the two men, which ends in Oppenheimer's capitulation to the decision to bomb Japan, is at the centre of the film and provides its main narrative drive.

The film was conceived on an epic scale, with Los Alamos, the Texas town where the military and scientists lived and worked whilst the project was under development, recreated in Mexico in order to come in within the budget. The eventual film combined actors with actual scientists, in a combination unusual in Hollywood, but familiar to Garnett. One result, according to one journalist, was that 'the filming sometimes seemed more like a history seminar than a movie set' with 'actors, scientists and others sat around debating the making of the Bomb' (Bygrave 1990).

Shadow Makers made several controversial claims about the development of the Bomb and how the decision to use it was made. 'The Allies knew the Germans were not even working on the Bomb well before Los Alamos delivered one,' Garnett claimed, and 'there was no military justification for dropping the Bomb on Japan. And ... radiation

experiments were carried out on unsuspecting civilians by the US government' (*ibid.*). It was a view that was hotly contested when the film was released in the USA, with historians going into print to denounce it. *Shadow Makers* was neither a box-office nor a critical success, and the reasons for this lie partly within the context in which the film was made and released.

When *Shadow Makers* was pitched as a film in the mid-1980s, the Cold War had not yet run its course: the Soviet Union was still in existence and the nuclear threat still a reality. The film, therefore, aimed to connect to contemporary anxieties about the Bomb and how it might be used. However, by the time of its release in 1989 the situation had changed, and the film was distributed in a very different climate. The new Soviet leader, Mikhail Gorbachev, had initiated a process of rapprochement with the West and liberalisation – perestroika – at home. An agreement had been signed to limit the development of nuclear arms, leading to the dismantling of medium- and short-range nuclear weapons. Most significant of all, the Berlin Wall was torn down in 1989 and East Europe began its rapid transition from communism: the West had won, and, in the view of its conservative leaders at least, its nuclear stance had been vindicated. This was not a climate in which *Shadow Maker*'s anti-nuclear politics would resonate with its audience, and this was cited as one reason for its commercial failure.

By the time *Shadow Makers* was released in Europe, Garnett had already decided to leave the USA and return to Great Britain. It is tempting to think that these were largely wasted years, because they did not yield the kind of spectacular results that he had achieved in British television. However, Garnett himself does not think so, and he came back mainly for personal reasons. He and his wife divorced at the end of the 1980s, and she returned to London, bringing their youngest son with them. It is possible that he would have wanted to live in Britain again at some point, but the timing of his return was dictated by his desire to remain in touch with his son.

Hollywood provided Garnett with a context in which he could re-think his career and, as a film-maker in his early forties with an established reputation, it was salutary to start again in a place where he was not known. He has said that Hollywood gave him an opportunity to re-examine what he knew about narrative and film-making (see Lipman 1990), and equipped him to function in a more open and competitive production environment, away from the warm embrace of the BBC. These were lessons that were to prove invaluable in the new context that faced him; the landscape of British broadcasting, like that of British society in general, changed irrevocably between 1980 and 1990.

Notes

1 Interview with the author, 7 March 2005.
2 *Ibid.*
3 *Ibid.*
4 Interview with the author, 7 July 2004.
5 Interview with the author, 7 March 2005.
6 *Ibid.*
7 Interview with the author, 7 March 2005. Garnett has made this comment, or variations on it, on several occasions.
8 Ken Loach participating in *Is this story true? Is this picture real?*, a discussion of documentary drama at BAFTA, Monday 19 January 2006.
9 The whole sorry story has been catalogued at length by Mark Hollingsworth and Richard Norton-Taylor in *Blacklist: The Inside Story of Political Vetting* (1988), London: Hogarth Press. I am indebted to them for much of the information in this account.
10 Interviewed with the author, 25 May 2006.
11 These articles were reprinted in a slightly abridged form in T. Bennett (ed) (1981) *Popular Television and Film* London: BFI publishing/Open University, along with all the other contributions to the controversy. For convenience, I will reference this source rather than the original.
12 In order to hold onto this distinction, I will use 'naturalism' in this discussion of Garnett/Loach/Allen's work.
13 Interview with the author, 7 July 2004.
14 *Ibid.*
15 Interview with the author, 16 January 2006.
16 In the USA, the film was released under the title *Fat Man and Little Boy*, the nicknames for the two bombs that were dropped on Hiroshima and Nagasaki respectively. It was felt that these soubriquets were not widely known outside the USA, and the film was re-titled for its European release.

Independence and dependency 4

And all this talk about being an independent producer: I say there's no such thing. I'm a dependent producer, because there are very few buyers and there are a lot of sellers. (Interview with the author, 16 January 2006)

When Tony Garnett returned to Britain he did not go back to the BBC but entered the arena of independent production. He was approached by an old friend and associate, John Heyman, to become the head of a new production venture in British television, Island World Productions. Heyman, who has extensive film producing credits in mainstream cinema,[1] is head of the World group of companies, the first of which he founded in 1963. Island World Productions was established in conjunction with Chris Blackwell, who had founded Island Records in the 1960s. Blackwell continued to be associated with the company until 1994, when his interests in Island were sold to Polygram and Island World became simply World Productions. Garnett approached Margaret Matheson, a former producer at the BBC in the 1970s who, like Garnett, had crossed over into cinema production, and she agreed to establish the company with him. Matheson remained with Island World until 1993, when she left to pursue film projects. From the outset, Island World[2] was not conceived as a money-making venture:

> He [Heyman] wanted a company that would bring some prestige, that could be taken seriously, that would do work that everybody, including he, could be proud of. And I don't think anybody could ask for a more interesting, more welcome brief ... The Company doesn't have to make a profit, it does have to break even, and it's to strive to do the best quality work we are capable of doing.[3]

The work has been diverse, in terms of both programme format and subject matter, and the company has produced work for all the

terrestrial channels (especially BBC2 and Channel 4 (C4)). At one end of the production spectrum, World Productions has been involved in feature film production. Garnett produced *Beautiful Thing* (1996) for Channel 4 (Film 4), based on Jonathan Harvey's play of the same name, and *Hostile Waters* (1997), an international co-production between World and a variety of companies, including the BBC and HBO (US cable channel). World Production's initial output for television was distinctive, but in a different sense. Island World's first venture, with Garnett as executive producer, was *The Staggering Stories of Ferdinand de Bargos* (BBC 1989), a satirical drama series which consisted of dubbed archive material. In 1993, Garnett took advantage of the new policy at the BBC of commissioning single films on bigger budgets, to produce *Born Kicking*. The film reunited Garnett with writer Barry Hines and concerned the story of an exceptionally talented woman footballer, who becomes the first woman to play for a First Division (now Premier League) team. World Productions has also made several two-part films including *Heart Surgeon* (BBC1 1997), *Men Only* (C4 2001) and *Rough Treatment* (BBC 2003); a five-episode series of discrete films, *Sharman* (BBC 1995–96), based on the detective novels of Mark Timlin and starring Clive Owen in the title role; the six-part vampire-hunting thriller, *Ultraviolet* (C4 1998); and several one-off films, notably *Love Again* (BBC2 2003), based on the poet Philip Larkin's relationship with women; *Ahead of the Class* (ITV 2005), starring Julie Walters, and *A Perfect Day* (Five 2005) – these recent projects indicating a new willingness by broadcasters to make single films once more. The company has also made a successful children's series, *Caribou Kitchen* (BBC 2003), and experimented with the short film form in *Black Cabs* (C4 2000) and *Table 12* (BBC2 2001) aimed at giving new writers, or writers new to television, the chance to try out ideas in a context away from drama series and the soaps. At the centre of World Productions output, however, has been the renewable drama series, and it is these that have achieved the highest profile and, perhaps paradoxically, that provide the clearest link to Garnett's earlier work and connect most directly to contemporary social and political concerns. These include: the police dramas *Between the Lines* (BBC1 1992), *The Cops* (BBC2 1998–2001) and *Murder Prevention* (Five 2004–05); the 'soap dramas' *This Life* (BBC2 1996–97), *Ballykissangel* (BBC1 1996–2001) – although very different, these are probably the two most popular series World has produced – and *Attachments* (BBC2 2000–02), set amongst dotcom entrepreneurs; the hospital-based *Cardiac Arrest* (BBC2 1994–96) and *No Angels* (C4 2004–06); *Outlaws* (BBC3 2004–05), concerning the criminal justice system; and *Buried* (C4 2003), set in a prison.

Not all these series – or indeed the one-off dramas and mini-series – sit readily alongside Garnett's earlier work: it is difficult, for example, to tout the social realist credentials of *Ballykissangel*. As a producing company, World Productions must make a range of material in order to be economically viable, and even though Garnett is at the centre of the company he is not a 'producer' in the same sense that he was in the BBC in the 1960s and 1970s. Neither his taste nor his politics determine every project (indeed, nearly all World's single films and mini-series were executive produced by others, notably Sophie Balhetchet in the mid-late 1990s). Garnett has adopted two separate but connected roles within World Productions, that of head of the company, responsible to Heyman and the parent company, and that of executive producer for specific projects. In the former role, he supports others and has defined a policy for the company not according to a manifesto but as a diverse body of work; in the latter, he assumes overall responsibility for a limited range of projects, to which he is particularly connected. Certainly, his name was, and is, important as a 'brand' guaranteeing a certain kind of high-quality, critically-regarded popular drama. As Robert Jones, one of the writer/devisers of *The Cops* and *Buried*, put it without rancour: 'journalists have a shorthand – "Tony Garnett made this or that" – and some are convinced that he wrote, directed and produced it. He finds that very amusing. A show gets a huge profile because Tony's name is on it' (Rees 2003). Garnett's main contribution has been the renewable, multi-episode one-hour series, produced within, and often against, established television genres – especially crime and hospital dramas – and this will inform much of what follows. That he chose to work in this way says a great deal about the changing conditions of British broadcasting since 1979 – and, indeed, of British society itself.

British society, and the broadcasting environment with it, changed irrevocably in the decade that Garnett was in Hollywood (see Chapter 3). The post-war consensus, troubled and fragmented throughout the 1970s, was finally laid to rest in the 1980s, and the political, social and economic order on which it rested transformed. The governments of Margaret Thatcher (later Lady Thatcher), who was in office throughout the decade, proposed a radical challenge to the post-war consensus, disturbing forever the settled arrangements between the public and the private spheres, capital and labour, and manufacturing and service industries. As Stuart Hall and Martin Jacques argued, 'The main reference points of the post-war political settlement – already weakened and eroded in fact under successive Labour governments – have been contested *in principle* ... [and] a new public philosophy has been

constructed, rooted in the open affirmation of "free market values" – the market as the measure of everything' (Hall and Jacques 1983: 11). The values of the private sector produced both mass unemployment (reaching over three million by 1983), wholesale privatisation of state industries and a deep suspicion of the public services.

Broadcasting in the Thatcherite and post-Thatcher eras

Thatcherism, with its hostility towards the public sector and any impediment to the untrammelled operation of the free market, did not leave broadcasting untouched. The BBC itself was an early target for reform, and the licence fee – a good example of the state removing the sovereign rights of consumers – was subject to scrutiny. The Corporation was also politically suspect, and charges of left-wing bias were made repeatedly throughout the decade. The government set up the Peacock inquiry in 1985 to look at the case for de-regulating television – indeed, at the case for public service broadcasting in any form. The government did not adopt the more radical proposals advocated by Peacock, but restricted licence fee increases and insisted that the BBC should take a minimum of 25 per cent of its output from independent producers, in a move that significantly benefited the independent sector. The 1990 Broadcasting Act, which established the quota for independent production at the BBC, also governed the renewal of the franchises for the commercial network and introduced a form of competitive tendering, in which the franchises would go to the highest bidder, tempered by the demand for a 'quality threshold'. This made the process seem less nakedly money-driven, but did not hide its free market intentions, also evident in subsequent legislation (see Franklin 2001).

By 1985, independents had received a boost from another source, with the birth of Channel 4 (C4). The new commercial channel was established to appeal to a wide range of different audiences with a diversity of programmes in a way that was unique in British broadcasting. It was also – in a move designed to appease the free market ethos of the government – conceived as a publishing house, and not a production company, commissioning rather than making programmes. The independent sector was an immediate and grateful beneficiary of the policy, and grew rapidly in the years that followed. The policy produced unexpected results, from the government's point of view: as Cooke points out, many of the independent companies came from radical traditions of film-making, and the early years of the new

channel were greeted with the same kind of vocal opposition from the right that had greeted The Wednesday Play two decades earlier (Cooke 2003: 129).

The growth of the independents, in volume and significance, that followed was not an unalloyed blessing, since it contributed to the casualisation of the workforce as the 1980s gave way to the 1990s. Garnett is instinctively antagonistic to the idea of an independent sector, arguing that it was 'created by Thatcherites to beat up the Trades Unions, which they effectively did'. The BBC shed 7,000 of its staff between 1986 and 1990, in a move that was designed to drive costs down and increase power at the centre. (However, even Garnett has conceded that there have been 'some very good results from this so-called independent sector', one of which has been the flexibility it has sometimes afforded companies like World).

Producer power and producer choice: working with the BBC

It might have been expected that Garnett would have come back to work for the BBC, given his track-record. Indeed, between 1989 and 2000, all of World Productions work exclusively for television was commissioned by the BBC. Yet his decision not to return to the Corporation was indicative of both the attractions of the deal that Heyman offered him at Island World and of internal developments within the Corporation. The BBC began a process of internal review and reorganisation that led to a radical restructuring associated with John Birt (now Lord Birt), and which was widely seen as a way of heading off government criticism. Initially appointed as Deputy to Michael Checkland, Birt became Director-General in 1993. Birt's reforms were aimed at producing efficiency and reducing waste, but they also led to an increase in bureaucracy and management and the results were felt far beyond the balance sheet. In 1996, the BBC split its production from its broadcasting arms – essentially separating the commissioning of programmes from the making of them. Known as 'producer choice', the system disenfranchised many of the people who had previously been at the centre of creative decision making, such as department heads. Producers, in particular, found that their power to commission and develop work had evaporated, with the controllers of the two BBC channels becoming key decision makers at every level. As a report commissioned by the Campaign for Quality Television put it, 'the minutiae of decision-making is being overseen by the programme controllers of each channel' (Barnett and Seymour 1999: 54). The

report quotes extensively from BBC insiders (anonymously) detailing the destructiveness of the new regime (see also Born 2005). This was in stark contrast to the de facto system of 'producer power', in which producers were trusted to seek out, commission and develop new work, that Garnett and others had benefited from, and helped to create, through the 1960s and 1970s.

Producer choice had been preceded by new systems of audit and accountability, which had transformed its culture. Garnett had a strong sense of this on his return, when he was informally invited back to the BBC Drama Department. 'They kindly made me very welcome, the drama people', he said later 'they had, more or less, said that I could write my own ticket but I had a little look at the place and it was ... a deeply uncreative organisation – and a very sick organisation – and being trampled over by management consultants.' As the new regime took hold, getting work onto the screen, whether at the BBC or the ITV, meant satisfying the tastes of an increasingly small group of people, commissioners and controllers who had hitherto been removed from the creative process. Addressing an audience of fellow television professionals in 1997, Garnett argued that the BBC had had a culture shift thrust upon it and had been slow to respond to the new situation. Its executives had instead 'behaved like arrogant bullies – at one point I said it would be more fun to stick needles in your eyes than do business with them. As individuals people at the BBC are charming. Collectively they too often give the impression of treachery' (Garnett 1997 unpaginated).

A new, de-politicised culture and a centralised and commercially-driven broadcasting environment did not, therefore, provide an ideal situation. Yet, as noted earlier, the majority of World Production's work has been for the BBC, and towards the end of the 1990s much of that was for BBC2. Garnett built a close working relationship with successive channel controllers, especially Mark Thompson (appointed as the BBC's Director-General in 2004), able to pitch ideas directly to them and command support. Speaking in 2000, he noted that 'the little bit of room I've been given on BBC2 in the last three or four years ... is the only enclave of creative freedom that I've had, or I've heard of anybody else having, in recent times that would compare with the kind of freedom we had under Sydney Newman.'[4] World Production's relationship with BBC2 is an example of how the BBC began to treat more serious, 'authored' drama in the 1980s and 1990s. As BBC1 confronted ITV for a share of the declining mass audience with a more entertainment-driven output, BBC2 increasingly became the home of the kind of critically-regarded radical drama, mostly in series form, which might once have earned a place on the main channel.

Despite the antagonism of government and economic constraints, radical and oppositional drama was still being made; it was less likely to be found, however, in familiar forms and in the usual places. The single play, the demise of which was predicted by Gardner and Wyver at the beginning of the decade (1980), had almost disappeared by its end. What single drama there was also changed in nature; by the mid 1980s, the television *play* had become the television *film*, concluding a process that had begun in the 1960s in which Garnett had played a key role. Play for Today was withdrawn in August 1984, with the BBC's Play of the Month (BBC1 1965–83) and Playhouse (BBC2 1983) preceding it. In 1985, the Corporation introduced Screen Two (BBC2 1985–97), Screenplay (BBC2 1986–93) and Screen One (BBC1 1989–97), all three signalling the actual, and symbolic, shift to filmed drama. This new orientation within BBC drama mirrored that of the commissioned filmed drama of the new Channel 4, which initiated Film 4, a distinctive concept in film production. Film 4 commissioned films that were destined for both television screening and cinema release, and the BBC has, less rigorously, pursued a similar policy. This is exactly the kind of initiative that Garnett had argued for in the 1960s, when he had tried to secure theatrical releases for *Cathy Come Home* and *The Lump*. Twenty years later, the technological convergence of television and film accompanied institutional, aesthetic and cultural ones; indeed, without television there would have been little British cinema in the decade (see Caughie 2000). It is interesting to speculate about what Garnett would have done with the new political and film-making opportunities (which included larger budgets and more generous shooting schedules) that Channel 4 offered had he been in the UK in the 1980s.

The essentially uneconomic nature of single play production (measured in terms of cost per broadcast hour) coupled with the limited potential for overseas sales made it uncompetitive in the new production environment of the 1980s. The economic arguments were, in fact, similar to those that Donald Baverstock and others had mounted against the single play in the early 1960s, and which Sydney Newman had so comprehensively defeated (then, too, the preferred option was series drama). However, money was not the only issue. As Cooke has observed, there were political sensibilities in play. The single play, associated with social criticism, ran the risk of exposing the BBC to attack from its Thatcherite critics (Cooke 2003: 141); but if the Corporation thought that the demise of single plays would mean the end of oppositional drama, then it, and the government, were to be disappointed.

The loss of the single play is frequently bemoaned as the loss of both an opportunity for writers (and, less obviously, directors) to develop

their craft and a space for oppositional work – with the one being a consequence of the other. However, series drama is as capable of producing political and experimental drama as the single play. Indeed, long-form drama, the generic term for different types of series and serials, was not simply imposed on broadcasting but has come about partly because it offers possibilities denied the single play, and writers, directors and producers wished it. Dennis Potter had already explored long-form drama in *Pennies from Heaven* (BBC 1978), as, of course, had Garnett with *Days of Hope* and *Law and Order*. Narrative complexity can produce political complexity as well, and it is no coincidence that the most significant dramas in the 1980s and 1990s, in the sense of being radical, politically and formally, were long-form: Alan Bleasdale's *Boys from the Blackstuff* (BBC 1982), which was five episodes, developed from a single play; Troy Kennedy Martin's four-part *Edge of Darkness* (BBC 1985); Dennis Potter's *The Singing Detective* (BBC 1986) (six parts); and, to take more recent examples, *Our Friends in the North* (BBC 1996) and Tony Marchant's *Holding On* (BBC 1997). The fact that it is possible to identify each by its writer is also an indication of the survival of authored drama in a new context. *Boys from the Blackstuff* is a particularly pertinent example, since it concerns the contemporary situation of the working class, and was a television event, much as *Cathy Come Home* had been, connecting to debates about unemployment and the cost of economic 'reform'.

However, socially aware drama was not confined to authored series. Popular drama, also long-form, was radicalised in the 1980s, which was in many ways the decade of the soaps, or continuous serials. In 1982, C4 launched its own soap, *Brookside* (1982–2003), and the BBC responded with *EastEnders* in 1985. British soaps, unlike their American counterparts, have been associated with social realism since the northern-set, working-class *Coronation Street* (Granada 1960–) came to the screen (see Dyer *et al.* 1981). Both the new soaps were, as Christine Geraghty (1995) has observed, very aware of contemporary social issues, with plot-lines in the 1980s and early 1990s frequently echoing newspaper headlines. The landscape of representation was challenged in the period through several popular police drama series that put women in positions of power and at the centre of the narrative action, including *Juliet Bravo* (BBC1 1980–85) and *The Gentle Touch* (LWT 1980–84). Similarly, *The Bill* (ITV 1984–) brought black policemen into the ensemble cast of Sun Hill police station, and dealt with issues of racism in the police force (Cooke 2003: 148–52). Elsewhere on the generic spectrum, *Casualty* (BBC1 1986–) frequently adopted a political stance, especially on issues concerning the management of the

health service, which was represented as being under assault from Thatcherite cuts and a new managerial culture. Popular drama was also the site of many of the distinctive forms of postmodern television narrative. As Robin Nelson (1997) has argued, new, more rapid forms of story-telling, drawing on the multiple storylines of the soaps, have been combined with traditional concepts of character and identification to produce a 'flexi-narrative' that characterises much popular drama. The development of flexi-narratives has been shaped by US television as well, which had an impact on dramatic forms in the decade generally. *Hill Street Blues* (NBC 1981–87), a police series set in New York, was particularly influential, demonstrating the possibilities of complex, over-lapping and multi-genre narratives written from a liberal perspective.

'Where the fun is': using the series form

Garnett returned to a context, therefore, in which different modes of long-form drama dominated. Talking about the available opportunities that greeted him on his return, he observed that the drama series was particularly attractive because of its appeal to the popular audience, where his interests had always lain:

> The first thing I realised was that I've always wanted to be where the audience was, and that what used to be called the single play or single drama was pretty well dead by 1990. The audience for drama, apart from soaps which is a challenge I did not want to take up, was really in front of renewable one-hour dramas, the drama series. Which is a trade I'd never practised, so I thought I'd better learn, so I started from scratch and tried to learn how to do it.

In practising the trade, Garnett also helped to develop it. Until the 1990s, series and serials could be seen as distinct forms, each with their own characteristics. Creeber defines these usefully in the following terms: series are 'continuing stories (usually involving the same characters and setting) which consist of self-contained episodes possessing their own individual conclusion' which, theoretically at least, could be screened in any order; whilst a serial has 'a continuous story set over a number of episodes that usually comes to conclusion in the final instalment' (Creeber 2004: 8). In practice, the episodic nature of both forms has meant that the possibility for convergence has always been there, and the typical series now utilises some of the recurring features of the serial – something that Garnett was quick to appreciate:

It was what you might call a criterial attribute of the drama series that you had no character development whatsoever, so that it could go into syndication to be played in any order. It could be distributed across the world – however you wanted to do it ... In episode 35, or whatever, of *Columbo*, and episode 6 of *Columbo*, Columbo is exactly the same character ... You know no more about him in one than the other, he hasn't changed, he doesn't change [...] I felt that's boring and misses an opportunity.

So what I, with colleagues, decided to do was to try to combine the 'series' with a 'serial'. The series always has an A-story that resolves in each hour; you set a hare running at the top of the show and you catch the bugger at the end, which satisfies an audience that may not want to watch every episode, who dip in and out, because there's always a reward. The 'serial' element was character development, because it was quite clear that the opportunity was wonderful. If you'd worked in single films for the cinema, say, two hours maximum, and for television at 75-minutes a night, that's all the screen time you get to develop character relationships; apart from not having a cliff-hanger every week this is a nineteenth-century episodic novel. You've got a broader canvas over a period of time, so that if you get renewed for two or three years, you have dozens of hours to explore character and pursue much longer narratives. So we try to build a serial inside the series ... And in one way or another we've been trying to do that in all our shows ever since, some more than others ... that's where the fun is, that's where the character development is.

This project runs through much of the output of World Productions from 1993 (*Between the Lines*) to the present, and its characteristic terms – the 'fun' of character development combined with an attention to social and institutional contexts, but contained within clear narrative arcs – will run through much of the analysis that follows. The rise of the series/serial is also related to another development within the ecology of television drama, the dominance of generic television.

One result of the new consumerist model has been the remarkable strength of television genres. Generic television is everywhere, especially within popular drama series, and the space for non-generic drama has contracted. This is not simply a matter of the invisibility of the single play/film, but is a result of the kind of market-oriented commissioning policies described above. Genre in this context does not refer to programme formats – one-off dramas, series, serials – but rather to assumptions shared between programme-makers and audiences about the conventions that govern what can, or cannot, happen in a given narrative and what its characters can, or cannot, do. Genres are rarely hermetically sealed against each other and are

frequently hybridised, maximising audience appeal. Genres have also been characterised by conventions of setting as much as of narrative – hence the predominance of medical and police dramas, 'cops'n'docs' – and have arisen out of the need to combine the potential for drama with a desire for strong characters and identification.

Generic television is attractive to commissioners because it appears to deliver audiences, although this is not a simple process. Certainly, the idea of genre, of the known and familiar, empowers audiences in their relationship with producers. David Edgar has expressed this succinctly: 'Genre itself involves a transfer of power. It is the viewer saying to the producer, I possess key elements of this event before it's begun ... If foregrounding the customer is the end, genre is the means' (Edgar 2000: 75). This might well be part of a larger case for the progressive potential of genres, 'giving people what they want' rather than what the broadcasters think they need, but for the left generic television has often been associated with the formulaic and repetitive. Certainly genres guarantee access and familiarity, and also impose a shape on the narrative that constricts what can be said and how; anyone choosing to work with genre accepts the rules of the game (although it is sometimes possible to change them).

The popular multi-episode drama series, which Garnett adopted as one of the main strands of World Productions' output, is one of the main homes of generic television. It is significant that most of the main drama series with which it has become associated can be discussed in these terms. *Between the Lines*, *The Cops* and *Murder Prevention* are, in different ways, about the police, whilst *Cardiac Arrest* and *No Angels* are hospital dramas. At a tangent to these main genres are *Buried* and *Outlaws*. The former is set in a prison, and shares some of the features of a crime drama, as does the latter, which concerns the criminal justice system. *This Life*, *No Angels* and *Ballykissangel* might be seen as soaps, viewed obliquely.

One of the attractions of these genres for Garnett is that they are largely 'precinct', or workplace, dramas; that is, they create defined worlds which are both societies in themselves and connect with a society beyond the precinct walls. They are also 'institutional dramas', in the sense that the narrative is at some level about the way that the actions of individuals are shaped by the ideologies and practices of specific institutions (the police, the law courts, the hospital). The originator of the modern precinct series drama was probably *Hill Street Blues*, which experimented with both character development and generic cross-over within a broadly liberal politics. Institutional dramas take their characters out of private and domestic spaces into the public

sphere of particular working environments, whereas other popular formats often propel them back into them – for example, domestic sitcom. Sometimes the escape into the heady air of the public arena is illusory, since the workplace is frequently reconstituted as a surrogate family (as dysfunctional and internally divided as in any soap), generating narratives that centre on personal betrayal and duplicity – to put it crudely, they become soaps. This has been the destiny of *The Bill*, for example, especially at the point at which it moved into a twice-weekly format, and of *Casualty*. Although there is a lesson to be learnt here about the way that the ideological underpinnings of popular genres constrict the engagement with a wider politics, institutional dramas offer a considerable potential for realism. It is, then, on the territory of generic drama that Garnett's engagement with the forms and politics of social realism can be most easily found.

New technologies: new working practices

Garnett's decision to work primarily within the series form was also connected to his long-standing interest in putting new technology at the service of a political aesthetic. *Between the Lines* was made on film; however, the next major series, *Cardiac Arrest*, was made on digital betacam, a high-quality digital video format that is lightweight, flexible and relatively cheap, and which looks much more like film than other video formats. This became the standard medium of most of the series that followed (though not always the mini-series or one-offs), particularly the contemporary and realist strand of the work – *The Cops*, *This Life*, *Attachments* and *Buried* for example. It was a deliberately low-budget strategy, since the speed and cost of digital video meant that episodes could be shot faster and more flexibly, with smaller crews. As Garnett said in interview with Cooke:

> *This Life* was eleven minutes of screen time a day, single camera. *The Cops*, and there are an enormous number of location movements in *The Cops*, all over town, is between seven and eight minutes a day, cut show, single camera. Now that's a lot. *Between the Lines* was three or four minutes. (Cooke 2003: 181)

This was one further reason why Garnett's productions were attractive to commissioners, and it bought him and his team a considerable room for manoeuvre; 'the creative freedom I got was enormous' he told Cooke 'because I'm on a low budget, because I'm on a minority channel. The broadcaster has never interfered in who was going to be in

them, who's going to direct them, who's going to write them, what the content was. I'll do something very cheap for that kind of creative freedom' (*ibid.*). The freedom Garnett refers to is largely freedom from interference. In all the series mentioned above, Garnett retained control over casting and the choice of director and technical crew, and was able to both employ writers of his choice and control the scripting process. It also bought him status within the Corporation. 'The hit series *This Life* ... is repeatedly presented to in-house producers as a paragon,' noted Georgina Born, 'it cost just £175,000 to £200,000 for each forty to fifty-minute episode and is taken to blaze a trail in high-quality, low-budget drama' (Born 2005: 167).

Whilst the filming strategy for *This Life* is not the same as for *The Cops*, and that of *Attachments* is different again, digital video allowed Garnett to develop a distinctive way of working, a specific set of 'rules', which although not identical for each series, established similar working practices across them all. In many ways, the combination of a new working context, the utilisation of a new and liberating technology and the chance to develop a new form of televisual realism appropriate to the times, invites comparison with the moment in the mid-1960s when Garnett and Loach first experimented with filmed drama.

The working process is, as always, a collaborative one, with Garnett at the centre, the first amongst equals. Each series has its own parameters, which emerge initially out of discussion between Garnett, the series originator (who might be Garnett – in the case of *This Life* it was the writer Amy Jenkins) and the commissioner, and later involve all collaborators (including the series producer, the director(s) and writer(s)). The result is often a set of 'rules', conventions which govern the series and will contribute to its particular 'look'. These rules are not simply stylistic, in the sense that they are about the filming mechanism alone, but are related to the intentions of the narrative. One of the distinctive features of *The Cops*, for example, which represented the often brutal world of the uniformed police in a northern town, was its fluid, hand-held aesthetic, which drew on the observational style of *Prostitute* and Garnett's earlier work with Ken Loach. The conventional two-camera set up, which obeys the rules of continuity editing, was not allowed. Instead, with very few exceptions, the action was shot with a single camera on one axis, and followed rather than shaped the action. Garnett did not always tell the cameramen what was going to occur next, but asked them to respond to what was happening in front of them. 'The instructions to the operators' Garnett said 'was that we wanted it to be as rock-steady hand-held as possible. At the same time, though, we told them that we were going to put them into very difficult

situations and that they were going to have to pull focus and move around and react quickly to events' (Garnett 1998: unpaginated). Cuts are rare, and are usually time ellipses or jump cuts. A good example of this is early in the first episode of the first series, where we are introduced to many of the main characters in the locker room of the police station as they prepare for the first shift. The scene is shot entirely from a point outside the room, the camera moving in to, or away from, the action, sometimes focusing on the actor speaking, and sometimes not. The effect is of a heightened 'reality', a sense that 'what was being enacted was an unrepeatable event' (*ibid.*) that was being witnessed by both camera and audience.

This Life was shot according to similar principles, but to different effect. Typically, the set was pre-lit, with only low, natural lighting levels allowed, to guarantee the maximum amount of filming. A single hand-held camera was used (again, held as steady as possible), positioned mainly outside the actors' space, cutting into it as necessary. Garnett has said that each scene was shot about ten or twelve times, using different shooting techniques and focal lengths, to allow the maximum amount of time in the editing process. (At least one of these might be the 'whip pan', one of the most distinctive stylistic features of the series, where the camera, instead of cutting from one speaker to another, simply moves across to them – and back again, as the dialogue demands). Garnett has described the development of the shooting style for *This Life* as an experiment, and said that 'we only started to discover the show about half way through the first series'.[5] He assembled a largely young and inexperienced team about him, partly because it is his policy at World to 'bring on' the next generation (see below), but also because he didn't want to use established practices. 'We just found some editors who were prepared to have a go,' he said to Cooke, 'it's who would say well let's throw the rules out and see what works and don't let's do it the way we've always done it'. Garnett also used new technology to make the editing process a more collaborative and creative one, linking the freedom gained at the editing stage to the decision to use a high shooting ratio: 'That's why I lay some basic rules down, so that we can be shooting a lot. And then in the cutting room it'd be tried one way then another way and people would say "oh let's try this"'.[6] Garnett's role in the editing process is indicative of how he works as an executive producer:

> I watch every foot that's shot and give notes on that and then forget about it. I'm working ahead on other scripts and further down the show. And then, when they've put it together, the editor and the director and maybe the producer [...] they'll do a cut. Then I'll look at it like a punter. I

want to look at it like a member of the public really, and not get too clever with it. I'll say, well is it clear, is that involving [...] Just simple questions really. And then we'd go back in and because Avid [the editing technology] is so quick we can try lots of different ways of doing it.

In working in this way, Garnett is both initiator of the project and the viewer's representative.

Postmodern politics and institutional dramas

Garnett's interest in series drama also has a political dimension, in that it was not just the form of the single play that he felt was no longer viable but also the specific political aesthetic that informed it. The didactic, 'cynical realism' of much of his pre-Hollywood work, for example, was rejected, although this did not signal a flight from politics. Garnett remains a socialist, and is still engaged with politics, intellectually and creatively (though is still not a member of any political party). At the time of the transmission of the first series of *Between the Lines*, Garnett defended himself against the charge that he had 'softened with age' by retorting that:

I still get deeply angry at the same things – hypocrisy in high places, the waste of human lives and enthusiasms ... But I no longer need to push messages down people's throats. That was the arrogance of my youth for which I should be forgiven. These days I don't think the answers are as easily found as I did then, and I have also learned that if serious dramatic fiction is going to survive, it will be through long-running popular serials like *Between the Lines*. I was too puritanical in my youth to realise that serious issues and entertainment could be taken together. (Stoddart 1992)

Garnett's comment was made with an awareness of the need to reposition himself in a new context, indicating a break from the political aesthetic of his earlier work. He has, however, always been pragmatic, politically and professionally: 'I've always thought,' he noted, 'politically and in every other way, you have to start from what is, not what might be, or ought to be, or hopefully you would like to be'.

Garnett sees himself, self-deprecatingly, as 'just an old relic of the enlightenment'[8] still interested in Marx and Freud in a postmodern era, where the grand narratives are no more. However, he has always been remarkably adept at responding to what is in the culture at any given moment – whether it is the anti-hegemonic politics and youth culture

of the mid-1960s, the counter-culture of 1968, the revolutionary socialism of the 1970s, a feminist agenda in the early 1980s – and doing so from his own distinctive point of view. Although the range of projects that he is now involved with is increasingly diverse, it is possible to trace in much of his work both recognition of the transformation of the notion of the political itself and a re-shaping of his socialism in a new context.

It has become a truism since 1968 to argue that 'the personal is political', under the impact of the alternative lifestyles of the late 1960s counter-culture and feminism. This is generally taken to mean that areas of social experience previously ignored by 'real' politics – the home, sexual and racial identity, for example – are both intimately connected to a wider, 'public' politics and *are* political on their own terms. The sociologist Anthony Giddens (1991) has called the focus on the personal as 'life politics', understood not as a mere extension of the consumerist model into the domain of politics but as a set of distinct choices now open as a result of the increasingly global nature of economic and political life, and which are closely connected to the search for personal identity in a postmodern world.9 Life politics puts questions of personal and cultural identity, for some time at the centre of much feminism, onto a wider agenda, and these are as much existential as they are moral and political. It also makes the *search* for identity a potential source of narrative energy, which many popular series, including Garnett's, have not been slow to exploit.

The exploration of identity does not, however, take place in a vacuum. It is no accident that so many of the drama series produced by World Productions have been set in and about the institutions of the state, especially the welfare state, and the agencies of law and order, since it is in these workplaces that the main political and cultural battles of the post-Thatcher era have been fought. Yet this concern with the relationship between individuals and their work contexts is not an easy one to disentangle; the latter is never simply a backdrop to the former, and the particular stresses felt within the welfare state or the criminal justice system are sometimes the focus of the series. This is hardly surprising given Garnett's political history. There is always a twist, something that makes the series 'more than' an exercise in genre, whilst being recognisably generic. Garnett has described the political rationale for this as mounting 'trojan horse' drama (Garnett 2001: 79). Whilst the comment clearly applies to Garnett's relationship with the broadcasters across four decades of producing, it also applies to the intended affects on audiences, since they too are often 'hoodwinked' into thinking that they are being rewarded with some of the familiar

pleasures of 'cops'n'docs'. These pleasures, in some measure, usually are on offer, but so is much else besides, some of it is less comforting.

Garnett's socialism since 1990 owes a lot more to Antonio Gramsci, the Italian Marxist activist and theoretician of the early twentieth century, than to Trotsky (though he might not express it in this way himself). Gramsci is a particularly useful point of reference, since his acute observations on the workings of hegemony and the nature of political and cultural intervention have been influential on the left in Britain, especially since the 1980s. This is not the place to engage at length with this influence, or Gramsci's theory, but it should be noted that he developed both a sophisticated sense of the way that hegemony operates as a system for winning and maintaining authority and power by constructing a consensus, and demanded that attention be paid to the precise relationships between all the forces at play – cultural, political and economic – in a given historical conjuncture. Crucially, for Gramsci, writing with the example of popular support for European fascism at his shoulder (he died in one of Mussolini's prisons), it was necessary to recognise the situation as it was, rather than as it should be. Garnett has, on several occasions, paraphrased Gramsci's dictum that the way to face the world is with 'the optimism of the will and the pessimism of the intelligence' (Garnett 2000a: 23).

There are, for current purposes, two ways of thinking about the role of state institutions and these map onto two ways in which television drama of the 1970s and 1990s/2000s has viewed them. The first sees institutions in a repressive role, as agents of coercion and control. Garnett's work with Jim Allen takes this broad approach, representing the police, media and even the institutions of organised labour, the trade unions, as de facto organs of state power – *The Big Flame, Days of Hope* and (to an extent) *Law and Order* are clear examples (Garnett has referred to this as 'cynical realism'; Garnett 1998: unpaginated). The choices are stark, and the main contradictions and conflicts are between the institutions of state and those who lie outside and in opposition to them; it is an 'us and them' drama, in political terms, progressing by means of familiar binary oppositions. However, as the Thatcherite revolution progressed, and its ideologues began a 'long march' through the welfare state and civil society, the process of managing consent frequently put institutions themselves into crisis. The welfare state, especially the NHS, is a key example. The second mode of representation presents them not so much agents of coercion (or not only this) but also metonyms of social disintegration and collapse. It is significant that some of the most interesting popular drama series in the 1980s and 1990s focus on the health service, which is one of the main battlegrounds in the ideological

conflict between a state committed to extending the free market into all areas of social life, no matter what the cost, and the defenders of the inevitable casualties. The contradictions here are within the institution itself. These are apparent in the early episodes of *Casualty*, which typically placed its embattled medical staff in conflict with hospital administrators. However, the struggles that powered these narratives were between groups that the series identified as 'good' and 'bad', and the villains were often 'outside' the casualty room – it was, once more, us-versus-them drama, with clear points of identification and an unambiguous moral viewpoint. These are the tropes of political melo-drama (and it has, perhaps, been easy to lose the 'political').

World Productions' generic drama series work, by and large, in a different way. These series are concerned with the everyday routines and practices of institutional life, which, in Gramscian terms, are ideological in their ways of working; that is, they embody ideology both at the level of explicit ideas and values and at the level of the practices that govern their operation. Institutions are, from this perspective, one of the main ways in which 'private' individuals negotiate, resist or enact the 'public' discourses of politics, and the potential for exploring this connection is written into the conventions of the form of the workplace drama series. Therefore, not only are individuals pitted against the institution, but the workplace setting is the means by which individuals are connected to their social context and political responsibilities in complex ways. However, the contract between individuals and the institutions in which they operate is not between equals, and this explains some of the pessimism that seeps into, say, *Cardiac Arrest* and *The Cops*. At their best, these series do not simply pit an individual against the state, but rather explore how actions and decisions, even the private and subjective ones, are impregnated with the ideologies of institutional practices.

The police and society – the society of the police: *Between the Lines* and *The Cops*

Charlotte Brunsdon has argued that police series in the 1990s staged 'the trauma of the break-up of the post-war settlement' (2000: 196). On the one hand, this trauma made manifest a crisis of authority that was one result of the managed dissensus of the 1970s. On the other, it connected to the changing nature of crime itself in the 1980s and early 1990s: as the ravages of long-term unemployment and social collapse were etched into the social fabric, a new iconography of drug dealing,

joyriding and casual, indiscriminate violence and theft soon found its way into police series. In the 1980s, the police were also placed in openly political confrontations between the government and those it had designated a threat – anti-nuclear protesters, demonstrators against the poll tax and striking miners. Yet, at the same time, the conduct of the police themselves was called into question, and the early 1990s saw a series of miscarriages of justice that called the integrity of the police into question (those imprisoned for two IRA-inspired bombings, for example, the Birmingham Six and the Guildford Four, were released on appeal).

It is no surprise, then, that Garnett and World Productions should look to the world of the police precinct as a source for realist genre-based drama, and World's first major drama series in the 1990s, *Between the Lines*, concerned the police. Commissioned by the BBC for its main channel in a prime slot on a Friday evening (9.30 p.m.), *Between the Lines (BTL)* ran for three series annually from 1992–94. It was created and overseen by J. C. Wilsher, who had had been a long-running contributor to *The Bill*. Wilsher wrote many of the episodes across all three series and created a single narrative arc for each, providing a framework for other writers. *BTL* has been placed alongside *Hill Street Blues* (Saynor 1993), Troy Kennedy Martin's *Edge of Darkness* (Nelson 1997) and Lynda La Plante's four-part police series *Prime Suspect* (Granada 1991) (Brunsdon 2000). What made *BTL* different, however, was its focus on the Criminal Investigations Bureau (CIB), whose job it is to investigate corruption in the police force.

At the centre of a large and changing cast was a trio of CIB detectives headed by Tony Clarke (Neil Pearson) and including Maureen 'Mo' Connell (Siobhan Redmond) and Harry Naylor (Tom Georgeson). Throughout the first series, the story arc that unites all thirteen episodes concerned an investigation into corruption at the police station at which Clark has recently been based. The centre of corruption, it emerges in the final episodes, is Deaken (Tony Doyle), the boss of CIB itself. The second series was more concerned with the relationship between the police and other enforcement agencies, especially the Special Branch and the secret service, MI5. The third saw its main protagonists now out of the police and pursuing crime as private investigators. The third series was generally regarded as being less successful than the previous two – perhaps one reason why Garnett became reluctant to push other series beyond what he and his collaborators regarded as their natural life span.

Police genres are often seen as conservative, in the sense that their central motif, the solving of a crime, the rooting out of a transgression and the subsequent restoration of the social order, serves to validate the

status quo and offer reassurance that it will survive (see Bignell and Orlebar 2005: 64–5). Such guarantees may be particularly attractive at times of social change and anxiety. As Garnett put it, 'when people are worried about crime, they want to see crimes being solved on the screen ... the less confidence people have in the solving of crimes in the real world, the more they want television shows where crimes are *always* solved' (Garnett 1998 unpaginated). *BTL* is one of the first of a new generation of police series, however, that exploited the widening gap between generic expectation and perceptions about the 'real' world, rendering the genre increasingly unstable and hybridised.

The series posed a number of questions concerning the nature of policing in the early 1990s, notably who is fit to police? And where there is uncertainty about this, who polices the police? By putting the CIB at the centre of the narratives, the nature of corruption could be explored in a complex manner: as Garnett put it at the time, 'we can put corrupt police officers on the screen every week' (Saynor 1993: 11). However, the series repeatedly asks its viewers – and its characters – to question what corruption is, how it might be separated from acceptable 'rule-bending' and what actions are permitted to root it out. As Eaton notes, 'The CIB works against two prevailing values of the Met and other police forces. The first is the widespread belief that it is acceptable to break the rules to bring villains to justice, the second that it is not acceptable to betray a colleague' (Eaton 1995: 179). One of the main concerns of the CIB, and therefore of *BTL*, is this 'canteen culture' which constitutes the informal, 'common-sense' values of everyday policing, linking institutional ideologies to individual dilemmas. The way that these values are enacted, challenged and renegotiated generates much of the narrative action, especially in the first series. One of the main strategies the series uses to open up the habitual ethics of policing is to challenge the generic character stereotypes.

The protagonist of many police series, especially those that feature detectives, is often an outsider, a maverick, who bends the rules to catch criminals usually despite the institutional bureaucracy that acts as a break on initiative. The aggressively masculine Jack Regan (John Thaw) in the highly popular (especially with the police) *The Sweeney* (Thames 1975–78) is one key example here. In the context of the early 1990s, however, with new anxieties about the conduct and efficiency of the police emerging in public discourse, the 'outsider' was cast in a different mould, responding to new political and cultural concerns. As Mike Wayne has argued apropos the new hero/heroine of series such as *Prime Suspect*, 'the central characters are outsiders not because they bend the rules but rather because they are black, or are women,

encroaching into the bastions of white male power ... the outsider is someone who believes in the effectiveness of the law as an *institution* and practices its legal procedures (Wayne 1998: 29–30). It is not so much Tony Clark, however, who occupies this role in *BTL*, but Mo Connell. Mo, it emerges through series two, is a lesbian, a radical decision for the time. Indeed, her sexuality is confirmed explicitly, in a way that parallels the depiction of heterosexual sex in the series, drawing attention to just how rarely such equality of representation is allowed on screen. Mo Connell, more than any other character in *BTL*, carries moral authority, aware of the institutional culture of the force in a way that Clark and Naylor often are not. Connell's role is in no small measure the result of her being excluded from the dominant, masculine police culture. This culture saturates the narrative action of all three series, and includes drinking, clubs and suggestions of Masonic intrigue. It is part of both the densely realised narrative world that the series creates, and an object of reflection within it. The inescapable conclusion of the series is that this canteen culture produces corruption, and this seeps into professional behaviour and private conduct.

However, the series maintains an ambivalence about canteen culture, and the tensions between older and newer ways of operating are often unresolved. As Brunsdon points out, *BTL* provides a 'demotic history' of 'older' forms of policing that cuts across individual stories (Brunsdon 2000: 211). This tension is a central one for Tony Clark, who is both a problematic 'hero', in the eyes of the series' creators, and someone who is ambivalent about where his allegiances lie. Clark's conduct, especially his sexual behaviour, is repeatedly called into question as its consequences unravel (in series one, for example, he is having an affair with WPC Jennie Dean, who commits suicide). Garnett has said that he had to fight the temptation amongst the writers to make Clark a more unambiguously heroic figure (Wayne 1998: 29–30), in recognition of the pull towards identification within the genre. In addition to his questionable personal conduct, Clark remains constantly uncertain about what is happening, his power to solve crime and effect change limited by the actions of those above him. This is especially true of the second series, where the plot lines deal more with the connections between the police and other agencies of the state.

Canteen culture has its attractions for Clark, who is pulled in two directions; by the need to do his job and his affection for the camaraderie he will inevitably leave behind. One of *BTL*'s achievements is that it shows how the inextricable connections between professional practice and personal conduct lead to compromise. This linking of

public and private morality is especially clear in Clark's sexual adventurism in series one. When questioned about his relationship with WPC Dean, Clark says it will not be barrier to his promotion, for 'she knows the score'. 'Knowing the score' is a phrase that resonates across the series. It is more than a private understanding between lovers, and means accepting the rules of the institutional culture that operate in favour of men like Clark – rules that eventually drive Dean to kill herself. *BTL* demonstrates that there is a cost to placing yourself outside the embrace of the institutional culture of the police. For Clark, who by the end of series one has made his choice, 'knowing the score' is unavoidable, but carries with it its own private and professional grief.

The next time Garnett and World Production returned to the police as a source for drama was in 1998 with *The Cops*.[10] The first episode begins with the following sequence. We are in a club, and a young woman is picked out on the dance floor; she later snorts cocaine in the toilets with friends before leaving, panic-stricken, on learning that it is now 5.00 a.m.; the camera follows her to a taxi, which takes her to her place of work, whilst she removes make-up and a navel ring; as she rushes from the taxi into an anonymous brick building the audience realises that we have arrived at a police station, and the woman, Mel Draper (Katy Kavanagh), is a policewoman. The sequence, part of which the BBC used as a trailer, illustrates graphically that *The Cops* is not going to be a conventional police series. It also indicates one of its central contentions – that the police are *part of* the society they have responsibility for, and this will structure the tension between the police *and* society and the police *as* a society.

Set amongst the uniform police in a fictional northern town, Stanton (in reality Bolton), *The Cops* ran over three series between 1998 and 2001 in hour-long episodes. The idea for *The Cops* had been around for at least three years, but its realisation was delayed by the second series of *This Life*. Garnett was fully involved in all aspects of devising and producing the series, and this is perhaps the main reasons why *The Cops* had a distinctive 'authorial' stamp. *The Cops* returns to some of the same questions as *Between the Lines* – to do with the nature of policing and the relationship of the police to society beyond the police station – but poses them in a different policing context. Whereas *BTL* was socially and geographically rootless, the precise setting of *The Cops* was very important to its fictional unity and its socio-political concerns. More than any other popular police drama in the period, *The Cops* is firmly on the terrain of social realism, thematically and stylistically. Its northern, working-class setting immediately signalled its antecedents, and each series' narratives of drugs, theft and violence are seen to come

out of, and impact upon, a class-based community in crisis. 'This is not really a cop show at all,' Garnett commented, 'it is certainly not about solving crimes or catching villains' (Garnett 2000b). Cop show or not, it achieved critical and popular success, and was praised across the reviewing spectrum for its realism and narrative energy, winning BAFTAs for best drama series in 1998 and 1999.

Garnett's comments suggest that he had another agenda; there was another agenda for the broadcasters as well, for whom the need to find new takes on familiar genres was pressing. The story of how the show was commissioned offers an object lesson in how the conditions of late 90s broadcasting might be opened up for this kind of project. BBC2, under the leadership of its then Controller Michael Jackson, was attempting to broaden its audience appeal and 'needed *The Cops* to be different'. Garnett noted:

> With every other channel having a cop show, questions would be asked about why BBC2 was doing one *unless* it was different in some way. This was an invitation to me to do more or less what I wanted. You don't often get these chances in television, and there are not many times in your working life when you're given the kind of support that BBC2 gave me on this project. (Garnett 1998: unpaginated)

The support, which was also freedom from interference, enabled Garnett to produce another example of 'trojan horse' drama, in which the forms of popular generic drama are used to convey more uncomfortable observation. Garnett has commented on this process in revealing detail:

> [W]hat I really wanted to do was a show that allowed us to go into parts of our society that are not shown on television, and which are not the experience of the middle classes who are watching. The society we wanted to represent in *The Cops* is one where 'sink-estates' show the results of grinding poverty through the generations: it's a society where there's no hope or expectation, and a society where all sense of community and stability has disappeared.
> Now if I'd gone to the BBC or Channel 4 and said 'I'd like to do a series about social workers', or a similar group of people that would naturally access this context, they'd have thrown me out of the room; but by going in and saying 'I want to do a show about cops' [...] I could be sure of an enthusiastic response. They're *very* interested then [...] So I thought, if we do this show in uniforms, I can get the show made and I can get an audience to watch it, but the uniforms will take us into parts of society that we usually don't enter. (Garnett 1998: unpaginated)

Garnett's tactics indicate unwillingness amongst broadcasters in the 1990s to countenance social class (especially the working-class) as a subject for television drama. Despite evidence that the gap between the rich and poor increased between 1980 and the early 2000s, working class experience has, as Rowbotham and Beynon have pointed out, 'become peculiarly unmentionable, politically and theoretically [and] enveloped in a fog of confusion' (2001: 3). This has its origins in the undermining of familiar and established notions of class identity by the economic transformations of the previous decade, notably the decline of British manufacturing, the traditional centre of working-class cultural and political identity and the source of much of the imagery of class, and the remorseless transfer of employment from manufacturing to the service industries. These have had an impact on the way that social class has been thought about and represented. The embarrassment in talking about class also stems from the greater visibility of other, previously marginalised, social categories, such as race and gender, which have produced their own forms of radical drama, and a new imagery to place alongside, or replace, that of social class. Depictions of class, meanwhile, have often originated in pessimism and a sense of decline and crisis in the working class and its communities. Certainly a great deal of social realist cinema of the 1990s has been preoccupied with schism, fragmentation and personal and social crisis (often of masculinity itself), even when it has aimed at humour (*Brassed Off*, 1996, and *The Full Monty*, 1997, for example).

Entering the world of the contemporary underclass via the police was a complex matter. Garnett's usual research methods were used once again; all the writers who contributed to *The Cops* spent at least two weeks on the streets with uniformed police (initially, the Bolton police force, but they withdrew their co-operation after the first series). Directors and actors were similarly required to engage in first-hand research; as Garnett put it, 'I didn't want actors who had no idea about even how to put on the uniform. It's the practical things that matter: how do you get in and out of a car with all that equipment around you? ... How do you arrest somebody?' (Garnett 1998: unpaginated). Garnett was not involved in the process himself, taking the role of final arbiter between the 'truth' of the story and the demands of series narrative. He also established an inflexible rule for writers: every scene is either set amongst the police or, where a wider society is involved, motivated by the entrance of a policeman or woman. The narrative, and therefore the audience, always followed the actions of the police, and each episode is structured around an 8-hour shift. The idea was to create a sense for the viewer that she or he had accompanied the police on their journey

through a society, experiencing the violence, poverty and social disintegration as they did. This approach also created tensions around different kinds of point of view: the narrative and literal one, associated with the filming strategy described, and what Garnett terms the 'editorial' one – that is, the socio-political viewpoint of the series, which is not consistently aligned with the police.

Reviews of *The Cops* predictably picked up on the series' antecedents amongst Garnett's work, alongside more recent fiction/documentary hybrids – docusoaps and 'reality shows' of different kinds – which were generally found wanting in comparison. Several reviewers noted a similarity to US series such as *NYPD Blue* (ABC 1993–), which adopted a restless, hand-held shooting style. Garnett, though an admirer of the narrative economy and realism of US police series such as this, explicitly denies an influence, finding the camerawork occasionally mannered (that is, pursing its own form and purpose rather than following the action). It may be, however, that no matter how much *The Cops* looks unlike conventional television drama, US series, as well as contemporary fly-on-the-wall documentaries, provide an interpretative context for the audience if not the film-makers. This also indicates the changing connotations of 'hand-held' camerawork, which increasingly signifies not only documentary, and therefore realism, but also a certain kind of 'quality' popular television drama (and some independent cinema), marked out by its self-conscious difference from established practices.

The Cops, then, challenged many of the increasingly elastic conventions of police series, whilst seeking to offer many of its pleasures. This is apparent in the way that it treats the police themselves. There is no 'hero' in *The Cops*, not even a Tony Clark-type anti-hero, and the series is, as its title suggests, an ensemble piece with multiple, overlapping plot lines. Garnett has described this strategy as a way of deflecting the pull towards identification with a single figure who then becomes the point of entry into the fictional world. Refusing this option is a kind of 'alienation effect so that the audience can be persuaded to move beyond its fixation on a hero and instead move towards an examination of its own judgements' (Garnett 1998: unpaginated).

At each stage, especially in series one and two, personal dramas are played out against the larger social dramas of Stanton and its underclass. The uniformed officers in *The Cops* exist in a world in which the corrosive influence of poverty shapes the crimes they must deal with, but rarely 'solve' in any conventional sense. In the first episode, Mel investigates the death of an elderly man, whose daughter, it transpires, is an addict who has been taking his prescription. There is

no easy moral judgement to make, however, for either Mel or the viewer, since it is clear that the poverty and neglect that allows the old man's death to go undetected until his decomposing remains leak into a neighbour's flat, is also responsible for the lack of support available to his daughter. By positioning the viewer alongside the uniforms, *The Cops* also demonstrates aspects of the canteen culture of policing at this level, presented as a series of assumptions, habits and attitudes, often revealed casually through local argot. For example, the inhabitants of the Skeetsmore estate, the source of most of the crime we witness, are referred to ubiquitously as 'scroats', and much of the series is concerned with low-level warfare between scroats and police over drugs, petty crime and violence (some of it by the police). The series is saturated with the many ways in which dealing with crime and criminals is normalised in police practice – black humour and sexual innuendo in particular – its low-key style inviting the viewer to observe an alien culture in action. This informal culture exists within, and sometimes in opposition to, an official power structure, headed by Chief Inspector Newlands (Mark Chatterton). Newlands represents the new order of accountability and bureaucracy (he has a photograph of Tony Blair on his wall), his presence signifying metonymically the locus of power which shapes all their actions. The gulf between Newland and his men is understated but unmistakeable, and is registered, like much else in the series, through language. Newlands' preferred speech register is a management-speak, in marked contrast to the demotic of his officers.

However, the engagement with a society under pressure is, as the series develops, largely refracted through narratives that focus on the Stanton police themselves, and the moral and social implications of the way they exercise power. This is an aspect of a form of gravitational 'pull' within the series form towards an interest in individuals and their interaction, as the audiences become familiar with, and assert a preference for, certain characters. J. C. Wilsher recently lamented that all series drama eventually mutated into soap opera (quoted in Creeber 2004: 1), melodramas of the self and family. *The Cops* does not exactly follow this trajectory, but the police *as* a society increasingly supplants the police *in* a society. In one episode, a known criminal is 'fitted up' for a crime he did not commit by police officers, in an echo of the main plotline in *Law and Order*. In another, Sergeant Giffen (Rox Dixon) puts pressure on a vulnerable young woman, who is also an addict, in order to get to her partner's family. She commits suicide, a fact that he initially withholds from her partner, hoping to gain more information. Here, as throughout the series, *The Cops* asks difficult questions about

how failing communities such as the Skeetsmore estate are to be policed. The acceptability within the canteen culture of the police of rule-bending, if it produces results, has already been noted (Eaton 1995), and Garnett has said that focus groups formed to discuss *The Cops* seem to share these values (there was considerable support for the rough-and-ready policing tactics employed by one veteran constable, Roy Bramell (John Henshaw)) (Garnett 1998: unpaginated). This apparent consensus between police and public is challenged across the series by demonstrating that the line that separates police from criminal can be easily crossed. The police force is not an agent of state repression, therefore, but rather a moral and political battlefield where allegiances are impossible to adhere to, and where there are no final victories. *The Cops* ends pessimistically, and the last scene in the final episode concerns two characters, Roy and Mel, who have become the centre of attention, both morally if not structurally. Mel, it is suggested, will leave the police and give up on the struggle that was so clearly signalled in the series' opening. The decision, like the murder of the kestrel at the end of *Kes*, does not resonate symbolically but it does indicate a defeat, not only for Mel but also for the police.

Working in institutions: *Cardiac Arrest* and *Buried*

The police are not the only source of generic drama that World Productions has engaged with. The second major popular drama series that Garnett launched in the 1990s was set amongst the other half of the generic tagline – docs, rather than cops. *Cardiac Arrest* ran over three series from 1994–96 on BBC1 in half-hour episodes to an average of eight million viewers. It was written by Jed Mercurio, a junior doctor in a NHS hospital. The story of how he came to write it is illustrative of the ways in which Garnett tried to ensure that his series were grounded in research and the personal experience of the writer. Island World placed an advertisement in the *British Medical Journal* asking for expressions of interest from doctors with an interest in writing a sitcom about hospitals and the NHS. The brief emphasised that direct experience of the health service was necessary, in preference to experience of writing for television. Mercurio, who had had no work broadcast previously, was duly hired (though he wrote under the name of John MacCure, as he was still working as a junior doctor at the time). He successfully resisted the idea that *Cardiac Arrest* should be a sitcom, despite its half-hour format, arguing for something altogether darker and more partial.

Cardiac Arrest is located entirely within a hospital, and rarely moves beyond its confines. It is very much an institutional drama, with the routines and practices of the medical system shaping the narrative in direct ways. The first series was set in a surgical ward, Crippen Ward (a satiric reference to the mass murderer, Dr Crippen) and follows a group of newly arrived junior doctors, who graduate to initiating a new group of juniors in series two and three, this time in a casualty ward. Mercurio gave the series its main narrative premise – that it adopts the viewpoint of the junior doctor, seeing everything and everybody through their eyes – and its angry, satiric tone. Placing junior doctors so clearly at the centre of the narrative proved to be one of the most challenging things about *Cardiac Arrest*.

The managerial culture that had invaded the BBC in the 1990s was also pervasive in the NHS. A growing bureaucratisation of the service, plus year-on-year budget cuts, produced widespread low morale, especially amongst those who were expected to make the system work. In the mid-1990s, junior doctors regularly worked excessive hours, often on continuous shifts, subject to renegotiation at short notice (Jacobs 2003: 82–3). The resultant disillusion and chronic exhaustion led to anxieties about efficiency and patient safety. As Mercurio said in interview in 1994, 'if you've got the brains to be a doctor you ought to have the intelligence to realise you should be doing a different job ... Are our lives truly safe in the hands of callow 25-year-olds making life-and-death decisions after days without sleep?' (quoted in Jacobs *ibid.*). The destructive effects of creeping managerialism were represented, and resented, in *Casualty* amongst others. As Jacobs argues, medical drama in the 1990s has 'the ability to connect to societal knowledges and anxieties about healthcare, and balance emergency treatment with explorations of personal and professional identity' (Jacobs 2003: 15). This certainly applies to *Cardiac Arrest*, but not simply so, and the series has its own distinctive features.

Like other World Production series of the mid-1990s, *Cardiac Arrest* picked up on a specific generational consciousness. Both Karen Lury (2001) and Sarah Cardwell (2005) have charted the ways in which popular drama series have engaged with, often by representing directly, a younger adult audience. Cardwell especially notes the influence of popular sociology and marketing on the way that this audience has been conceptualised as 'Generation X'. The label suggested an 'in-between' generation, difficult to categorise in a more positive way, and is to be treated with circumspection, since its chronological vagueness makes it suspect (it is said to apply to anyone borne between 1965 and the late 1970s; Cardwell 2005: 124). Like most generational categories,

it was probably of more use to advertisers than to anyone else, but 'Generation X' attracted attention beyond the world of consumerism because it caught the cynicism, political disengagement and detachment from the career-building certainties of the immediate post-war years that series such as *Cardiac Arrest* and later *This Life* represent.

The junior doctors that we encounter in *Cardiac Arrest* are thoroughly disillusioned, submitting to the values of a system that promises – eventually – power and a good salary, but with no sense that this will bring happiness or fulfilment. The lack of emotional and moral engagement is palpable. The clearest example is Claire Maitland (Helen Baxendale), who is responsible for much of the on-ward training of the juniors in the first series, but remains one of the central characters throughout all three. Maitland's skill as a doctor is not in doubt, and the series offers her professional competence as a means of confirming her personal status with her peers and, by extension, the viewer (Maitland/ Baxendale was often at the centre of press comment on the series, seen to be one its main attractions for viewers of either sex; see Jacobs 2003: 98). Claire is both sexually attractive and highly intelligent, able both to critique the boorish 'lad culture' of the men and able to take on aspects of it; she can drink with the best of them and enjoy causal sex, but her aloof cynicism, lack of tolerance of 'wimps' of either gender, and coruscating directness and honesty, which is the source of much of the black humour of all three series, challenges both social and generic stereotypes.

There is a strand in the press discussion of *Cardiac Arrest* that notes her potential symbolically to 'emasculate' both male characters and viewers (see Jacobs *ibid.*), responding to an implicit, and threatening, feminism. This, however, is not acknowledged by Claire herself. She is harsh in her treatment of Liz (Caroline Trowbridge), a struggling and incompetent female colleague, and it is left to a consultant to chide her about her response to Liz and remind her, and the viewer, that 'workplace feminism' is still important. Her attitude to most of the men in the series is no more tolerant, and they are subjected to her indifference or withering contempt, rather than anger. One of the ways in which *Cardiac Arrest* explores the relationship between the institution and the individual is that by placing unconsciously sexist attitudes in the mouth of a strong female character they appear as institutional values, not gender-specific ones. Indeed, the series presents us with a con-tradiction: Claire, and many of the others, resists and subverts the everyday ideologies and practices of the NHS often by mute indifference, but those same values nonetheless shape her attitudes. The series form allows this contradiction to play out in different situations over time without resolution.

The NHS is described as a 'war zone' by one character, and from the point of view of the junior doctors, the enemy is the patients and nursing staff as much as the consultants and administrators. We are led into, and through, *Cardiac Arrest* by Andrew Collin (Andrew Lancel), who joins Crippen Ward in the first episode and is murdered by a psychopathic patient in the last. His view of events is privileged by the narrative structure, but not by its politics. Andrew is an engagingly uncharismatic figure, competent as far as he is allowed to be, but frequently subject to the whims and actions of those around him, notably the surgeons and consultants. The series' worm's-eye view of the system represents those in authority as either crazed authoritarians or incompetents, concerned only with their private practices and golfing handicaps. Everyone else simply gets by. The action of *Cardiac Arrest* juxtaposes the banal with the highly dramatic, often within the same scene, with the crisis of the institution represented at all levels. One episode represents, spectacularly, a haemophiliac bleeding to death from his nose; another sees Andrew, forlorn, in a toilet cubicle with no toilet paper. Juxtapositions such as this are woven into the recurrent formal strategies of all three series, and are reflected in the *Cardiac Arrest*'s formal stylisation, in which structured and self-aware contrasts of lighting and sound, of movement and stasis, replace both familiar continuity editing and hand-held verité.

At the launch of *Cardiac Arrest*, Mercurio argued in the *Radio Times* that the series was 'intentionally a-political' although there are 'elements that will provoke argument and discussion' (quoted in Jacobs 2003: 88). This is a curious statement in some ways, and was probably made with an eye to Garnett's reputation for analytical realism. *Cardiac Arrest* is undoubtedly political, though it does not present a clear critique of the problems it explores or any solution to them. It is hard to come away from a viewing of any episode in the series and remain sanguine about the state of the NHS, and this was one aspect of the public debate about the series. As Craig Brown commented in the *Sunday Times*, 'if I were Virginia Bottomley [the then Health Secretary] I would judge the continued transmission of *Cardiac Arrest* a far graver threat to my department's image than any number of crochety press reports' (Brown 1994: 10). One of its most radical features was its absolute refusal to adopt the favourite generic devices of hospital dramas. In the end, most medical series – however realistic their appeal, and however critical of their characters' actions they are on the way – offer a liberal fantasy of redemption: doctors are caring and basically competent (more or less), malpractice is discovered, the institution is flawed but rescued by the actions of those who are charged

to make it work. This is true, for example, of ER (NBC 1994–) and also of most police series. *Hill Street Blues*, for example, had its flawed but decent captain to anchor the audience's sense that it was possible to hold the line against encroaching chaos. Such redemptive strategies suggest that the enemy is, ultimately, not within but 'out there', and that characters, however troubled, can be made into figures of empathy. *Cardiac Arrest*, however, claims that the enemy, if he or she can be identified as such, is to be found within the NHS itself and its practices; the NHS *is* the problem. The main difference between Garnett's series and others, such as *Casualty*, was precisely its refusal to compromise its anger and cynicism. *Cardiac Arrest* offers neither an escape from the problems is explores, nor a solution to them, but rather poses dilemmas for its audiences to consider for themselves. Occasionally, a character is allowed to articulate a grievance or summarise a dilemma, but this has no explanatory or analytical force, and is more often a howl of frustration. In the mid-1990s, the radicalism of *Cardiac Arrest* lay in its refusal to remove its characters from the institutional pressures, ideologies and practices of the NHS that shape their actions, or to offer 'personal' solutions that diluted a rare and uncompromising anger. The anger at the workings of the institutions of state took a different form when Garnett and his collaborators turned their attention to the prison service.

Buried was an eight-part series of 60-minute episodes transmitted in early 2003 on Channel 4. Produced by Kath Mattock, the show was devised by writers Jimmy Gardner and Robert Jones, who, like Mattock, had also worked on *The Cops*. Garnett was executive producer, retaining a strong interest in the project throughout. *Buried* is set entirely in a fictional prison, HM Prison Mandrake, and the central narrative arc concerns Lee Kingsley (Lennie James), who is imprisoned for ten years for the attempted murder of a man who raped his sister. Lee, a successful builder, insists that he should not be in gaol, that his case was badly handled and that he will be released on appeal. From the beginning, he distances himself from those around him; 'I've worked all my life' he tells one fellow inmate in the first episode, 'You're just a fuck-up'. Lee has an edge on his fellow inmates, in that his brother, Troy, is one of the most feared prisoners in the system, and this gives him 'top dog' status but does not bring him peace of mind. He covers for the murder of one prisoner and carries out a second himself, tricked into believing his victim is a paedophile with fantasies about his daughter. The series follows his descent into the hell that is prison life, finding a sliver of peace before being casually murdered (we assume, though it is not clear). As this bald summary suggests, but does not

adequately represent, *Buried* is a disturbing and complex series, which is interested in more than just the material reality of prison life. The title of the series comes from a line from a Jacobean play: 'Art thou poor and in prison? Then Thou art buried before Thou art dead'. In *Buried*, imprisonment is as much a metaphysical and moral state as it is a physical one.

Buried was described in the press as a generic drama, but its connection to other dramas about prison is not strong. Another, more appropriate, point of reference was indicated in the press when *Buried* was announced in the C4 schedules. *Pact* magazine headlined its article on new C4 drama with 'Channel 4 – the UK's HBO?' (Anon 2003d). The reference to the US cable channel is apposite, since it has acquired a reputation as the home of 'quality' television drama, mostly in series form. HBO has scored considerable popular and critical success in Britain since the late 1990s, with a string of influential and highly-regarded series, such as *Sex and the City* (1998–2004), *The Sopranos* (1999–) and *Six Feet Under* (2001–). US series such as these, whether produced by HBO or the networks, are a model of how to write for the hybridised series/serial (Steve Coombes, the creator of *Outlaws*, has said that he learned the discipline of writing for television series by analysing *LA Law* (NBC 1986–94)). They are also a point of reference for the media evaluating a home-grown, 'quality' drama in a popular form. *Buried*, with its high standards of performance, writing and ambition, might well be placed in this context. A second relevant context is that provided by earlier World Productions. As we have noted, both the series creators and producer worked on *The Cops*, as had one of the main directors, Kenny Glenaan. Certainly, some of the main characteristics of the earlier series are relevant here, especially the commitment to a realism of setting, language, and narrative incident. The research and script development processes were also similar. *The Cops*, however, is more a point of departure than a model. Glenaan, for example, was clear that the visual style would not conform to the hand-held, documentary-style aesthetic of *The Cops*, and would not be linked to a particular narrative point of view (that of the police in *The Cops*). Instead, it would aim to be 'like the view of a lifer – not surprised by anything that happens. All-seeing, all-knowing, very wry. It can be ahead of the action ... with a lot of heightened realism' (Glenaan 2003). The film style still owes something to earlier series, and *Buried* is shot using natural light and an observational style that is more like Garnett's film work than *The Cops*; indeed, the use of extreme close-up that characterises many World series from *Cardiac Arrest* onwards is evident here.

At one level, *Buried* takes pains to establish its realism. The scripts were the product of the usual exhaustive research process, with Mattock, Gardner and Jones spending a lot of time talking to people in the prison service, especially in London's Wormwood Scrubs, where they were given considerable access to both officers and prisoners. The set was based on Woodhill high-security prison in Milton Keynes. A series 'bible' was produced, which was developed with the aid of other writers brought on board when C4 had approved the commission. It was important, therefore, to Garnett and his team that the series establish a fictional world that, as far as possible, accorded with social reality (although most of the audience would not be in a position to judge this) and that this verisimilitude be established at all levels, especially the *mise-en-scène* and performances. The realism of *Buried* is also connected to bringing hitherto unrepresented social experiences and groups into public view. One former prisoner, Erwin James, reviewed the series in the *Guardian* and argued that 'make-belief and fantasy about the subject [prison] has been peddled by programme-makers for too long [...] the team behind *Buried* have performed a great public service. It should be watched by anyone who wants to know about the darker side of serving time in a closed prison' (James 2003).

However, *Buried* is not only concerned to document or critique prison life, and its realism is not only of the observational and mimetic kind. *Buried* invests the real with significance by drawing attention to it. This is evident in its representation of the cacophonous noise that is a constant background to prison life, even at night, oppressive in its own right and a metonym of the oppression of prison life generally. Episode one, for example, begins in small rooms, and there is a moment where the camera follows Lee from a group therapy meeting into Mandrake's main social area. The noise as the viewer is led into the prison proper is palpable and overwhelming. *Buried* also breaks through the surface of mimetic realism on several occasions and in several ways. It does so, however, not because it wants to draw attention, self-reflexively, to its form, but because its main concern is with the nature of the subjective experience of prison life, and this cannot be represented solely by the established mimetic conventions.

Lee's subjective fears, dreams and nightmares break through the surface of the narrative. He sees his wife and daughter in his cell, conjuring the former up when he speaks to her on a smuggled mobile phone. There are echoes of Shakespearean tragedy, too; Lee obsessively washes his hands, Lady MacBeth-like, after the first death, and the ghost of his murder victim comes back, like Banquo's ghost, to haunt him. Lee is befriended by 'Rollie Man' (Sean McKee), who gives him

advice and support, but whose reality status is uncertain; no-one else acknowledges him, and he appears as a guardian angel, who is also a chorus, commenting on the action. In a pivotal episode, Troy is transferred to Mandrake and shares a cell with his brother. It is a moment when he and Lee must confront certain truths about their childhood, but Troy is increasingly delusional. Throughout the scene, his language is biblical – 'What you doing in this pit of despair?' he asks Lee – and he emerges naked, with a crown of thorns made from bedsprings around his head. Although this does not break the frame of the fictional world, the context invites the viewer to place it alongside the other anti-mimetic devices, allowing it to resonate with them.

In his review of *Buried*, Erwin James wrote the following about the experience of being in prison:

> The modern closed prison structure – the prison officer hierarchy, buildings, fabric and regime – have developed into a firmly established hostile entity which has the effect of systematically undermining any sense of a shared humanity. That is not to say that prisoners themselves cease to feel or believe themselves to be human. But the feeling that the system whose mercy they are at resents them – despises them in fact – creates a psychological detachment. This feeling of detachment is reinforced by the press depiction of prisoners as a different species of creature to the 'law abiding majority'. Prisoners see other prisoners as the primary source of potential harm. (James 2003)

Buried clearly wants to challenge the idea that prisoners are 'a different species', but wants to do more than this, however; it is the undermining of the 'shared humanity' that James attests to, and its consequences, that are *Buried*'s main focus. This is not explored in a sociological frame, but rather a psychological one. *Buried* moves across the boundary between the outer and inner worlds, between objective and subjective reality, and – most importantly – between outside and inside, which refers both to physical separation from the world beyond the prison walls and to the individual's subjective accommodation to the fact of prison life. Lee's story is paralleled by that of Nick Vaughan (Stephen Walters), a prison psychologist, who is similarly challenged by the experience of being 'inside'. Nick's role and the nature of his interactions with prisoners foregrounds the psychology of prison life, though not in obvious ways. The first scene of episode one is a prologue, in which Troy encounters Nick and asks him to look out for his brother. 'You come to a prison to learn psychology, my friend,' he says, 'not to teach it.' Later he taps his head and asks 'How long do you think I spend inside here? I live in here'.

Buried represents the struggle to hold onto identity in a situation where everything conspires to destroy it. Prison tests the self, especially the masculine self, revealing aggression, rivalry and self-protection as the primary values. Some prisoners adopt its values and find a kind of peace; one, who is gay, confesses to the murder Lee has committed so that he does not have to leave prison – 'it is liberating' he says. Lee and Nick, however, are challenged in ways that forces them to re-think who they are. Nick, who as young man was guilty of arson, says on several occasions that his purpose is 'to do good', but this proves impossible for much of the time. As a psychologist, he is regarded with suspicion by governor, warders and prisoners. His power over the latter is real, since his role ensures that his opinion carries weight, but it is personal authority that is really at issue. In attempting to gain real power – that is, respect and status from both inmates and staff – he loses his way morally and ethically. He seduces a female warder, and gives Lee the option of escape, unsure of how to weigh 'doing good' against his desire for personal validation. 'Have I helped you, Lee, since you've been here?' he asks in the last episode; Lee's answer, an impassive and ambiguous 'Yes', is not what Nick is looking for, but then nothing is.

Buried is pessimistic and uncompromising, yet garnered considerable critical approval. However, placed late at night in the schedules (it was not transmitted until 10.35 p.m.), it did not get the expected ratings, and C4 did not trust it enough to protect it until the programme found its audience. It may have fallen victim to a change of programming policy, as well. 'Why should a channel ... want [a series] as brilliantly acted, as sharply written, as difficult and interesting as this,' wrote the *Guardian* reviewer ironically, 'when there's the tantalising prospect of late-night specials of Hollyoaks?' (Anon 2003b). Difficult it certainly was, in the sense that it did not sit easily within either the familiar genres of popular television or the conventions of mimetic social realism. Garnett has always sought the popular audience, but recognised that within the ecology of contemporary broadcasting winning audiences 'the hard way' is a high-risk strategy.

'Soap dramas' – a politics of intimacy and identity: *This Life*, and *Attachments*

When Peter Flannery's nine-part series *Our Friends in the North* finished on BBC2 in March 1996, its place was taken by World's *This Life*. There is a symbolism in this succession, as Cooke has pointed out (Cooke 2003: 170). *Our Friends* charted the political and personal

activities of a group of friends from the northeast from 1964 to the mid-1990s, and in the process provided a chronicle of post-war British political history from a left perspective. As such, it was the kind of drama that Garnett – with Loach and Allen as collaborators – might have made in another era. *This Life*, with its emphasis on 'life politics' and the relationships between a group of middle-class, metropolitan 'twenty-somethings' seems to be a world apart – narrower in its focus and less ambitious in its view of history, but more immediately connected to the mid-1990s.

Garnett was executive producer for *This Life*, with Jane Fallon as producer. The series ran over two seasons, the first of eleven 40-minute episodes and the second of twenty-one. Amy Jenkins was the originator of the series and its principal writer. Although the conception was Jenkins', the initial stimulus for the show came from Michael Jackson, then Controller of BBC2. Jackson, who was attempting to change the brand identity of the channel and attract a new audience, contacted Garnett and 'asked whether I'd be interested in making a post-watershed show that would appeal to young people and, by the way, could the show be about lawyers?' (Garnett 1998: unpaginated). The conversation illustrates the way that broadcasters, even at the BBC, had become intensely concerned with audience profile as well as overall share (it also indicates how interventionist channel controllers had become). Jackson's instincts were right, in that the eventual success of *This Life* was in large measure the result of the way that it connected with its audience. *This Life* concerns a group of friends, who met at university, become lawyers and solicitors in London and live together in a shared rented house. The initial group of housemates consists of Anna (Daniella Nardini), Miles (Jack Davenport), Warren (Jason Hughes), Egg (Andrew Lincoln) and Milly (Amita Dhiri); during series two, Warren leaves and is replaced by Ferdy (Ramon Tikaram). Beyond them are a wider group of work colleagues, friends, casual acquaintances, sexual partners (gay and heterosexual) and (a few) parents. There is no single narrative arc, but Anna's on/off feelings for Miles, whose wedding to someone else concludes the second series, is threaded through the story, as is Egg and Milly's long-term, but ultimately doomed, relationship.[11] *This Life* is primarily character- rather than plot-driven.

As Creeber (2004), Cardwell (2005) and Cooke (2003) have argued, *This Life* was closely connected to its historical moment – and indeed to its moment within the internal history of BBC Drama, which is one of the main reasons why it seems so different to *Our Friends in the North*. As Cooke observes, 'Where *Our Friends in the North* represented "old style" BBC social realism, *This Life* represented the fast-paced, "new

realism" of flexi-narrative drama' (Cooke 2003: 179). According to Georgina Born, this distinction was exactly replicated in the BBC Drama Group, represented in the contrasting attitudes of Michael Wearing, the executive producer for *Our Friends*, and the channel controller for BBC2, Michael Jackson. Wearing thought Flannery's drama 'important and innovative,' whereas 'Jackson found it ultimately outdated, even if successful, and instead spoke of series and soaps as *the* contemporary form: lacking closure, polyphonic with no dominant narrative line or voice. For Jackson and others, *This Life* exemplified this fertile trend' (Born 2005: 356). *This Life* embraced, and helped to define, an energetic and visually innovative narrative style tailored to the series/serial form. As Cooke (2003: 181–2) has demonstrated, the narrative is fast-paced, using an unusually short average shot length, combined with a hand-held aesthetic that incorporates intense close up (see above). Whilst some reviewers found this visual style distracting (see McGregor 1997: 126–7), there is no doubt that it was influential and distinctive.

The open narrative structure and the close relationship between series and audience are suggestive of soap opera. Creeber has called *This Life* and series like it 'soap drama', a variant of the series/serial hybrid that incorporates 'elements of soap opera, drama, comedy and comedy drama' (Creeber 2004: 115). The connections with soap lay primarily in *This Life*'s interest in the personal lives of, and relationships between, its characters as they go about their 'everyday' business. This involves endless talk, sex (hetero and homosexual, casual and committed), drug-taking, going to the loo, taking baths, drinking and eating – and much else besides, including going to work. This, in turn, generates an investment from the audience that is similar to that produced by the continuous serial, with characters' lives running parallel to those of viewers. There is no obvious and necessary climax to the narrative, although the need to conclude series two produced closure of a sort in a wedding (which suggests, of course, a new beginning). Significantly, it is not the locally-realised social realism or the anxiety about (working-class) community that informed the early days of the British continuous serial that is picked up on, although the absence of 'community', and an unspoken wish for something to replace it, is in the fabric of *This Life*.

The political differences between *Our Friends* and *This Life* can be exaggerated: towards the end of *Our Friends*, as the series moved into the 1990s, it seemed to acknowledge the relevance of 'personal' politics, as issues around the relationships between fathers and sons moved into the frame. Similarly, *This Life*, though clearly not like the

specific forms of social realism familiar from television drama of the 1960s and 1970s, can nevertheless be discussed within the broad realist tradition. Above everything else, the appeal of the series was to the *contemporary*, one of the central criteria by which realism has been defined (see Williams 1981). Additionally, there are clear connections between *This Life* and Garnett's earlier work, not least at the level of film style, since the series' hand-held aesthetic is a variant on the observational realism he had already developed, and which had also informed the style of *Cardiac Arrest*.

This Life also shares some of the same narrative territory as *Cardiac Arrest* since it, too, explores the contemporary in terms of a distinctive generational consciousness. *This Life*'s twenty-something characters are cut off from both the 1960s of their parents and the 1980s of their teens. As Sarah Cardwell has noted (2005), the series is self-consciously aware of itself as being about a particular generation – 'Generation X' – that is marked out by its cynicism, detachment and lack of faith in what lies beyond the tangible immediacy of the personal. The world beyond the house is at times incomprehensible and certainly unchangeable; at worst, it is threatening. The first line of the first episode is voiced by Warren speaking to his unseen therapist: 'Outside is chaos'. Egg, in the course of his interview for the law firm (also in the first episode), says 'I don't believe in theories ... You can't do anything about the world'. The house is a curiously adolescent space, in which the responsibilities of the adult world are put on hold. Whenever 'adults' – that is, people from another generation – enter the space they are either alien outsiders, or, like Egg's dad (Paul Copley), in flight from adult responsibilities. Cross-generational relationships, such as Millie's affair with her boss, the middle-aged O'Donnell (David Mallinson), are doomed and destructive. As Sarah Cardwell aptly puts it, 'the "twenty-somethings" in *This Life* embrace the present over the past, whilst hoping to defer the future' (2005: 130). This attitude is not theirs alone.

Amy Jenkins, a former law clerk, was clear that *This Life* was both about, and aimed at, a particular generation:

> I wanted to give a voice to my generation, because they've never had one on television ... We wanted to reflect that this generation is the first who can't expect to do better than their parents; who can't afford to buy property; who find it very hard to get a job; and who are not threatened by casual drug use. There's a new cynicism – or reality – about relationships because so many of us have seen our parents split up. *This Life* isn't about these issues, but they are there in the background. (Jenkins 2003)

The first episode makes several references, some ironic, to the 'voice of youth'. Indeed, the phrase is used directly of Miles, who is part of an interview panel when Anna is seeking a position at his chambers and is asked for his opinion. At another point, Anna says to Egg 'I'm going to say something really subversive now. The Beatles were crap'. More generally, *This Life* uses popular culture to delineate its fictional world. In episode two it is the turn of the 1980s: Miles' new Paul Smith jacket is derided by his housemates as being 'so '80s', along with champagne ('M&S [Marks and Spencer] do it cheaper', as Millie says).

Part of the realism of the series lay in the way that it showed a world in which swearing, nudity, recreational drug-taking and casual sex (both gay and straight) was an accepted part of everyday life. It is not celebrated, denigrated or exploited symbolically, but is simply *there*, and there is no editorialising in its narrative stance. This refusal to condemn or foreground what some reviewers found indecent provoked a response in the press that echoed the reception of *Up the Junction*. The *Yorkshire Post* review argued that '[t]he destruction of young minds proceeds apace and a demoralised public has stopped even protesting about it.' The *Daily Mail*, late to the feast, was 'appalled at the drugs, booze and, worst of all, simulated sex between homosexuals' in the final episode, and, adopting a stance redolent of Mary Whitehouse and the NVLA, argued that '[w]e should complain more often and perhaps our comments would have some weight in preventing such trash being shown' (McGregor 1997: 126). Positive reviews celebrated its depiction of the reality of contemporary Britain: 'Whilst some viewers will doubtless whip up the familiar storm about the language, nudity and explicit sex,' argued the *Financial Times*, 'others will welcome a drama which, without being coy or aggressive, shows young people behaving as they actually do behave' (1997: 127). This clearly places the series on the territory of contemporary realism, defining 'how things really are' at a particular moment of cultural and political change. Between the series' first episode and its last, the Labour Party won a general election, and the argument about the series was quick to encompass this changed political landscape (though not always positively). 'This is Brown–Blair's Britain,' wrote the *Guardian*, 'Joy tends to be fleeting, and introduced by chemicals and the prospect of Anna' (1997: 127).

The realism of *This Life* was also bound up with another of Williams' criteria, that of social extension, although it is not the marginalised experience of the working class that is brought centre-screen but rather sexual orientation and ethnicity. *This Life* adopted a ground-breaking (for the time) view of gay identity. The series is notable for not representing homosexuality within the stereotypes of campness or

victimhood, with its gay characters – particularly Warren and the initially bi-sexual Ferdy – allowed an identity beyond the confines of their sexuality. Similarly, Ferdy's ethnic background is not an issue (Ramon Tikaram is of Fijian descent). *This Life* marked television's 'catching up' with some of the complex realities of mid-1990s Britain. It offers a range of characters and attitudes, from Egg's attempt to be a 'new man' when he gives up his job to become a writer, to Miles' ambivalence about what is expected from him in a post-feminist world of equal opportunities. All the women work, and Millie supports Egg.

Work is important to the main characters, and indeed to the narrative of the series. The workplace, which includes the courts, is often a place where the personal dilemmas encountered in the house are echoed or refracted through the experience of others. Egg, for example, cannot feel passion or commitment about anything much outside football, but is made to reflect on the need to 'sieze the day' by a cancer sufferer who passes through the office. 'When we started doing *This Life*,' Garnett has said, 'we realised that most of the stories related to the law firms were boring ... So we then asked our writers and legal advisers to come up with suggestions of cases that somehow resonated with the problems that our characters had that week ... The attempt was to make one thing resonate with another' (Garnett 1998: unpaginated).

The characters in *This Life* live in a world where friendship substitutes for family, and where work is a means of making a living rather than defining one's identity. The programme benefited from the success of the US series *Friends* (NBC 1994–2004), which provided another take on the situation of twenty-something communal living, and was one of several series from both sides of the channel set amongst friendship groups (Creeber 2004: 115). (Although it was not an influence on the series, *Friends* was a point of reference for the reviewers and possibly the audience.) The sociologist Anthony Giddens has termed the kind of relationship networks that are freely-chosen and based on friendship as 'pure relationships', which have the characteristics of the 'late modern' – that is, contemporary – period. 'In contrast to close personal ties in traditional contexts,' he argues, 'the pure relationship is not anchored in external conditions of social or economic life – it is, as it were, free-floating' (Giddens 1991: 89). Pure relationships, including those that were previously founded on social contracts, such as marriage, are 'sought only for what the relationship can bring to the partners involved' (1991: 90). They are also 'reflexive', meaning that that they require self-examination and regular checking: '"Is everything alright?" figures as a leading motif' (1991: 91). Pure relationships bring their own anxieties, which centre, in this context, on

questions of commitment and intimacy. 'Intimacy, or the quest for it, is at the heart of modern forms of friendship and established sexual relationships' writes Giddens (1991: 95), and is at the core of each individual's self-identity.

Intimacy, what it consists of, how it might be won and maintained, is a particular concern for the characters in *This Life*. The search for intimacy drives some of the most important plot-lines (especially, but not exclusively, those involving sexual identity), and the difficulty of finding and holding onto it creates much of the complexity around the characters. The house becomes a space where intimacy can be negotiated, resisted and broken, often in unexpected ways. As viewers, we are witnesses to characters in states of vulnerability (naked, emotionally distressed), whilst the problem of intimacy is often foregrounded. 'I hate talking,' says Anna, 'it's so intimate [...] I just want a fuck.' Anna's attitude crystallises an important narrative and emotional point, that real intimacy is based on communication, which can be dangerous. Anna is a pivotal character in this respect, since both intimacy and self-identity are elusive for her. In this, she represents a particular kind of 'post feminist' dilemma, in which fulfilment can't be found in either of the places where it is supposed to reside, inside a relationship or in the workplace. Anna, like Claire Maitland in *Cardiac Arrest*, is sexually attractive, highly intelligent and remorselessly honest and direct, showing behaviour that is often considered 'male'. Like Claire, she drinks, has a repertoire of memorable putdowns, and is capable of ruthlessness – especially sexually. Anna is outwardly confident and highly vulnerable, a tension that is held across both series and provides one of their central emotional and narrative threads. True to the series's desire for openness, it remains unresolved. Ultimately, the problem for Anna is one of commitment, which may embrace sexual trust and fidelity but is not reducible to them. Commitment is hard to build and demands reciprocity. As in most soap dramas, issues of commitment, how it is obtained, to whom should it be given and on what terms, and – crucially – how it is to be maintained, are vital to *This Life* and animate the intricate web of everyday actions and interactions that constitute the narrative.

Despite the success of *This Life*, the series concluded after two series. This was not popular with the audience, many of whom wrote to the BBC demanding a third. In reality, it was Garnett and World Productions who chose not to make a third series,despite concerted pressure from Mark Thompson and BBC2. Garnett/World's view was that there was nothing more that could be done with either characters or situation. The eventual success of the series is illustrative of the way that

innovative series succeed, or not, in the circumstances of contemporary broadcasting. *This Life* did not win immediate, or huge, audiences. Thompson, like Michael Jackson before him, had made a personal investment in the show, and sought to protect it by putting repeats of the hugely popular *Absolutely Fabulous* in front of it. It was not until the second series (which had been agreed as part of the original deal) that *This Life* seems to have taken off, both in terms of its critical reputation and connection with its audience. However, the series' success was of a particular kind. At no point did it gain a mass audience (its average audience was 2.7 million, but the last episode attracted nearer four million). This was respectable for BBC2, but not remarkable. The key to its significance can be gleaned from some of the press comments: '*This Life* is said to dominate the conversation at every smart dinner-party in London' wrote the *Evening Standard*, and the *Daily Express* noted that it was 'the programme that made BBC2 cool again' (McGregor 1997: 126). *This Life* was successful, therefore, with a particular, highly desirable audience, and this helped BBC2 to connect to that audience, and change its brand image in the process.

The success of both *This Life* and *The Cops* meant that BBC2 were receptive to new series, although pre-disposed to see any new ideas in terms of World's proven success. The successor to *The Cops* was a precinct drama of a rather different sort, one which placed itself between the institutionally located 'cops'n'docs' and the soap drama exemplified by *This Life*. The series, *Attachments*, ran for two series, the first of ten 50-minute episodes in 2000 and the second of sixteen 30-minute episodes in 2001–02. Garnett was executive producer, with Simon Heath as producer. The writing team was led by Richard Zajdlic, who was head writer of the second series of *This Life*, and there were several directors. *Attachments* was set largely in the offices of a fledgling internet company as its originators, Mike (Justin Pierre) and his business and sexual partner Luce (Claudia Harrison), are set to turn a hobby into a business with the aid of a backer. They are aided in their efforts by a lesbian journalist Sophie (Amanda Ryan) and the misanthropic Reece (William Beck), a website designer, Jake (David Walliams) and computer geek Brandon (Iddo Goldberg). It was the first major drama series to concern itself with the workings of a company involved in the dotcom boom of the late 1990s and early 2000s. There is no single narrative arc, but the difficulties faced by Mike and Luce in keeping both their relationship and business intact against a series of personal and financial threats run across both series. *Attachments* was innovatory as well in that the website at the centre of the business was simultaneously run by World on the web (www.seethru.co.uk)[12] and

was updated to parallel events in the series. Garnett was particularly proud of this, seeing it as an extension of his interest in the technologies of television drama and as a way in which audiences might be engaged in the narrative that was appropriate to an age of computer games and the Internet.

BBC2 placed *Attachments* – and Garnett's reputation – at the centre of its drama offerings in the 2000 season. 'If you want to see where BBC2 is going just now,' said the new controller of the channel, Jane Root, quoted in a BBC press release, 'just look at *Attachments*. As well as being a stunning piece of modern new drama really pushing the boundaries of innovation and experience, it is also an undiluted expression in our trust in Tony's track record as a creative who delivers the fresh ideas and talent that define BBC2 time and again' (BBC 2000). The auguries were good, therefore, and the series' arrival was eagerly anticipated. However, *Attachments* did not achieve the success of *This Life* and did not connect with an audience in the way that the earlier programme had done. The reasons why are complex, and lay partly in the way that the series attempted a hybrid between soap drama, defined in relation to *This Life*, and a 'precinct drama' of the kind that was found elsewhere in World's output (*The Cops, Cardiac Arrest*) where the practices of the institution itself are at issue.

Attachments represented what was seen to be a contemporary phenomenon, that of workplace relationships. In a culture of long hours, where work provides a source of personal identity as well as income, it is the workplace where many people find intimacy and self-identity (Giddens 1991). In *Attachments*, the workplace fulfils many of the same functions as the house does in *This Life*. This is caught in the description of the series contained in the BBC press release, which give an accurate sense of its concerns, if not its ambitions:

> Exploring the growing phenomenon of workplace relationships this bold new drama goes into the modern day office and under the skin of the thirty-somethings who are increasingly blurring the boundaries between life, sex and career.
>
> Set in an internet start-up company, *Attachments* is less about the world-wide web that the tangled web of sex, politics, ambition, power play, harassment and e-courtship that typifies the daily interaction of the site itself.[13]

What *Attachments* only intermittently achieves is a sense of the reality of that specific work environment, of the particular pressures and challenges of an internet start-up company, within a dramatic format. The series has its '*ER* moments', where what is at stake, dramatically

and emotionally, is evident at moments of crisis, even though the specific dialogue (in the case of *ER*, the medical terminology) is incomprehensible to the uninitiated viewer. However, as Kathryn Flett noted in her *Guardian* review, 'it's pretty difficult to squeeze high drama out of a scene starring a crashing computer' (Flett 2000). Generally, the press reaction to the first series was in agreement that the more the narrative focused on the internet business, the less successful it was, whilst agreeing that *Attachments* was generally well-researched and realistic. The interactive website, similarly, did not catch on. This was partly because, in a cruel accident of timing, the appearance of the series coincided with the bursting of the dotcom bubble, and the stock market collapse of many of the seemingly impregnable high-flying companies. The first series did, however, represent something of the threats and dangers faced by a start-up company, even in the new web-based sector, where predators and venture capitalists wait, as they do in every other sector of the economy.

Series two, however, placed much less emphasis on the specific environment of an internet company, and much more on the workplace per se, and the relationships between characters in it. *Attachments* began to share some of the same emotional territory as *The Office* (BBC 2001–03), set in the same featureless space, which betrays little of what is actually done, and where the most important things happen in the interstices between 'work'. As Jacques Peretti observed in the *Guardian*, '*Attachments* nails the full horror of the modern office with surgical precision' (Peretti 2001). Economic insecurity occasionally cast a shadow across *This Life*, with Anna's debts mounting (pointing to the clerk in episode one, Anna remarks ruefully that 'he's the only person I know with a pension'), but it bites deeper, if less obviously, in *Attachments*, providing a sub-text against which relationships can be measured. One result is that people spend more time at work, dissolving the boundaries with leisure and many other aspects of the personal. Peretti again:

> *Attachments* has been compared to *This Life*, but the five years between the two have been marked by a telling shift towards work. In *This Life*, the ratio of home to work locations was 50:50. In *Attachments*, it is about 80:20. Yet even in a recession, TV writers will continue to focus on the intense relationships of the office. Every hermetically sealed work environment, from The Oval one inhabited by Martin Sheen in *West Wing*, to the polystyrene one inhabited by Ricky Gervais, is governed by the same laws. (Peretti 2001)

'The laws' here are essentially the laws of workplace exploitation in a postmodern cloak, and the series seems like a response to theories,

such as those of Richard Reeves, who celebrated the new workplace culture. In *Happy Mondays* (2001), Reeves argued that in a de-unionised workplace, in which 'fun' was tolerated (and 'rights' irrelevant), the new work/leisure environment was the future. 'Work is a provider of friends, gossip, networks, fun, creativity, purpose, comfort, belonging identity – and even love. Work is where life is' (Reeves 2001: 2). The reality, as *Attachments* shows, is an increasing powerlessness and desperation, in all its character's relationships. Intimacy seems an illusion, as is commitment. Garnett felt that *Attachments* did not really take off, even in the second series, because its characters were all too 'negative'; there was no-one, in the end, with whom the audience could identify.[14] Perhaps this is not in the end simply a question of 'character' but of environment; *Attachment*'s vision is, ultimately a deterministic one – more so than Garnett's ostensibly naturalist dramas of the 1960s and 1970s.

Looking to the future

By the mid-1990s, especially after Margaret Matheson left, Garnett was becoming increasingly exhausted by the strain of keeping fully involved in all of World Production's projects. 'I did get to the point ... where I was pretty well killing myself,' he later said, especially when *Cardiac Arrest* and *Ballykissangel* were in production. Over the next few years, Garnett began to take a different tack, in which he became less involved in the detail of production – 'doing less of giving notes on the fifth draft of the fourth episode, or detailed notes on rushes and things like that' – and more concerned with general direction and policy. The plan was to secure some 'thinking time' in which to develop a particular kind of company, one in which producers and executive producers are supported in a creative role – the sort of role he had always tried to create for himself:

> I've always thought there was room for a different kind of company. Not everybody wants to work for a big organisation like the BBC, and the days when producers can start their own drama company are pretty well over. It just costs too much and is too risky. Lead times are so long and so on. Also, most really creative producers want to put all their energies into putting a show together, they don't want to be business people. They don't want to be worrying about the VAT, or whether the photocopier is working, or clause 5b in a changed format contract for the BBC. So I realised that we had a company with a track record and business affairs and accounts and IT and all the infrastructure, and all that sort of bullshit you need to run a company, and access to

broadcasters, and so we had somewhere which, hopefully, I could turn into a company of producers. Where everything is taken off their backs, except what they're there to do, which is to be creative and actually make good work happen. And we've now got 8–10 producers here [January 2006] and they all are doing their own show. And I help them as much as I can ... So it's a different company to the one we started in 1990.

The result of this re-orientation of Garnett's role has been that he is increasingly less likely to have his name on the credits. 'I'm there as a resource,' he noted, 'I'm working more anonymously across a bigger range of shows. That's why I don't take many credits – at my age I don't need credits on a screen but they do'. Garnett dates the changes described here, which were more to do with his role and the culture of the company than its basic mode of operation, to the turn of the century, and sees them as the result of an evolutionary process. In effect, what he outlines is a model that is strongly reminiscent of the BBC Drama Department of the mid-1960s under Sydney Newman. He did not plan it this way, and realised only later what his real intentions had been:

It only dawned on me after I'd been doing it for quite a while that that's really what I was trying to recreate ... the fifth floor of the Television Centre in 1964, '65, '66. When I was there with Ken Trodd, Roger Smith, and there were a whole number of other drama producers on that corridor, all doing their thing ... But we would be in and out of each other's offices, saying 'hey, do you know anybody who could write this' or 'I've got a problem casting'. It was at its best a very, very energising and supportive atmosphere.

In one sense, then, Garnett's future is in his past: but in another, of course, World Productions is thoroughly embedded in the ecology of contemporary drama production, and is probably stronger, and certainly larger, than it has been at any point in its sixteen-year history. World's website (June 2006) indicates that a range of work is forthcoming, including several new multi-part series. These include *Lillies*, with Garnett as executive producer, an eight-part drama set in the Liverpool docklands during the 1920s, which is described as a 'coming of age' drama about three sisters set against the backdrop of the depression; and *Party Animals* an eight-part series set amongst twenty-something political advisers, described as 'the rugrats of the political area in a post-Brown and Cameron generation'.[15]

Garnett also remains passionately interested in the potential of new digital technologies to produce a new democratic era, with the ability to

produce high-quality drama (technically speaking) cheaply. Contrasting the contemporary situation with that of forty years ago, Garnett argued thus:

> Now [it is] point and shoot, and it's a bit like writing; most people can write, but very few people can write in a way that other people want to read. But now anybody can shoot a film, we still call it a film, but not many, obviously only some people are going to be able to do it in a way that means something to others but it's marvellous. I love it. And everything will be accessible to everyone because server space is pretty well infinite and streaming video is round the corner. The problem is finding it, so it's going to be a marketing problem ... you won't have to book a cinema, you won't have to own a TV station ... you can put your own website up in your own room and people can get it when they want, and this is only the beginnings of that, and so it is the democratisation of the business. Of course, through brands and marketing clout, the big media companies will continue to dominate. And the state will try to clamp down. But the opportunities for direct communication are radically increasing. That has to be good. I wish I were twenty again.

This is a characteristic mixture of enthusiasm and caution, since the proliferation of drama does not guarantee its quality, and the ownership and control of the means of distribution will still be a live political issue. The task for all practitioners engaged in creating drama in a digital age remains essentially the same as it has always been – finding a 'truth' and telling it. Garnett summed this up succinctly and optimistically in 2001:

> We all see ourselves and each other being represented on television. You can't raise consciousness unless you confront reality, and I still think it's important to struggle for true representations. That is achieved through constant struggle and goes beyond any particular political agenda. Dramatic fiction, if it rings true, can help us feel what it is like to be someone else. It can make us feel less alone, and it can be the invisible glue that binds communities and social classes. We all live by stories, by myths; we all need a narrative to hold our lives together. The question is: which narrative? That is why history is so fought over. Tell us a story, tell us a true story. Well, I shall attempt to go on doing so. (Garnett 2001: 82)

Notes

1 For a biography of John Heyman, see World Productions, website: www.world-productions.com/wp/content/world/worldwh2.htm. Accessed 28 March 2006.

2 I will refer to the company as World Productions when dealing with either post-1993 work or when discussing its output as a whole, and Island World when referring to work before 1993.

3 Interview with the author, 16 January 2006. All quotations from Tony Garnett that follow in this chapter come from this interview unless otherwise stated.

4 Interview conducted by Lez Cooke, 29 February 2000.

5 *Ibid.*

6 *Ibid.*

7 *Ibid.*

8 *Ibid.*

9 I am grateful to Glen Creeber (2004) for drawing my attention to Giddens' work.

10 World's six-part *Ultraviolet* (1998), about a team that tracks down vampires, shares some of the features of an investigative thriller but is not, strictly-speaking, a 'police series'.

11 An episode guide can be found in T. Macgregor (1997) *This Life: A BBC Companion* London: BBC Books/Penguin.

12 Although the programme is now off the air, the website can still be accessed (26 May 2006).

13 'BBC News Release: Autumn test-bed on BBC 2 for fresh ideas and talent' www.bbc.co.uk/info/news/news263.htm last accessed 25 April 2006.

14 Interview with the author, 7 July 2004.

15 www.world-productions.com/pages/productions last accessed on 19 June 2006.

Appendix I:
List of television plays and films

Tony Garnett as producer: television plays/films and long-form dramas

Up the Junction
BBC Wednesday Play; tx 3 November 1965
Writer Nell Dunn; Director Ken Loach; Producer James MacTaggart
(Garnett was nominally story editor, but took a co-producing role)

Cathy Come Home
BBC Wednesday Play; tx 16 November 1966
Writer Jeremy Sandford; Director Ken Loach

The Little Master Mind
BBC Wednesday Play; tx 14 December 1966
Writer Nemone Lethbridge; Director James MacTaggart

The Lump
BBC Wednesday Play; tx 1 February 1967
Writer Jim Allen; Director Jack Gold

In Two Minds
BBC Wednesday Play; tx 1 March 1967
Writer David Mercer; Director Ken Loach

The Voices in the Park
BBC Wednesday Play; tx 5 April 1967
Writer Leon Griffiths; Director John Mackenzie

Drums Along the Avon
BBC Wednesday Play; tx 24 May 1967
Writer Charles Wood; Director James MacTaggart

An Officer of the Court
BBC Wednesday Play; tx 20 December 1967
Writer Nemone Lethbridge; Director James MacTaggart

The Golden Vision
BBC Wednesday Play; tx 17 April 1968
Writers Neville Smith and Gordon Honeycombe; Director Ken Loach

The Gorge
BBC Wednesday Play; tx 4 September 1968
Writer Peter Nicols; Director Christopher Morahan

Some Women
BBC1; tx 27 August 1969
Writer Tony Parker; Director Roy Battersby

The Big Flame
BBC Wednesday Play; tx 19 Feb 1969
Writer Jim Allen; Director Ken Loach

The Parachute
BBC Play of the Month; tx 26 January 1969; as a Wednesday Play on 6 August 1969
Writer David Mercer; Director Anthony Page

In Black and White
Kestrel/LWT; not transmitted
Writer Jeremy Sandford; Director Ken Loach

After a Lifetime
Kestrel/LWT; tx 18 July 1971
Writer Neville Smith; Director Ken Loach

The Resistible Rise of Arturo Ui
BBC; tx 22 February 1972
Writers Bertolt Brecht and George Tabori; Director Jack Gold

Hard Labour
BBC Play for Today; tx 12 March 1973
Writer/Deviser/Director Mike Leigh

Blooming Youth
BBC Play for Today; tx 18 June 1973
Writer/Deviser/Director Les Blair

Stephen
BBC Play for Today; tx 4 June 1974
Writer/Deviser/Director Brian Parker

The Enemy Within
BBC Play for Today; tx 10 June 1974
Writer/Deviser/Director Les Blair

Five Minute Films: *The Birth of the 2001 FA Cup Goalie; Old Chums; Probation; A Light Snack; Afternoon.*
BBC; made 1975; untransmitted until 1985 (various times)
Writer/Director/Deviser Mike Leigh

The Price of Coal x 2
BBC Plays for Today; *Meet the People: A Film for the Silver Jubilee*: tx 29 March 1977; *Back to Reality*: tx 5 April 1977
Writer Barry Hines; Director Ken Loach

The Spongers
BBC Play for Today; tx 24 January 1978
Writer Jim Allen; Director Roland Joffe

Law and Order x 4
BBC Play for Today; *A Detective's Tale*: tx 6 April 1978; *A Villain's Tale*: tx 13 April 1978; *A Brief's Tale*; tx 20 April 1978; *A Prisoner's Tale*: 27 April 1978
Writer G.F. Newman; Director Les Blair

Tony Garnett as executive producer for (Island) World Productions

Only Island/World programmes where Garnett has been producer or executive producer are included here.

The Staggering Stories of Ferdinand de Bargos
BBC2; four series tx 16 November 1989–3 September 1995
Executive Producer Tony Garnett; Writers/Producers Geoff Atkinson and Kim Fuller

Born Kicking
BBC1; tx 20 September 1992
Writer Barry Hines; Director Mandie Fletcher; Producer Tony Garnett

Between the Lines
BBC1; 3 series (35 episodes) tx 18 September 1992–21 December 1994
Series creator and main writer John Wilsher; other writers included Dusty

Hughes and Rob Heyland; directors included Ross Devonshire, Alan Dosser, Charles McDougall, Jenny Killick and Roy Battersby; Producer Peter Norris

Cardiac Arrest
BBC1: 3 series (27 episodes) tx 21 April 1994–22 June 1996
Writer Jed Mercurio (aka John MacUre); directors David Hayman, Audrey Cooke, Morag Fullerton, David Garnett, Jo Johnson, Peter Mullan; producers Paddy Higson and Margaret Matheson.

Ballykissangel
BBC1; 6 series (58 episodes) tx 11 February 1996–15 April 2001
Series creator and main writer Kieren Prendiville; other writers include Niall Leonard, Jo O'Keefe, John Forte, Robert Jones and Rio Flanning; directors Richard Standeven, Paul Harrison, Dermot Boyd; producers Joy Lale, Chris Griffin, Chris Clough, David Shanks; Garnett was executive producer for series 2 only (series 1, 4–6 were executive produced by Sophie Balhetchet, series 3 by Brenda Reid)

This Life
BBC2; 2 series (32 episodes) tx 18 March 1996–7 August 1997
Series creator and main writer Amy Jenkins; writing team included Richard Zajdlic, Jimmy Gardner, Amelia Bullmore Patrick Wilde, Mathew Graham, Mark Davies Markham, Joe Ahearne, Ian Iqbal Rashid; directors included Sam Miller, Audrey Cooke, Nigel Douglas, Harry Bradbeer, Joy Perino, Joe Ahearne, Morag Fullerton; Producer Jane Fallon

The Cops
BBC2; 3 series (24 episodes) tx 19 October 1998–15 March 2001
Writing team included Jimmy Gardner, Anita Panolfo, Stephen Brady, James Quirk, Robert Jones; directors Harry Bradbeer, Alrick Riley, Kenny Glennan; producer Eric Coulter (who was also executive Producer on series 3)

Attachments
BBC2; 2 series (29 episodes) tx 26 September 2000–24 April 2002
Series creator Tony Garnett; writers Toby Whitehouse, Richard Zajdlic, Amelia Bullmore, Harriet Brown, Harriet Braunn, Rachel Pole, Simon Block, Simon McCleave; directors Harry Bradbeer, Omar Madha, Julian Homes, Kenny Glenaan, Tony Smith, Susannah White; Producer Simon Heath

Buried
Channel 4; 1 series (8 episodes) tx 14 January–4 March 2003
Series creator and main writers Jimmy Gardner and Robert Jones; other writers Stephen Brady, Richard Zajdlic; directors Kenny Glenaan, Morag McKinnon; producer Kath Mattock.

Appendix II:
List of films for theatrical release

Tony Garnett as producer: films for theatrical release

Kes: 1969
Kestrel/United Artists/Woodfall
Writer Barry Hines; Director Ken Loach

The Body: 1970
Kestrel/EMI
Writer/Creator Tony Garnett from the book by Anthony Smith; Director
Roy Battersby

Family Life: 1971
Kestrel/EMI
Writer David Mercer; Director Ken Loach

Black Jack: 1978
Kestrel
Writer Ken Loach from the book by Leon Garfield; Director Ken Loach

Prostitute: 1980
Writer, Director and Producer Tony Garnett

Hand Gun (aka *Deep in the Heart*):1982
Kestrel/Warner
Writer, Director and Producer Tony Garnett

Follow that Bird: 1985
Warner/World Film Services/Children's Television Workshop
Writers Tony Geiss and Judy Freudberg; Director Ken Kwapis

Earth Girls are Easy: 1988
De Laurentiis Entertainment Group/Kestrel
Writers Julie Brown, Charlie Coffey and Terence McNally; Director Julian
Temple

Shadow Makers (aka *Fat Man and Little Boy*): 1989
Paramount
Writers Roland Joffe and Bruce Robinson; Director Roland Joffe

Beautiful Thing: 1996
World Productions/Channel 4
Writer Jonathan Harvey; Director Hettie MacDonald; Co-producer Bill
Shapter

Hostile Waters: 1997
World Productions/BBC/HBO/Ufa Flach Films
Writer Troy Kennedy Martin; Director David Drury

Bibliography

Books and articles

Adler, T. (2004) *The Producers: Money, Movies and Who Really Calls the Shots*, London: Methuen.

Afterimage (1970) 'The interview: Tony Garnett', unpaginated.

Anon (1968) '*The Gorge*', *Sunday Mail*, 8 September.

—— (1970a) 'The body beautiful', *Observer*, 3 May.

—— (1970b) 'Kestrel's move', *The Times*, 8 January.

—— (1980) 'Too rude for telly' *Sunday Times*, 13 January.

—— (2003a) 'Channel 4 – the UK's HBO', *Pact*, January.

—— (2003b) Review of *Buried*, *Guardian*, 19 February.

Bakewell, J. (1974) 'Tony Garnett's morality plays', *The Listener*, 13 June, 754–5.

Barnett, A., J. McGrath, J. Mathews, P. Wollen (1976) 'Interview with Tony Garnett and Ken Loach: *Family Life* in the making', *Jump Cut*, 10:11, 43–5.

Barnett, S. and E. Seymour (1999) *"A Shrinking iceberg travelling south ..." Changing Trends in British Television: A case study of drama and current affairs*. A Report for the Campaign for Quality Television Ltd., University of Westminster.

BBC 'Audience Research Report: *Up the Junction*', BBC WAC VR/65/169.

BBC 'News Release: Autumn test-bed on BBC 2 for fresh ideas and talent' www.bbc.co.uk/info/news263.htm.

Bennet, T. (1981) 'The *Days of Hope* debate: an introduction' in T. Bennett (ed.) *Popular Television and Film*, London: BFI and the Open University.

Bignell, J. and J. Orlebar (2005) *The Television Handbook*, (third edition) London: Routledge.

Black, P. (1965) 'This must be just about THE LIMIT', *Daily Mail*, 6 November.

—— (1966) TV column, *Daily Mail*, Thursday 17 November.

—— (1967) 'If Cathy made you think last night', *Daily Mail*, Thursday 12 January.

Born, G. (2005) *Uncertain Vision: Birt, Dyke and the Reinvention of the BBC*, London: Vintage.

Bourdieu, P. (1992) 'The aristocracy of culture', *Distinctions*, London: Routledge.

Brandt, G. (ed.) (1981) *British Television Drama*, Cambridge: Cambridge University Press.

Bream, P. (1970) 'Spreading the wings at Kestrel', *Film and Filming*, 18:6, March, 36–40.

Brecht, B. (1977) 'Against George Lukacs' in E. Bloch, G. Lukacs, B.Brecht, W. Benjamin and T. Adorno, *Aesthetics and Politics*, London: New Left Books.

Briggs, A. (1995) *The History of Broadcasting in the United Kingdom, Volume V: Competition*, Oxford: Oxford University Press.

Brown, C. (1994) 'Here's to you, Mrs Bottomley', *Sunday Times*, 24 April.

Brown, M. (2002) 'Meet the producer', *Guardian*, 28 October.

Brunsdon, C. (2000) 'The Structure of anxiety: recent British television crime fiction' in E. Buscombe (ed.) *British Television: A Reader*, Oxford: Oxford University Press.

Bryant, S. (1989) *The Television Heritage*, London: British Film Institute.

Bygrave, M. (1990) 'The shadow of the fat man', *Guardian* 1 March.

Cardwell, S. (2005) 'The representation of youth and the twenty-something serial' in M. Hammond and L. Mazdon (eds) *The Contemporary Television Series*, Edinburgh: Edinburgh University Press.

Carney, R. (2000) *The Films of Mike Leigh: Embracing the World*, Cambridge: Cambridge University Press.

Caughie, J. (1981) 'Progressive television and documentary drama' in T. Bennett (ed.) *Popular Television and Film*, London: BFI and the Open University.

—— (2000) *Television Drama: Realism, Modernism and British Culture*, Oxford: Oxford University Press.

Clayton, S. (1966) 'Play's plea for homeless families', *Daily Telegraph*, 17 November.

Clements, P. (1983) *The Improvised Play: The Work of Mike Leigh*, London: Methuen.

Cohen, S. (1973) *Folk Devils and Moral Panics*, London: Paladin.

Cook, J. (1995) *Dennis Potter: A Life on Screen*, Manchester: Manchester University Press.

Cooke, L. (2003) *British Television Drama: A History*, London: BFI.

—— (2005) 'The new social realism of *Clocking Off*' in J. Bignell and S.Lacey (eds) *Popular Television Drama: Critical Perspectives*, Manchester: Manchester University Press

Corner, J. (ed.) (1991) 'General introduction: television and British society in the 1950s', *Popular Television in Britain: Studies in Cultural History*, London: BFI.

—— (1996) *The Art of Record: A Critical Introduction to Documentary*, Manchester: Manchester University Press.

Coveney, M. (1996) *The World According to Mike Leigh*, London: Harper Collins.

Creeber, G. (2004) *Serial Television: Big drama on the small screen*, London: BFI.

Dyer, R.C. Geraghty, M. Jordan, T. Lovell, R. Patterson and J. Stewart (1981) *Coronation Street*, London: BFI.

Eaton, M. (1995) 'A fair cop? Viewing the effects of the canteen culture in *Prime Suspect* and *Between the Lines*' in D. Kidd-Hewitt and R. Osborne (eds) *Crime and the Media: The Post-Modern Spectacle*, London: Pluto Press.

Edgar, D. (2000) 'Playing shops, shopping plays: the effect of the internal market on television drama' in J. Bignell, S. Lacey and M. Macmurraugh-Kavanagh (eds) *British Television Drama: Past, Present and Future*, Basingstoke: Palgrave Macmillan.

Finch, J. with M. Cox and M. Giles (eds) (2003) *Granada Television: The first generation*, Manchester: Manchester University Press.

Flett, K. (2000) 'Geek heroes: can the launch of a dotcom make compulsive viewing? Well, Tony Garnett did his best', *Observer*, 1 October.

Franklin, B. (ed.) (2001) *British Television Policy: A Reader*, London: Routledge.

—— (2005) *Television Policy: The MacTaggart Lectures*, Edinburgh: Edinburgh University Press.

Fuller, G. (ed.) (1998) *Loach on Loach*, London: Faber and Faber.

Gardner, C. and J. Wyver (1980) 'The single play: from Reithian reverence to cost-accounting and censorship', Edinburgh International Television Festival 1980, Official Programme. Reprinted in *Screen*, 24:4–5, (1983) 114–24.

Garnett, T. (1964) Letter, *Encore*, 49, May–June, 45–6.

—— (1966) Memo, 19 July, BBC WAC T5/695/1.

—— (1967a) 'Early warning synopsis' of *In Two Minds*, BBC WAC T5/1,5222/1.

—— (1967b) Draft preview of *Drums Along the Avon*, BBC WAC T5/1,300/1.

—— (1967c) Draft preview of *An Officer of the Court*, BBC WAC T5/1,738/1.

—— (1997) 'Speech to the Drama Forum: 1977', www.world-productions.com/content/reference/tony/lectures_02.htm.

—— (1998) '"Trojan Horses" and "Bad Apples": Tony Garnett discusses *The Cops*'. Unpublished transcript of a seminar held in the Department of Film and Drama, University of Reading in November 1998, plus material incorporated from an interview by Madeleine Macmurraugh-Kavanagh on 5 January 1998. Unpaginated.

—— (2000a) 'Contexts' in J. Bignell, S. Lacey and M. Macmurraugh-Kavanagh (eds) *British Television Drama: Past, Present and Future*, Basingstoke: Palgrave Macmillan.

—— (2000b) 'The Cops: A Short history and background', www.world-productions.com/wp/content/shows/cops/info/history.htm, last accessed April 6 2006.

———— (2001) 'Working in the field' in S. Rowbotham and H. Beynon (eds) *Looking at Class: Film, Television and the Working Class in Television*, London: Rivers Oram Press.

Geraghty, C. (1995) 'Social issues and realist soaps: a study of British soaps in the 1980s/1990s' in R. C. Allen (ed.) *To be continued ... Soap operas around the world*, London: Routledge.

Giddens, A. (1991) *Modernity and Self-Identity: Self and Society in the Late Modern Age*, Cambridge: Polity Press.

Glenaan, K. (2003) 'A director's view, www.world-productions.com/wp/content/shows/buried/productioninfo, last accessed 7 April 2006

Goodwin, A., P. Kerr and I. McDonald (eds) (1983) *BFI Dossier 19: Drama-documentary*, London: BFI.

Goorney, H. (1982) *The Theatre Workshop Story*, London: Eyre Methuen.

Grahame, J. (2002) 'Talking to Tony: an interview with Tony Garnett', *English and Media Magazine*, 46, June, 20–2.

Griffiths, T. (1973) *The Party*, London: Faber and Faber.

Hall, S., C. Crichter and T. Jefferson (1978) *Policing the Crisis*, London: Macmillan.

Hall, S. and M. Jacques (1983) *The Politics of Thatcherism*, London: Lawrence and Wishart in association with *Marxism Today*.

Hallam, J. (2005) *Lynda La Plante*, Manchester: Manchester University Press.

Hallam, J. and M. Marshment (2000) *Realism and Popular Cinema*, Manchester: Manchester University Press.

Henri, A. (1988) 'Introduction', *Up the Junction*, London: Virago Press.

Hillier, J. (1993) *The New Hollywood*, London: Studio Vista.

Hoggart, R. (1957) *The Uses of Literacy*, London: Chatto and Windus.

Hollingsworth, M. and R. Norton-Taylor (1988) *Blacklist: The Inside Story of Political Vetting*, London: Hogarth Press.

Hudson, R. (1972) 'Television in Britain: description and dissent: interviews with Tony Garnett and John Gould', *Theatre Quarterly*, 2:6, April–June, 18–25.

Jackson, M. (1978) 'After Tony Garnett, truth will never be the same again', *Daily Mail*, 7 April.

Jacobs, J. (2000) *The Intimate Screen: Early British Television Drama*, Oxford: Oxford University Press.

———— (2003) *Body Trauma TV: The New Hospital Dramas*, London: BFI.

James, E. (2003) 'Forbidden Knowledge', *Guardian*, 13 January.

Jancovich, M. and J. Lyons (eds) (2005) *Quality Popular Television: Cult TV, the Industry and the Fans*, London: BFI Publishing.

Jenkins, A. (2003) www.ThisLife-TVHeaven.com last accessed 24 April 2006.

Johnson, C. and R. Turnock (eds) (2005) *ITV Cultures: Independent Television Over Fifty Years*, Maidenhead: Open University Press.

Jordan, M. (1981) 'Realism and convention' in R. Dyer *et al. Coronation Street*, London: BFI Television Monograph.

Kavanagh, D. and P. Morris (1995) *Consensus Politics from Atlee to Major*, Oxford: Blackwell.

Kennedy Martin, T. (1964a) 'Nats go home: first statement of a new drama for television', *Encore*, 48, March–April, 21–33.

—— (1964b) Letter, *Encore*, 49, May–June, 47

—— (1965–66) 'Up the junction and after', *Contrast*, 4:5/6, Winter–Spring, 137–9.

Knight, D. (1997) 'Naturalism, narration and critical perspective: Ken Loach and the experimental method' in G. McKnight (ed.) *Agent of Challenge and Defiance: The Films of Ken Loach*, Trowbridge: Flick Books.

Lacey, S. (1995) *British Realist Theatre: The New Wave in its Context 1956–1965*, London: Routledge.

—— with Macmurraugh-Kavanagh (1998) 'Who framed theatre? the "moment of change" in television drama', *New Theatre Quarterly*, 57 (Feb. 1999), 58–74

—— (2005) 'Becoming popular: some reflections on the relationship between television and theatre' in J. Bignell and S. Lacey (eds) *Popular Television Drama: Critical Perspectives*, Manchester: Manchester University Press.

Laing, S. (1986) *Representations of Working-Class Life 1957–1964*, Basingstoke: Macmillan.

Leigh, J. (2002) *The Cinema of Ken Loach: Art in the Service of the People*, London: Wallflower Press.

Levin, G. (1971) *Documentary Explorations: 15 interviews with film-makers*, New York: Doubleday.

Lipman, A. (1990) 'Tony come home', *Producer*, 11, Spring 9–11.

Lury, K. (2001) *British Youth Television: Cynicism and Enchantment*, Oxford: Oxford University Press.

MacCabe, C. (1981a) 'Realism and the cinema: notes on some Brechtian theses', in T. Bennett et al (eds) *Popular Television and Film*, London: BFI (Originally published in 1974 in *Screen*, 15:2, 7–27).

—— (1981b) 'Memory, phantasy, identity: *Days of Hope* and the politics of the past' in T. Bennett et al. (eds) *Popular Television and Film*, London: BFI.

McGrath, J. (1977) 'Television Drama: The Case against Naturalism', *Sight & Sound*, 46:2, 100–5.

—— (1981) *A Good Night Out*, London: Eyre Methuen.

—— (2000) 'TV drama: then and now' in J. Bignell, S. Lacey and M. Macmurraugh-Kavanagh (eds) *British Television Drama: Past, Present and Future*, Basingstoke: Palgrave Macmillan.

McGregor, T. (1997) *This Life: The Companion Guide*, London: BBC Books/Penguin Books.

McKnight, G. (ed.) (1997) *Agent of Challenge and Defiance: The Films of Ken Loach*, Trowbridge: Flick Books.

Macmurraugh-Kavanagh, M. (1997a) 'The BBC and the birth of "The

Wednesday Play", 1962–66: institutional containment versus "agitational contemporaneity"', *Historical Journal of Film, Radio and Television*, 17:3, 367–81.

—— (1997b) '"Drama" into "News": strategies of intervention in "The Wednesday Play"', *Screen*, 38:3, Autumn, 247–59.

—— (1997c) 'Interview with Nell Dunn: 13 October 1997', unpublished.

—— (1998) '"Kicking over the traces": an interview with Tony Garnett', *Media Education Journal*, 24, Summer, 23–30.

—— (1999) 'Boys on top: gender and authorship on the BBC Wednesday Play 1964–70', *Media, Culture and Society*, 21:3, 409–25.

—— (2000) 'What's all this then?: The Ideology of Identity in *The Cops*' in B. Carson and M. Llewellyn-Jones (eds) *Frames and Fictions on Television: The Politics of Identity within Drama*, Exeter: Intellect Books.

MacTaggart, J. (1967) Letter to Mrs J. Mould concerning *Drums Along the Avon*, BBC WAC T5/1,300/1.

Madden, P. (1976) *Complete Programme Notes for a Season of British Television Drama: 1959–1973* held at the National Film Theatre, 24 October 1976, London: BFI.

—— (1981) 'Jim Allen' in G. Brandt, *British Television Drama*, Cambridge: Cambridge University Press.

Maddison, J. (1963) 'What is a television film?', *Contrast*, 13:1, Autumn, 7–9, 71–5.

Mercer, D (1967) Letter to Dr Ward, BBC WAC T5/1,5222/1.

Moore-Gilbert, B. and J. Seed (eds) (1992) *Cultural Revolution? The Challenge of the Arts in the 1960s*, London: Routledge.

Murtin, L (1978) 'Top BBC producer joins ITV', *Evening Standard*, 14 August.

Nelson, R. (1997) *TV Drama in Transition: Forms, Values and Cultural Change*, Basingstoke: Macmillan.

Newman, S. (1964a) Letter, *Encore*, 49, May–June, 39.

—— (1964b) Memo to Kenneth Adam, 24 June, BBC WAC Ref: T16/62/3.

—— (1966a) Memo, 12 March, BBC WAC T5/695/2.

—— (1966b) 'The Wednesday Play', Memo to Kenneth Adam, 15 June, BBC WAC T5/695/2, 3798/9.

Ojumu, A (1999) 'A typical reaction was a snigger ... I was making a film about the wrong kind of bird', *Guardian*, 29 August.

Orbanz, E. (1977) *Journey to a Legend and Back: The British Realistic Film*, Berlin: Volker.

O'Sullivan, T. (1991) 'Television memories and cultures of viewing' in J. Corner (ed.) *Popular Television in Britain: Studies in Cultural History*, London: BFI.

Page, A. (ed.) (1992) *The Death of the Playwright?*, Basingstoke: Macmillan.

Paget, D. (1990) '"Cathy Come Home" and "Accuracy" in British Television Drama', *New Theatre Quarterly*, 57 (Feb. 1999), 58–74.

———— (1998) *No Other Way to Tell It: Dramadoc/docudrama on Television,* Manchester: Manchester University Press.

Parker, T. (1999) 'Principles of tape-recorded interviewing' in K. Soothill *Criminal Conversations: An Anthology of the work of Tony Parker,* London: Routledge.

Pawling, C. and T. Perkins (1992) 'Popular drama and realism: the case of television' in A. Page (ed.) *The Death of the Playwright?'* Basingstoke: Macmillan.

Pearson, R. (2005) 'The writer/producer in American television' in M. Hammond and L. Mazdon (eds) *The Contemporary Television Series,* Edinburgh: Edinburgh University Press.

Peretti, J. (2001) 'Attachments – Preview', *Guardian,* G2, 22 October.

Petley, J. (1997) 'Factual fictions and fictional fallacies: Ken Loach's documentary dramas' in G. McKnight (ed.) *Agent of Challenge and Defiance: The Films of Ken Loach,* Trowbridge: Flick Books.

Poole, M. and J. Wyver (1984) *Powerplays: Trevor Griffiths in Television,* London: BFI.

Potts, B. (1978) Letter on behalf of the pressure group Radical Alternatives to Prison, *Guardian,* 6 May.

Quart, L. (1980) 'A fidelity to the real: an interview with Ken Loach and Tony Garnett', *Cineaste,* 4, Autumn, 26–9.

Radin, V. (1978) 'Briefs and blaggers', *Observer,* 2 April.

Rees, J. (2003) 'From cops to robbers', *Daily Telegraph,* 9 January.

Reeves, R. (2001) *Happy Mondays: Putting the Pleasure Back into Work,* London: Momentum/Pearson.

Rolinson, D. (2005) *Alan Clarke,* Manchester: Manchester University Press.

Rowbotham, S. and H. Benyon (eds) (2001) *Looking at Class: Film, Television and the Working Class in Britain,* London: Rivers Oram Press.

Sandford, J. (1972) 'Patronising the proles', *Plays and Players,* 19:8, 58.

———— (1973) 'Edna and Cathy: just huge commercials', *Theatre Quarterly,* 3:10, April–June, 79–85.

Savoury, G. (1967) Memorandum to Paul Fox dated 12 June, BBC WAC T47/176/1.

Saynor, J. (1993) 'Imagined communities', *Sight & Sound,* 3: 12, 11–13.

Schiach, M. (1989) *Discourse on Popular Culture,* Oxford: Polity Press/ Blackwell.

Seed, J. (1992) 'Hegemony postponed: the unravelling of the culture of consensus in Britain in the 1960s' in B. Moore-Gilbert and J. Seed (eds) *Cultural Revolution? The Challenge of the Arts in the 1960s,* London: Routledge.

Shepherdson, K. (2004) 'Challenging television: the Work of Tony Garnett'. (Unpublished PhD thesis, University of Kent, Canterbury.

Shubik, I. (1975) *Play for Today: The Evolution of Television Drama,* London: Davis-Poynter.

———— (2000) 'Television drama series: a producer's view' in J. Bignell, S.

Lacey and M. Macmurraugh-Kavanagh (eds) *British Television Drama: Past, Present and Future*, Basingstoke: Pelgrave Macmillan.

Stoddart, P. (1992) 'New lore on order', *Guardian*, 1 September.

Sutton, S. (2000) 'Sydney Newman and the "Golden Age"', in J. Bignell, S. Lacey and M. Macmurraugh-Kavanagh (eds) *British Television Drama: Past, Present and Future*, Basingstoke: Palgrave Macmillan.

Taylor, D. (1990) *Days of Vision – Working with David Mercer: Television Drama Then and Now*, London: Methuen.

Thomas, J. (1967) 'Getting a bit blurred on TV ... "Drama" and "Real-life"', *Daily Express*, 2 March.

Thompson, K. (1998) *Moral Panics*, London: Routledge.

Tracey, M. (1983) *A Variety of Lives*, London: Bodley Head.

Turnham, S. and T. Purvis (2005) *Television Drama: Theories and Identities*, Basingstoke: Palgrave Macmillan.

Tynan, K. (1984) *A View from the English Stage*, London: Methuen.

Wayne, M. (1998) 'Counter-hegemonic strategies in *Between the Lines*' in M. Wayne (ed.) *Dissident Voices: The Politics of Television and Cultural Change*, London: Pluto Press.

Whitehouse, M. (1967) *Cleaning Up TV: From Protest to Participation*, London: Blandford.

Wiggin, M. (1965) 'Little Nell's curiosity shop', *Sunday Times*, 7 November.

Williams, R. (1977) 'Lecture on Realism', *Screen*, 18:1, 61–74 (re-printed in 1990 as 'A defence of realism' in *What I Came to Say*, London: Hutchinson Radius).

—— (1981) *Culture*, London: Fontana.

—— (1990) 'A defence of realism', *What I Came to Say*, London: Hutchinson Radius.

Wolff, J. (1978) 'Bill Brand, Trevor Griffiths, and the debate about political theatre', *Red Letters*, 8, 56–61.

Woodman, S. (1983) 'The law, disorder and G. F. Newman' in A. Goodwin, P. Kerr and I. McDonald (eds) *BFI Dossier 19: Drama-Documentary*, London: BFI.

Woollacott, M. (1969) 'Rout of the BBC censors claimed', *Guardian*, 17 February.

Wyndham Goldie, G. (1967) 'Stop mixing TV fact and fiction', *The Sunday Telegraph*, 8 January.

References to material in the BBC Written Archives (by programme)

Up the Junction: BBC WAC T5/681
Cathy Come Home: BBC WAC T5/695/1
The Lump: BBC WAC T5/1,263/1
Drums Along the Avon: BBC WAC T5/1,300/1
In Two Minds: BBC WAC T5/1,522/1
An Officer of the Court: BBC WAC T5/1,738/1

Websites

BBC: www.bbc.co.uk

'BBC News Release: Autumn test-bed on BBC TO for fresh ideas and talent' www.bbc.co.uk/info/news/news263.htm

Clark, A., *Cardiac Arrest*, www.screenonline.or.uk/tv/id/481778/index.htm

Clarke, P., *This Life*, www.screenonline.or.uk/tv/id/802194/index.htm

Cooke, L., *Roland Joffe*, www.screenonline.or.uk/people/id/533554/index.htm

Moat, J. *The Parachute*, www.screenonline.org.uk/tv/id/576490/index.htm

Rolinson, D., *Hard Labour*, www.screenonline.or.uk/tv/id/485368/index.htm

Sinyard, N., *Jack Gold*, www.screenonline.or.uk/people/id/498435/index.htm

Vahimagi, T., *Sydney Newman*, www.screenonline.or.uk/people/id/522017/index.htm

Whitehead, T. *Mike Leigh on TV*, www.screenonline.or.uk/people/id/1154778/index.htm

Winston B. *Tony Garnett, British Producer*, www.museum.tv/archives/etv/G/htm/G/garnetttony/htm

World Productions: www.world-productions.com

Index

Note: 'n.' after a page reference indicates the number of a note on that page